日本と世界の塩の図鑑

ソルトコーディネーター
青山志穂

あさ出版

Contents

日本と世界の 塩の図鑑

カタログの見方	4
はじめに	6

まずは知りたい
塩の基礎知識

「いい塩」ってどんな塩？	8
自分の「推し塩」を見つけよう！	10
塩の個性は原料×製法で決まる！	12
製塩のおもな工程	14
塩づくりの現場	
①沖縄県「高江洲製塩所」	
②沖縄県「塩田」	
意外と知らない!? 塩の常識、新常識	20

Chef's Interview 1
アル・ケッチァーノ 奥田政行シェフ … 24

知れば知るほど個性豊かな
海水塩、藻塩

海水塩	28
Sea salt World Map	
世界	30
Sea salt Japan Map	
北海道〜中部	50
近畿〜四国	72
九州〜沖縄	84
藻塩	106

Chef's Interview 2
てんぷら小野 志村幸一郎氏 … 112

Staff 写真 稲福哲彦、masaco／スタイリング 二野宮友紀子／イラスト ナカオテッペイ
デザイン&DTP 小関悠子（MATCH and Company Co., Ltd.）／執筆協力 伊藤睦

色どりが美しい
岩塩

岩塩116

変わり種いろいろ
そのほかの塩

湖塩130
地下塩水塩134
シーズニング139
　燻製139
　混ぜる141
　煮詰める146
Senior Salt Coordinator
おすすめの塩と使い方149

料理も暮らしも楽しくなる！
塩のおいしい使い方

使いわけで塩をもっと楽しむ154
しょっぱさ×粒の大きさマトリックスで
とってもかんたん塩選び156
食材・料理別に使いわける158
店頭で困らない塩選びのいろは160
キッチンで
塩をトコトン使いこなそう162
かんたん、おいしい！
塩の3stepクッキング166
塩とお酒のペアリングを楽しもう168
こんなに便利！暮らしの塩活用術170
もっとキレイになる！塩の美容術172
塩の歴史174
生命に不可欠って本当？塩と健康176
減塩はもう古い!?「適塩」を目指そう178

salt column

塩も「熟成」する53
塩にも「香り」がある58
「食塩」は商品名でもある75
「にがり」のじょうずな使い方77
古くて新しい塩の形「水塩」101
「ひとつまみ」と「少々」はどう違う？105
大きくてかたい塩には「ミル」がおすすめ125
塩のための道がある128
世界で一番大きい「塩湖」は？132
「盛り塩」の起源は中国の皇帝だった138
おいしさの要は「いい塩梅」140
法律上の塩の分類148

塩名索引 salt index180
Information183

カタログの見方

食材マーク 相性のよい食材がひと目でわかる。

- 牛肉
- 豚肉
- 鶏肉
- 赤身の魚（マグロなど）
- 白身の魚（ヒラメなど）
- 淡泊な野菜（レタスなど）
- 濃厚な野菜（トマトなど）
- ごはん
- 揚げ物
- たまご
- 豆
- 乳製品

国名、都道府県名

商品名

結晶の拡大写真
結晶の具合を見ることができる。

塩の味わい
テイスティングの結果、塩の味わいを表現している。例えば、「ミネラル感」は石や鉱物を思わせる味や、さまざまなミネラル成分由来の奥深い味わいを表現するのに便宜的に使用している。
※著者と日本ソルトコーディネーター協会の見解によるもの。

相性のよい食材や料理
※著者と日本ソルトコーディネーター協会の見解によるもの。

価格
商品の価格は表示のないもの以外、税抜きで表示している。価格とパッケージは2016年10月現在のもの。

問い合わせ先
2016年10月現在のもの。

40年かけて育まれた体にやさしい塩

粟國の塩 釜炊き

沖縄

DATA
- 食塩相当量 71.7g
- ナトリウム 28.2g
- カリウム 550mg
- マグネシウム 550mg
- カルシウム 1530mg

形状 凝集結晶
水分量 しっとり
工程 天日／平釜
原材料 海水

TASTE
しょっぱさ、うまみ、甘味、酸味、苦味、雑味が次々と口の中で広がる。どっしりと厚みのある味

おすすめの食材＆料理
豚肉の塩漬け、秋刀魚の塩焼き、スポーツドリンクづくりに、塩おにぎり

●価格／160g入り500円
株式会社 沖縄海塩研究所
沖縄県島尻郡粟国村字東8316
tel.098-988-2160
http://www.okinawa-mineral.com/

専売制度の下、全国の有志とともに自然塩復興運動に尽力した読谷村出身の小渡幸信さんが、理想の環境を探してたどり着いたのが沖縄本島からおよそ60km離れた離島・粟国島。1995年、目の前に美しい海が広がる島の北端に製塩所を構えた。1万5000本もの竹枝を使って高さ10mに組んだ立体式の塩田タワーは圧巻で、粟国の風が効率よく流れるよう、向きや大きさなどが考えぬかれた設計だ。そこに海水をかけ流し1週間ほどかけて濃縮、薪で焚いた平釜で煮詰めて結晶させている。
体にやさしい塩をつくりたいという小渡さんの思いが込められた結晶は、海水のミネラルをバランスよく取り込むよう、独自の技法でじっくりにがりをなじませている。にがりをよく含むため、ナトリウム構成比も非常に低いうえ、まろやかで滋味深い塩に仕上がる。

97

原産地または製造地
地図上のピンの先端がおおよその場所を指している。

成分表
塩100g中の食塩相当量、ナトリウム、カリウム、マグネシウム、カルシウムの含有量。なお（ ）でくくった数字は推定値、未検出の場合は未掲載。食塩相当量の推定値は「ナトリウム（g）× 2.54」で算出している。
※「食塩相当量」とは食品に含まれるナトリウム量を食塩の量に置き換えたもの。

しょっぱさ×粒の大きさマトリックス

粒の大小を 6 段階、しょっぱさの強弱を 10 段階で評価。
マトリックス内の左上、右上、左下、右下、中央のどこに位置するかで、
相性のよい食材が大まかにわかる。
「しょっぱさ×粒で味わいが変わる」(p.155) を参照。

【粒径のめやす】

粗大粒────粒径 5mm 以上
粗粒────粒径 1.2mm 以上　5mm 未満
大粒────粒径 0.45mm 以上　1.2mm 未満
中粒────粒径 0.3mm 以上　0.45mm 未満
微粒────粒径 0.1mm 以上　0.3mm 未満
粉末────粒径 0.1mm 未満

味覚チャート

掲載した塩のなかで各項目の数値が 5 の「青い海」(p.102) を基準とし、しょっぱさ、酸味、うまみ、甘味、雑味、苦味を 10 段階で評価したもの。三角形の形によって塩の個性がわかる。

大きい────力強い味わい
小さい────繊細な味わい
正三角形────バランスが良い
いびつな三角形────特徴的な味わい

※塩のテイスティングは、テイスティングのトレーニングを積んだ、日本ソルトコーディネーター協会認定のソルトコーディネーター資格保有者 22 名にて実施し、その評価を総合している。

データ欄

形状

立法体
正六面体の結晶で、各方向に均等に結晶が成長したもの。

凝集晶
小さな立方体がくっつき合った、不均等な形。結晶はほどけやすい。

フレーク
濃縮海水の表面で成長した薄い板状の結晶。溶けやすい。

トレミー
フレーク結晶が自重で沈みながら成長した、ピラミッド形の結晶。

球状
立方体の結晶が濃縮海水のなかで転がりながら成長した球形の結晶。

粉砕
さまざまな形状の結晶を粉砕した不定形のもの。

パウダー
水分を瞬間的に蒸発させたもの。または非常に微粒に結晶したもの。

顆粒
パウダー状の塩を顆粒状に成形したもの。

水分量

しっとり
紙の上に塩をのせて左右に軽く振ったときに、結晶がほとんど動かない。結晶が水分でくっついている。

標準
紙の上に塩をのせて左右に軽く振ったときに、結晶が多少動く。

さらさら
紙の上に塩をのせて左右に軽く振ったときに、結晶が左右に動く。

工程

濃縮⇒結晶⇒仕上げの順で記載している。なお、濃縮と結晶が同じ工程の場合はひとつに省略（例：平釜／平釜 ⇒ 平釜）。

原材料

塩の原料になっているもの。

塩のテイスティングについて

味覚は体調によっても感じ方が変わるため、塩のテイスティングの際には味覚チャートの数値がすべて「5」となる基準の塩を設定し、それと比較しながら評価を行うことで、ブレを極力減らしている。日本ソルトコーディネーター協会では、味覚のバランス・粒形・水分量・品質の安定性などをふまえ、「青い海」(p.102) を基準の塩として選定している。

※データは 2018 年 3 月現在のものです。パッケージ等に変更がある場合がございますので、最新情報は製造元にお問合せください。

はじめに

同じ種類の野菜や果物の味が、季節や生産者によって異なるように、塩もひとつひとつ味や形が異なり、驚くほど個性豊かです。現在、国内では約4000種類を超える塩が流通しています。塩の楽しさを多くの方々に知ってほしいと、この本では、かつて「自然塩」※と呼ばれた、イオン膜製法以外でつくられた塩を中心にご紹介しています。

塩の使いわけ方、食材との組み合わせ方、プロの料理人がオススメする塩活用法など、塩をおいしく、賢く楽しむコツも満載です。

塩を使いわけると、ひとつの食材をさまざまな味で楽しむことができるうえ、食材そのものの味が際立つため、結果的に使用量も少なくて済みます。複数の塩を料理に添えて提供すれば、「私はこれが好き」「この赤い粒も塩なの?」などと、食卓での会話がいっそう弾むでしょう。

この本をご覧になったみなさんの食卓や暮らしが、塩を通じてより健康的で豊かな、楽しいものになることを願っています。

ソルトコーディネーター
青山志穂

※食用塩公正取引協議会の規約では、「自然塩」「天然塩」という名称を使った商品のPR・販売は規制されています。しかしながら、現在それに代わる呼称がないため、本書ではイオン膜製法以外で製造された塩を、従来通り「自然塩」と総称しています。これは、イオン膜製塩でつくられた塩が自然の塩でないことを意図するものではありません。

Part 1
まずは知りたい
塩の基礎知識

日本では約4000種類もの塩が売られていること、ご存知でしたか？
日々の暮らしはもちろん、人間の身体にとって欠かせない塩。
知っているようで実は知らない基礎知識をまとめました。
塩の種類や製造工程など、
塩のいろいろをのぞいてみましょう。

最初に知りたい
「いい塩」ってどんな塩?

国内の小さな製塩所の塩や、各国からの輸入塩など、
どんどん広がる選択肢。さて、どんな塩を選んだらいいのでしょう?
「いい塩」ってどんな塩なのでしょう?

目的によって「いい塩」は異なる

「一番いい塩はどれか?」というのは、実はとても難しい質問です。なぜなら、「何に使いたいか」「どういう味で食べたいか」によって、「一番いい塩」が違ってくるからです。

例えば、「揚げ物のつけ塩」の場合、油をさっぱりさせたいときと、油の甘味も感じながらこってり食べたいときとでは、合わせる塩は異なります。冷やしたトマトの甘味を引き出してくれる塩が、豆腐に合わせるとえぐみを引きだしてしまうこともあります。

本書で紹介している、塩と食材の合わせ方(p.154～)や、塩の図鑑を参考にすれば、目的に合わせた塩を選ぶことができます。ぜひ目的に合わせてその時々の「一番いい塩」を見つけましょう。

CASE 1
どんな塩をそろえたらいい?

まずは「使いわけで塩をもっと楽しむ」(p.154)を参考に、粒の大きさとしょっぱさの異なる塩を4種類、何にでも合う塩とおもてなしの塩を各1種をそろえるといいでしょう。合計6種類あれば、じゅうぶんに楽しむことができます。

PART ❶ 塩の基礎知識

CASE 3
減塩できる塩って？
食材の風味にぴったりの塩を合わせると、塩の量が少なくてもしっかり効くので、結果として使う量を減らすことができます。ナトリウム構成比の低い塩もあるので、それを使ってもOK

CASE 2
ふだん使いの塩はどうすればいいの？
味のバランスがよく、形や大きさが標準的で、水分量もほどよい、どんな食材にも合いやすい塩がおすすめ。値段が高い＝いい塩ではないので、価格は気にせずお気に入りの塩を見つけましょう

CASE 4
おもてなしにいい塩って？
お客様がいらしたときや記念日など、食卓をにぎやかにしたいときはシーズニングがおすすめ。彩り豊かなハーブや花が入った塩は、それだけで食卓を華やかにしてくれます

銘柄数は数千！
自分の「推し塩」を見つけよう！

塩の種類は原材料によってわけられる

　全世界での塩の年間生産量は約2億8000万t。日本で手に入るだけでも、約4000種類以上の塩があります。そして、いずれの塩も、原材料別に「海水塩」「岩塩」「湖塩」「地下塩水塩」に分類することができます。

　日本で塩といえば海水塩のイメージが強いものの、世界的には岩塩が主流。生産量の約6割を占めています。数億年前に起きた地殻変動で海が大地に囲まれ、長い年月を経て結晶したものが岩塩で、その過程が塩湖であるといわれています。また、世界各国の沿岸では海水を原料とした塩がつくられており、生産量の3割を占めています。

　このほか、すでにでき上がった塩を原材料としてつくる「再製加工塩」や、ハーブやスパイスなどをブレンドした「シーズニング」、日本古来の「藻塩」などもあります。

海水塩　28ページ
海水を何らかの方法で濃縮・結晶させた塩。製法によっても異なるが、にがりが含まれることが多い。世界の沿岸地域で生産される。

おもな塩の種類

湖塩　130ページ
塩分濃度の濃い湖で採取される塩。イスラエルの死海やボリビアのウユニ塩湖が有名。乾期にしか収穫できないので生産量は多くない。

塩は原材料の違いで大きく4つにわけられ、
さらに再加工したりブレンドしたりと姿を変えます。

藻塩　　106ページ

海藻に海水をかけ流したり、いっしょに煮詰めたりするなどして、海藻のエキスを塩に含ませる日本独自の塩。

岩塩　　116ページ

地殻変動で大地に囲まれた海が、長い年月を経て地中で結晶した塩。土壌の成分の影響で色づいたものも多い。基本的にナトリウム構成比は高め。

地下塩水塩　　134ページ

岩塩が伏流水で溶かされるなどしてできた、地中を流れる塩水の川や地底湖の塩水からつくられる塩。岩塩同様、土壌の影響を受ける。生産量は少ない。

シーズニング　　139ページ

塩にハーブやスパイスをブレンドしたり、塩分入りのタレやエキスを煮詰めて結晶させたりしたものなど、さまざまな素材をブレンドした塩。

塩の個性は
原料×製法で決まる!

塩は単純にしょっぱいだけではありません。それぞれ異なる味があり、形があり、色があります。これらの違い、つまり塩の個性は、原料×製法のかけ算で決まります。

塩の基礎知識

原料による違い

海流

暖流は貧栄養でプランクトンが少なく、野菜に合うような、あっさりとした味に。寒流は栄養豊富でプランクトンが多く、牛肉など味の濃い食材に合うような、こってりとした味に。その中間地点では、魚に合うような、バランスのよい味になりやすいという傾向があります。

取水ポイント

河口付近で取水する場合、背後にある山が持つ成分の影響を大きく受けます（例：鉄鉱山⇒鉄の味）。一方、沖合で取水する場合はそこを流れる海流の味に。海洋深層水はすっきりしたキレのよい味になる傾向があります。

取水のタイミング

海中のミネラルが豊富になるという満月の日の満潮時の海水でつくった塩は、しっかりとした味わいになりやすく、反対に、新月の日の海水でつくった塩は、繊細で潮の香りが強くなる傾向があります。

塩には多くの種類があり、それぞれ豊かな個性があります。味の濃淡、塩分の強弱、粒の大きさ、色、結晶の形など、さまざまな要素が組み合わさって、それぞれのおいしさ、個性を持った塩ができ上がっています。

また、採取場所、採取時期によって原料の違いが、製造方法によって、粒の大きさや形、水分量等の違いが生まれます。例えば、河口付近で取水された海水を、平釜で炊いてつくると、山のミネラルを含んだ塩になります。同じ製法でも沖合いで取水した海水を使うと、海流の特徴を持った塩になります。

製法による違い

粒の大きさ

粗大粒　粗粒　大粒　中粒　微粒　粉末

粒は粒径に応じ、大きいほうから、粗大粒、粗粒、大粒、中粒、微粒、粉末に分類されます。結晶が大きければ大きいほど、溶けるのがゆっくりなため、まろやかに感じやすく、小さければ小さいほど溶けるのが早いため、しょっぱさを感じやすくなります。

結晶の形

結晶の形は立方体が基本で、温度や湿度によってさまざまな形に変化します。フレーク状やトレミー状のものは食感も楽しめるのでトッピングに、パウダー状のものは食材への浸透が早いので下ごしらえに◎。岩塩や湖塩はほとんどが粉砕されています。

水分量

しっとり　さらさら

塩に含まれる水分は「にがり」と呼ばれるマグネシウムとカリウム、少量のナトリウムを主体とした液体で、製法や結晶ができた後に塩を寝かせる時間によってその含有量は変わります。岩塩や湖塩にはほとんど含まれません。

成分のバランス

塩の主成分はナトリウム、マグネシウム、カリウム、カルシウムです。成分ごとに結晶するタイミングが異なります。海水塩の場合、塩を釜から採取するタイミングによって、ミネラルのバランスが変化します。岩塩の場合はナトリウムの構成比が高くなります。

塩の基礎知識

製塩のおもな工程

日本でおなじみの海水塩は大きく3つの工程を経てつくられています。
ひと口に工程といっても、製塩所によってその方法はさまざま。
塩ができるまでを知れば、それぞれの塩の個性を理解しやすくなります。

塩の基礎知識

工程 1 濃縮

海水の塩分濃度を高めて濃縮する

海水の3.4%前後の塩分濃度を6〜20%程度まで高めます。火力を使うと燃料費がかかるため、天日や風にさらして水分を蒸発させる、自然の力を利用した方法も多く採用されています。濃縮工程を経て塩分濃度を高めた海水を「かん水」と呼びます。

工程 2 結晶

塩分濃度をより高めて結晶化させる

かん水の塩分濃度をさらに高めて結晶化させます。塩の成分（カルシウムやナトリウムなど）によって結晶化する濃度が異なるため、天日か火力か、どこまで結晶させるかなどによってミネラルバランスが変わり、結果、味わいに個性が生まれます。

塩づくりの現場 ❶ 沖縄県「高江洲製塩所」

1 原料となる海水は、高江洲製塩所の前に広がる海（プランクトンが少ない黒潮が流れている）から満潮時に汲み上げている。周囲に民家や畑などがないので、生活排水や農薬の心配はない。

2 海水を濃縮するための「枝条架式塩田」。ポンプで海水を汲み上げ、上段の竹枝にゆっくりと流し込んで3.5mの高さから海水が竹枝を伝って落ちてくる間に、自然の風と日光で水分を飛ばす。下まで落ちてきた水は、またポンプで汲み上げ上段から流す。何度も循環させ、夏は2〜3日、冬は1日かけて15%以上に濃縮している。

3 結晶工程を行う「平釜」。1回の作業で大きめの平釜に800Lの濃縮した海水を仕込む。ボイラーで30分ほど温めると沸騰しはじめ灰汁が出てくるので、最初はつきっきりで灰汁を取り除く。1時間ほどすると結晶が見える。

海水塩は3つの工程からでき上がる

塩づくりには、「濃縮」「結晶」「仕上げ」という3つの工程があります。

海水塩は、海水の塩分濃度3.4％前後を最終的に20〜30％まで濃くする必要があるため、まず「濃縮」の工程を行い、ある程度まで濃縮させます。その後「結晶」→「仕上げ」の工程に移ります。岩塩や湖塩など、すでに結晶化した塩を採掘してつくる場合には、基本的に「濃縮」はなく、「結晶」→「仕上げ」の工程のみになります。

海外では、内陸部で岩塩の採掘、沿岸部で広大な塩田による天日塩づくりが盛んですが、日本では、岩塩層も塩湖もなく、国土が狭くて高温多湿なため、それぞれの工程で多種多様な方法が開発されてきました。

工程 3 仕上げ

でき上がった結晶を整える工程

結晶を焼成してさらさらにしたり、顆粒やタブレット状に成形したり、添加物などを混ぜたりして仕上げます。海水塩の場合、特に仕上げはせずに、結晶化した塩を置いてにがりを切り、異物を取り除いてそのままパッケージする場合もあります。

4 泡のように見える灰汁と、釜底にできた結晶が混ざらないよう、ヘラをうまく使うのがコツ。結晶は低温で炊くと粗くなり、高温で炊くと細かくなるため、粒の具合を見ながら釜の温度を微妙に調整しながら炊くという。

5 釜の中ででき上がった結晶は、にがりとなじませてから出す。3時間半ほどで炊き上がる。

6 でき上がった結晶は、にがりを含むためほんのり茶色である。これをすのこに布を敷いた箱に移し、かき混ぜながら寝かす。2〜3日後、ほどよくにがりが抜け、結晶が純白に変わったら完成だ。

> 昔ながらのおいしい塩づくりを目指しています

「高江洲製塩所」塩職人・高江洲優さん

沖縄本島中部の離島・浜比嘉島で塩づくりに取り組む、高江洲製塩所。施設の随所に塩職人・高江洲優さんの工夫が隠されています。1000本の竹ぼうきを解いてつくった枝条架式塩田は、取り外し可能な竹枝で台風対策をしたり、平釜の熱源を直火ではなく蒸気にしたり……。「どれも試行錯誤の結果。自然の力を借りて、うまい塩をつくりたい」と高江洲さんは力強く語ってくれました。

▶▶▶「浜比嘉塩」（高江洲製塩所）⇒99ページ

1 濃縮工程 *concentration*

結晶前に海水を濃縮

　海水を塩分濃度3.4%前後から6〜20%程度まで濃縮します。

　縄文時代の化石からは、先人が海水をそのまま土器で煮詰め続けて濃縮・結晶させていた様子がうかがえます。しかし、釜で最初から炊き続けて結晶させるには、長い時間と大量の燃料が必要になるため、この工程を行うようになりました。そうすることで、結晶工程の効率化を図ることができます。

塩の基礎知識

濃縮方法の種類

天日

海水を濃縮するために太陽と風の力だけを使う製法を「天日」と表現します。「天日」とひと言でいっても、その製法はさまざま。屋外で行われるため、天候に大きく左右されます。

伊豆大島にある海の精株式会社のネット架流下式塩田。ネットをかけた高さ6mのタワーの上から海水をかけ流し濃縮させる。

天日で行うおもな濃縮方法の種類

珠洲市で6代続く角花家の揚浜式塩田。

揚浜式塩田（あげはましき）	塩田に海水を撒いて天日にさらして乾燥させた後、塩のついた砂を集めて、そこに海水をかけ流して濃縮海水をつくる方法です。石川県珠洲市が有名な産地で、江戸時代から続く塩田があります。
入浜式塩田（いりはましき）	海の干満の差を利用して海水を引き入れ、毛細管現象を利用して海水を撒かずとも塩田表面に海水を行き渡らせます。塩が付着した砂に海水をかける点では揚浜式塩田と同じですが、省力化が図られています。
流下式塩田（りゅうかしき）	立体的にタワーを組んで、高いところから海水をかけ流して濃縮します。枝が細かくわかれていること、強度が高いこと、人体に無害であることから、古くは竹枝が使われ、「枝条架式塩田（しじょうかしき）」という名称で呼ばれてきました。竹枝が入手しにくくなった現在では、漁業ネット（ネット式塩田）やすだれなど、さまざまな素材が使用されることも多くなっています。 タワーから落ちてきた海水を集めるために、緩く傾斜のつけられた「流下盤」と呼ばれる坂とセットで使用するため、この2つを合わせて「流下式塩田」と呼びます。

> **memo** 毛細管現象とは、液体に細い管を立てると管の中の液が外の液体より上がる（または下がる）現象。塩田の周囲に海水を引き入れると、砂の細隙から塩田に海水が上がる。

塩づくりの現場 ❷ 沖縄県「塩田」

沖縄本島北部の屋我地島で、昔ながらの入浜式塩田を復活させた株式会社塩田。数百年前に薩摩から伝わった入浜式塩田は、砂利の上ではなく、珊瑚礁の干潟の上に砂を敷くという沖縄独自の形に発展。ここでは昔の塩田跡を利用して塩づくりを行っています。「珊瑚の石灰質を通るから、カルシウムなどを多く含んだ風味ある塩ができる」とおいしさの秘密を教えてくれました。

1 塩田周囲の溝に水門から海水を引き入れると、毛細管現象により海水が地中から塩田表面に吸い上げられる。

2 海水が日光と風で砂に付着しながら結晶化。珊瑚礁と粘土質の砂でつくった塩田の底を傷めないようにしながら、砂だけをかき集める。重い砂を扱う作業はかなりの重労働だ。

3 集めた砂の上から海水をかけると、容器の底から濃縮した海水が出るしくみ。それを薪で焚いた平釜にかける。

▶▶▶「屋我地マース」(塩田)⇒101ページ

塩の基礎知識

濃縮方法の種類

逆浸透膜
水以外の物質を通過させない特殊な性質を持つRO膜（Reverse Osmosis Membrane）を使って、海水から淡水を分離し、濃縮海水を得る方法。1回で海水を約2倍の濃度にすることができます。

イオン膜
陽イオンと陰イオンだけを通す特殊な膜に電流を流すことで、海水中にあるナトリウムイオンだけを集めます。これによりナトリウム純度の高い濃縮海水を効率よく得ることができます。

溶解
「再製加工塩」を製造する際、または、岩塩を溶かして取り出す際に使用される方法で、塩を真水または海水に溶かすことで、異物を沈殿させて除去しながら、効率よく濃縮海水を得ることができます。

浸漬（しんせき）
日本で最も古い濃縮方法で、基本的には「海藻を乾燥させて塩が付着した状態にし、そこに海水をかけ流す工程を何度もくり返しながら、濃縮海水をつくる」ことを指します。磯の香りがするうまみの強い塩になる製法。

平釜
海水を非密閉の釜に入れて煮詰めて濃縮させる方法。豪雪地帯や降雨量の多い地域で採用されることが多く、大がかりな装置を必要としないため、小規模でも製塩することが可能。

立釜
海水を密封した釜に入れて熱を加え、濃縮させる方法。減圧して沸点を低くすることで、平釜にくらべて効率よく濃縮することができます。

2 結晶工程
crystallization

濃縮海水を結晶させる

　海水の濃度を最終的に20〜30%まで濃くして、結晶させます。海水に含まれるミネラルは、種類によって結晶化するタイミングが異なるため、どの程度の塩分濃度で塩として収穫するかによって、その塩に含まれるミネラルバランスが変化。それはそのまま塩の味わいに影響するため、海水塩づくりにおいて、非常に重要な工程といえます。また、結晶した後には、にがりといわれるミネラルの濃縮液が残ります。

高江洲製塩所の平釜。釜の底に通した蒸気管に熱い蒸気を通して熱する。薪やガスなど直火で熱するところも多い。

結晶方法の種類

天日
太陽と風の力だけで結晶させる方法。海外では屋外の広大な塩田に、日本ではハウスの中に小さな箱（結晶箱）を並べて、そこに濃縮した海水を入れて結晶させる方法が多く採用されています。ゆっくり時間をかけて結晶するので、粒が大きく、フレーク状の塩もできやすい製法。

平釜
非密閉の釜に入れて煮詰めて結晶させる方法。中華鍋ほどのものから、プールのようなものまで、大きさはさまざま。ぐつぐつと沸騰させる場合は細かい凝集晶状の塩、沸騰させない場合は大きめの結晶のフレーク状、トレミー状の塩ができやすい製法です。

立釜
密閉式の釜に入れて煮詰めて結晶させる方法。減圧することで沸点が下がるため、平釜より効率よく結晶化できます。結晶は立方体になることが多いですが、釜のコントロールで変えることも可能です。

採掘
すでに結晶となっている岩塩や湖塩を採取する工程を指します。特に岩塩の場合は、土壌の影響を色濃く受けるため、鉄分や硫黄など、その土地に豊富な成分が入った塩が採取されます。

噴霧乾燥
温かい部屋の中の高いところから、温風とともに濃縮海水を噴霧し、瞬間的に水分を蒸発させます。加熱ドラム同様、にがりを含んだままパウダー状の塩になります。

加熱ドラム
熱したドラム状の金属板に濃縮海水を噴霧し、瞬間的に水分を蒸発させる方法。結晶を形成する時間がないため、パウダー状の塩になります。通常は分離するにがりも含む塩に。

塩の基礎知識

3 仕上げ工程 *finish*

でき上がった塩を整える

収穫・採取した塩はそのまま商品として出荷されることもありますが、焼いたり成形したりと、何らかの仕上げを行ってから商品化、出荷されることもあります。

なお、海水塩では、海水を煮詰めて結晶を採取した後、ざるなどに塩をのせて、にがりを分離させることがよくあります。これは仕上げ工程には当てはまりません。

添加物にも注目しよう!

栄養強化のため、炭酸カルシウムや塩化カリウムなどが添加される場合があります。海外産の塩にまれに添加されているフェロシアン化合物は、日本では安全性が疑問視されているため、おすすめしません。また、ヨウ素（ヨード）は、海外では栄養強化を目的に使われますが、日本では添加物として認められていません。輸入塩を使う場合には注意しましょう。

仕上げ方法の種類

焼成

「焼塩」をつくる工程のことで、380℃を境に「高温焼成」「低温焼成」に分かれます。焼成することによって塩の結晶が破裂して細かくなり、マグネシウム化合物でコーティングされるため、さらさらになります。

キパワー株式会社の焼成炉。独自の焼成技術で高温焼成を実現したという。

粉砕

塩の結晶を砕くこと。大きな塊で採取する岩塩や湖塩だけに行われていると思われがちですが、海水塩も使いやすいように粉砕しているものが多くあります。砕き方によってサイズはさまざまです。

造粒

塩を何らかの方法である形にすること。パウダー状の塩を使いやすくするために顆粒状にしたり、パスタのゆで塩用に大きなタブレット状に成形したものなどがあります。

洗浄

主に輸入塩に対して行われます。真水または飽和塩水で塩を洗うことで、塩の表面に付着した不純物を取り除きます。真水で洗うと、ナトリウム以外のミネラルが先に流れ落ちるため、ナトリウムの純度が高くなります。

混合

塩の結晶に何かほかのものを混ぜること。固結防止や栄養強化のほか、ナトリウム構成比の低い低ナトリウム塩をつくる際に、マグネシウムやカリウム、カルシウムなどが添加されます。

塩の基礎知識

\ 意外と知らない!? /
塩の常識、新常識

身近だけれど、まだまだ奥が深いのが塩の世界。
塩の特徴やとりまく世界をギュッとまとめて紹介します。

塩の基礎知識

コップ1杯の海水から
小さじ1杯の海水塩ができる

知ってた?

ナトリウムだけで構成されている「食塩」の場合、塩1粒の重さは約0.1mg。海水の塩分濃度は約3.4％で、その中で塩化ナトリウムが占める割合が約78％。ここから計算すると、塩1粒約0.1mgの「食塩」は約0.0377mLの海水からできていることになります。つまり、小さじ1杯（5g）の「食塩」をつくるには約186mLの海水が必要で、コップ1杯分の海水からやっと小さじ1杯分の塩がつくり出せるというわけです。

※この計算は海水の比重を1としています。ナトリウム以外の成分が塩に含まれる場合には、上記の数値とは異なります。

一杯の海水 → 小さじ一杯の塩

日本の塩は、メキシコや
オーストラリアに支えられている

常識！

日本で年間に生産される塩の量は約93万t（2014年）。年間の日本の使用量は約800万tで、そのほとんどを海外からの輸入に頼っていることになります。消費量は世界第6位でありながら、生産量は世界第32位。実は日本は世界第3位の塩の輸入大国なのです。

世界各国から輸入していますが、おもな輸入国はメキシコとオーストラリア。メキシコには東京都23区と同じくらいの大きさの世界最大の塩田が、オーストラリアには東京ドーム4000個分ほどの大規模塩田が複数あり、そこで数年かけて濃縮・結晶させた完全天日塩を輸入しています。これらの塩はおもに工業に使用されています。

日本の塩の輸入量と国の内訳
（Total 711万t）

- メキシコ 295万t 41%
- オーストラリア 280万t 39%
- インド 85万t 11%
- その他 51万t 9%

出典：「財務省貿易統計2015」
メキシコやオーストラリアから輸入される塩は、ほとんどが工業用として使われる。

PART ❶ 塩の基礎知識

塩は身体にいい！適切な量の塩は人間に欠かせない

新常識！

海で生まれた生命が進化し、陸に上がることができたのは、体内に海水を抱えることができたから。赤ちゃんが育つ羊水は、ほぼ海水と同じ組成で、人間の体液には、約0.9％の濃さで塩分が含まれています。体重60kgの標準体型の成人男性なら、約306gもの塩が体内に溶け込んでいます。体内に溶け込んだ塩は、新陳代謝の基礎機能を担ったり、筋肉や骨、血液などを構成したりするなど、生命活動に重要な役割を果たしています。

そのため、大量の発汗や極度の減塩などで体内の塩分濃度が薄くなり過ぎると、身体が生命の危機を感じて血圧を上げるホルモンが分泌されたり、倦怠感、無気力、痙攣、嘔吐などの症状が起こったり、最悪の場合には死に至ることも。江戸時代にはこの生理作用を利用して「塩抜きの刑」があったほど。近年の減塩ブームで悪者にされがちな塩ですが、適切な量の塩を摂取することは、人間にとってとても重要なことなのです。

胎児が10か月過ごす羊水や人体の7～8％を占める血液のミネラルバランスも海水とほぼ同じだ。

食材の味を引き出す塩はどんな調味料より味覚を育てる

常識！

塩味・酸味・苦味・甘味・うまみの五味のなかで、塩味だけはほかに代替するものが存在していません。また、「塩は百肴の将、酒は百薬の長」という言葉があるほど、塩は食材のうまみを引き出すのに欠かせない存在です。

食材に味を重ねるソースやドレッシングなどの複合調味料と違い、塩だけで味つけをすると、素材そのものの味が強調されて全面に押し出され、旬や産地の違いによる味の差にも敏感になります。塩での味つけを続ければ味覚が鍛えられ、食材そのものにも興味が湧きやすくなるでしょう。

塩の味わいは健康のバロメーター！？

知ってた？

塩を構成するミネラルにはそれぞれ味があります。大まかにいうと、ナトリウムがしょっぱさ、マグネシウムが苦味とうまみ、カルシウムが甘味、カリウムが酸味となります。そのため、それぞれがどのくらいのバランスで含まれているかが、塩の味に大きな影響を与えます。

また、通常時はもっともおいしいと感じやすい塩分濃度は体液と同じ約0.9％ですが、体内にミネラルが不足しているときは高濃度の塩をおいしく感じやすく、じゅうぶんに足りているときは、低濃度であってもしょっぱく感じるなど、身体の状態によって塩の味の感じ方は大きく変化します。一概に「おいしい塩」を選べない理由はここにあります。

塩の基礎知識

「ミネラルたっぷり」の謳い文句はウソだった！？

知ってた？

　海水塩、岩塩、湖塩など、塩の種類にかかわらず、もとをたどれば塩はすべて海水からできています。海水はさまざまなミネラルで構成される液体なので、それを凝縮した塩は、まさにミネラルの塊であるといえます。

　製法などによって大きく異なりますが、塩はおもにナトリウム、マグネシウム、カルシウム、カリウムで構成されています。これらはどれも、人が健康にすごすために1日100mg以上摂取する必要がある「主要ミネラル」。

　なお、"ミネラル豊富"といった謳い文句を見かけることがありますが、これは塩の主成分であるナトリウム以外のミネラルを指しているようです。ただ、ナトリウムもりっぱなミネラルなので、どんな塩でも「ミネラル豊富」といえます。

　しかしながら、塩の平均的な摂取量が約10g／日であることを考えると、塩だけで1日に必要なミネラルをすべて摂取するのは不可能。さまざまな食材を食べ、そこに適した塩を選んで使うことが大切です。

海水の成分構成比

- 塩化ナトリウム 78%
- 塩化マグネシウム 9.6%
- 硫酸マグネシウム 6%
- 硫酸カルシウム 4%
- 塩化カリウム 2%
- 微量ミネラル 0.3%

海水に含まれるのはすべてミネラル。塩の結晶になったときに、どのミネラルがどれだけ残るかで味わいが大きく変わる。

ミネラルたっぷり！！
Na Mg Ca K

中国がアメリカを追い抜いて塩生産量トップに！

常識！

　塩は工業にも使われるため、工業が発達すると塩の消費量は必然的に増えていきます。塩の生産量は、かつてはアメリカが1位でした。しかし、近年、急激な経済発展にともない、中国の国内での塩の消費量が増えたことから海水、岩塩、塩湖、地下鹹水など、豊富な塩資源を使って国内での塩の生産量が増加。2013年からは生産量世界一を誇っています。

　工業用を除く、食べる塩という意味では、各国ともに地産地消の傾向が強く、それぞれの国にある塩資源を有効に活用した塩づくりが行われています。

世界各国の塩の生産量

- 中国 64,338
- アメリカ 44,100
- インド 27,637
- カナダ 14,168
- オーストラリア 13,453
- ドイツ 11,136
- メキシコ 11,000
- チリ 10,553
- 日本 928

（単位：千トン）

出典：「World Mineral Production2010-2014」
各国で生産される塩の多くが岩塩。そのため、岩塩層を持つ大陸の国が上位にきている。

塩の基礎知識

常識！

食用に使われているのはたったの2割 ほとんどが工業用

　日本で年間に使用されている塩の量は約800万t。そのうち食用や食品加工用として使用される塩は、約2割強ほど。そのほかの約7割強のうち一部は、石鹸や合成ゴムなどの生活用品、融氷雪用、生理食塩水などを製造するのに使用されますが、ほとんどはソーダ工業用として苛性ソーダ、ソーダ灰などに姿を変え、ガラスやプラスチック、合成革や合成繊維、アルミなど、さまざまな基礎素材としても消費されています。目には見えない形ですが、私たちの生活は塩によって支えられていると言っても過言ではありません。

新常識！

自然塩、精製塩はじょうずに使いわけるのが◎

　日本ではかつて、イオン膜という方法で、海水からナトリウム成分だけを収集してつくられた塩を「精製塩」、それ以外の製法でつくられた塩を「自然塩」「天然塩」と呼んで区別してきた歴史があります。現在では、食用塩公正取引協議会※1の規約により、同協議会加盟企業の製品については「自然塩」「天然塩」という呼称は使われなくなりました※2。

　化学的な製法だとして、ワルモノにされがちな「精製塩」ですが、どんな塩にも最適な用途があります。例えば、ナトリウム以外のミネラルも含む「自然塩」は、食材の成分に働きかけてうまみを最大限に引き出してくれるものの、季節や生産状況によって味が微妙に変化します。一方、「精製塩」はいつでも味が一定。最終的な塩味の微調整（決め塩）に使えば、ブレることなく、いつでも狙った味に近づけます。うまみを出すなら自然塩、料理の味の最後の微調整には精製塩といった、賢い使いわけが料理じょうずへの近道です。

塩の基礎知識

常識！

パッケージに表示がなくてもOK！ 塩に賞味期限はない

　塩を構成するミネラルは無機質で、腐敗菌が生きるための養分を含んでいません。そのため消費期限や賞味期限はなく、法律においても、表示を省略してよい食品として分類されています。

　ただし、水分にはとても弱く、水分の多い場所に置いておくと湿気でかたまってしまったり、匂いを吸着しやすくなってしまうという性質を持っています。塩は水分と強い香りを避けて保存しましょう。

※1　業界有志によって平成20年に設立された団体。加盟する製塩企業は約180社（2016年）で、消費者へ正しい情報の伝達を目的に、塩の商品表示のルール等を策定し普及を行っている。

※2　この本では、「自然塩」「天然塩」に代わる呼称がないこと、その言葉の認知度を踏まえて、歴史的に呼ばれてきたこれらの呼称を使用しています。

Chef's Interview 1

アル・ケッチァーノ 奥田政行 シェフ

いい素材にいい塩
これさえあればおいしい料理ができる

料理のおいしさは
素材と塩で8割方決まる

　山形県鶴岡市のイタリアンレストラン「アル・ケッチァーノ」のオーナーで、料理によって地域食材の魅力を発信する奥田政行シェフ。
「わかりやすく伝えるためにイタリア料理と表現しているけど、僕がつくっているのは、"素材料理"。料理は素材と塩のみで決まる、と僕は思っています」

　その言葉の通り、奥田シェフの店では、コース料理にも、ソースを使ったお皿はほとんど登場しない。
「塩だけを使うといっても、塩味ではありません。主役は素材の味そのもの。素材のおいしさを引き出してくれるのが、塩なのです」

　野菜を塩もみすると水分が出て、野菜の味

が濃くなったと感じるように、塩は塩味をつけるだけでなく、素材の味をはっきりさせる役割を果たしているという。

なぜ塩にはそんな力があるのだろう。
「食べ物は、生き物。生き物にはさまざまな成分が含まれていますが、ミネラルだけは含まれていない。だから、どんな生き物も、本能的にミネラルを欲しています。料理においても、素材の持ち味を発揮させるには、ミネラルを補う必要があるのです。究極にシンプルでおいしい料理を目指すなら、いい素材にいい塩をふり、ゆでる・蒸す・ローストするといった熱媒体を選ぶだけ。後は相性のいい食材を組み合わせれば、ソースがなくても豊かな味わいを生み出せるのです」

では、どんな塩を使えばいいのか。奥田シェフは19種類の塩を常備し、素材や料理によって使いわけている。
「塩は海の味をギュッと凝縮したもの。どの海で採れたのか、季節によっても味が違います。また、使用する食材も、そこに含まれる成分によって欲する塩が違うので、素材に合う塩を選べば、おいしさを最大限に引き出せるのです」

刺身などの生魚であれば、もともとその魚が泳いでいた海の塩を使うと、味がまとまりやすいという。肉料理には、粒が溶けず味がはっきりした岩塩を。ほかにも、「乳製品のような」「牡蠣のような」独特の香りがある塩を、用途に応じて選んでいるそうだ。
「素材のどこをフィーチャーするかによっても、合わせる塩は変わってきます」

今回は入門編ということで、まずそろえておきたい3タイプの塩を教えていただいた。
・苦味の強い塩（マグネシウムが多い塩）
・甘味の強い塩（カルシウムが多い塩）
・酸味の強い塩（カリウムが多い塩）

これらに加えて、精製塩があるといいという。天然塩は時期によって味に差が生じるため、まずは天然塩で素材のよさを引き出し、最後に精製塩で味を調整するのがコツなのだとか。

使い方のコツを知れば さまざまな味を生み出せる

それでは、タイプ別に使い方を紹介しよう。苦味の強い塩は、青魚やゴーヤといった苦味のある食材や唐揚げにかけるのがおすすめ。
「苦味同士を組み合わせると、異色のコクに化けます」

今回つくっていただいた「ワラサと月の雫の塩」は、まさにこの組み合わせによるもの。生の切り身には独特の苦味があるので、苦味の成分であるマグネシウムが多い「月の雫の塩」という塩を合わせている。

甘味のある塩は、野菜と相性がいいという。
「料理を口に入れたとき、『うまい！』と感じる正体は、甘味と脂です。野菜には脂が含まれ

アル・ケッチァーノのスペシャリテ「ワラサと月の雫の塩」。奥田シェフが店で使っているラインナップは、随時更新される。取材時にお聞きしたのは、奥田シェフの故郷・庄内浜の満月の夜の海水からつくられた「月の雫の塩」、野菜に合う「マルドン」、肉料理に使う岩塩、リコッタチーズの風味が生まれる「雪塩」、牡蠣の味が楽しめる「伊達の旨塩」、万能に使える「粟國の塩 釜炊き」、土の香りがするという「あっちゃんの塩」、自然塩では珍しく、1年中、味が安定していて、乳酸発酵を促しやすい「わじまの海塩」など。

ていないため、脂を持っているお肉と相性がいいですが、甘味のある塩をつければ、それだけでうまい！と感じます」

奥田シェフの代表的なレシピのひとつ「生のラタトゥイユ」は、数種類の野菜を甘味のあるまろやかな「わじまの海塩」と、野菜から染み出た汁のみでまとめた一品だ。

酸味のある塩は、魚のトロなど脂ののった部位や赤身に合わせると、ビネグレットソース※のような味わいになるという。

料理のバリエーションをもっと楽しもう

奥田シェフは、「塩と素材のみのシンプルな組み合わせだからこそ、無限のバリエーションをつくり出せる」ともいう。

「例えば少しオイルを足すだけで、新しい味が生まれます。料理の幅が広がりますよ」

先に紹介した「ワラサと月の雫の塩」は、仕上げに、青草の香りがするオリーブオイルをかけている。最終的にフルーツのような味わいになるから不思議だ。

さらには、塩が水分に溶ける性質に着目した、味わい方のコツも教えてもらった。

「イカの刺身など、甘味のある素材に酸味の強い塩をかけて、少し時間をおきます。すると、塩が食材から出た水分に溶け込んで、甘味と酸味が中和されます。イカの甘味と塩の酸味をそれぞれ際立たせたいなら、塩をかけてすぐに食べるといい」

塩を素材となじませるのか、対比させるのかを意図することで、異なる味わいを引き出せることがわかった。塩を知ることで、料理のバリエーションは一気に広がりそうだ。

※いわゆるフレンチドレッシング。酢と油を1：3の割合で混ぜて、塩や胡椒などで味を調える。

「生のラタトゥイユ」は、きゅうり、グリーントマト、パプリカ、ミョウガなど7種類の山形産野菜を塩のみで仕上げた、野菜のだしたっぷりの身体がよろこぶ一品。

奥田政行

山形県鶴岡市生まれ。フランス料理、イタリア料理などの修業を積んだ後、2000年「アル・ケッチァーノ」をオープン。生産者の顔が見える料理を提供し、山形県庄内支庁より「食の都庄内」親善大使にも任命される。イタリア スローフード協会が選出する「世界の料理人1000人」の1人。塩だけでつくられた上の写真の料理は、ミラノで行われた野菜料理選手権ベジタリアンチャンスで3位入賞。国内外で活躍している。http://www.alchecciano.com/

Shop Data

Al-ché-cciano

住所：山形県鶴岡市山添一里塚83
TEL：0235-78-7230　休日：月曜日

YAMAGATA San-Dan-Delo

住所：東京都中央区銀座1-5-10 ギンザファーストファイブビル山形県アンテナショップ「おいしい山形プラザ」2F
TEL：03-5250-1755　休日：月曜日・年末年始

Part 2
知れば知るほど個性豊かな
海水塩、藻塩

世界各国、日本各地の沿岸で製造されている、海水を原料にした海水塩。
一見同じに見える白い結晶も、海水を汲み上げるエリアや製造方法によって、
まったく異なる味わいを持っています。
この違いが楽しめるようになったら、あなたも立派な塩通！
日本古来の塩として知られる藻塩も併せて紹介します。

海水塩

日本でもっとも多い
海水を原料にした塩

　海水を原料にして生産された塩を「海水塩」と呼びます。海水の塩分濃度は3.4％前後でばらつきがありますが、それをさまざまな方法で20〜30％まで濃縮・結晶させてつくります（p.14〜19）。海水塩は世界各地の沿岸で生産されており、生産量は塩全体の3割ほど。オーストラリアなどのように広大な土地があり、降雨量の少ないエリアでは屋外の塩田で、太陽と風の力だけで結晶にする完全天日塩の生産が多く、日本のように狭く降雨量が多いエリアでは、火力を使った釜炊きでの生産が多く行われています。

　海水を構成するミネラルのバランスはほぼ一定ですが、貧栄養の暖流なのか、栄養豊富な寒流なのか。取水する周辺に何があるのか、取水した場所は河口付近なのか沖合いなのか、表層水なのか深層水なのかなど、周辺の環境や

check! 海水塩を選ぶポイント

☐ どんな海で採れた海水か

❶ 取水エリアの海流で味は大きく変わる！
暖流の海水を取水してつくった塩はあっさり味、寒流はこってりした味、混合地点はバランスのよい味わいの塩ができる傾向にあります。

❷ 周辺環境がミネラルバランスに影響！
近くに山がある場合、河口で取水すると山からのミネラルを含んだ塩になります。海藻が多く繁殖している場所では、磯の香りが強い塩が、珊瑚礁が多いエリアではカルシウムが多く甘味の強い塩ができる傾向にあります。

☐ どんな製法でつくられているか

❶ 生産者の想いを感じとる！
低コストで大量生産し、多くの人に届けたいのか、人の手と時間をかけて少量でもじっくりつくるか……生産者の想いがもっとも出やすいのが製法です。

❷ 製法を見れば味わいがイメージできる
火力で炊いた塩は、粒が細かくふわふわとした結晶に。天日で結晶させた塩は、粒が大きくかたい結晶になる傾向があります。また、各種ミネラルは結晶化する濃度が異なるため、どの塩分濃度で結晶を採取するかも味を左右しています。

☐ 粒の水分量と形状で使いわける

❶ 水分量＝にがりの量
塩の水分量は結晶を採取した後にどれくらいにがりを切るかによって変わります。にがりを多く含むしっとりした塩は、ナトリウムの構成比が低くなり、その分、苦味やコクが強くなります。

❷ 粒の形状でしょっぱさが変わる
粒の形状は、結晶させる製法によって決まります。ぐつぐつと炊くと海水が流動して粒が細かく立方体や凝集晶に。ゆっくりと低めの温度で結晶させると、フレークやトレミーに成長。細かい粒は口の中ですぐに溶けるので、しょっぱさを強く感じ、大きい粒は溶けにくいのでまろやかに感じる傾向があります。

海水塩

「浜比嘉塩」（p.99）の取水地。沖縄県中部の浜比嘉島にある浜

取水場所によって味は異なります。さらに、製法によって、でき上がる塩に含まれるミネラルのバランスが変わるため、味に大きく影響します。

一般的に岩塩や湖塩よりも多くにがりを含むため、ナトリウム以外のミネラル、特にマグネシウムの含有量が多い傾向があり、にがりの影響でしっとりとした仕上がりになるものもあります。製造方法によって立方体はもちろん、フレークやトレミー、パウダーなど、特徴のある結晶ができ上がるのも海水塩の魅力のひとつです。

Sea salt World Map 世界

暖流
寒流

海水塩

- サルデニア島の海塩 粗塩 → P.36
- サリーナ ディ チェルビア サーレ ディ チェルビア → P.35
- 宮廷塩 → P.43
- 古都ニンの天日塩 フラワーソルト → P.38
- 水晶塩 → P.42
- マルタ フレーク海塩 → P.41
- イスラエル 紅海の塩 → P.42
- カンホアの塩 石窯焼き塩 → P.40
- モティア サーレ・インテグラーレ・フィーノ → P.35
- フィオッキ・ディ・サーレ → P.34
- ピンハオ村の海水塩 → P.41
- デルタサル → P.38
- インド洋の海水塩 → P.44
- マドゥラ島の海水塩 → P.41
- ヨーロッパ拡大図
- ピラミッドソルト → P.39
- ゲランド エキストラファン → P.32
- マルドン シーソルト → P.34
- バリ島アメッドの塩 → P.40
- ノアムーティエ セルファン → P.32
- ピランソルト ソルトフラワー → P.37
- イル・ド・レ フルール・ド・セル → P.33
- カマルグ フルール・ド・セル → P.33
- プレミアム・シーソルト → P.36
- ポルトガル天日塩 → P.38
- ベロ 海の塩 → P.35

PART ❷ 海水塩、藻塩

海水塩は、世界各地の沿岸部で生産されています。大きな三角錐型のものからパウダー状のもの、しっとり水分の多いものからサラサラのものまで、じつに個性豊かです。
オーストラリアなど、沿岸地域が平坦で広く、降雨量が少ない地域では塩田による天日塩づくりが、それ以外の地域では釜を使った塩づくりが行われる傾向にあります。多くの国では地産地消が基本で、日本に輸出されていない海水塩も多く存在しています。

海水塩

キパワーソルト → P.43

全羅南道の海水塩 → P.43

カナディアンシーソルト → P.48

セルリアンシーソルト → P.49

カリブ海 バハマ産 天日塩 → P.49

アメリカ マルガリータソルト → P.49

アラエア 火山赤土塩 → P.46

ハワイアン シーソルト → P.47

マスコット クリスタルソルト → P.47

クリスマス島の海の塩 → P.48

越後やすづか 雪むろの塩 → P.44

マングローブの森の海水塩 → P.44

南大西洋の海水塩 → P.49

南の極み → P.45

フレーキーシーソルト → P.45

千年続く伝統製法でつくられる塩
ゲランドエキストラファン
フランス

原産地 フランス

国の自然保護区で、千年以上続く製法を継承しながら、国家資格を持つ塩職人によって生み出される完全天日塩。洗浄工程を経ないため、土とプランクトン、ミネラルの影響で灰色に色づき、風味にどこか土を感じる。フランス有機農業推進団体認定の塩。

TASTE! まろやかなしょっぱさ、わずかな酸味、すみれの香り、苦味
おすすめ食材&料理 根菜のバターソテー、カカオとミルクを使った菓子

DATA
形 状	凝集晶
水分量	しっとり
工 程	天日/粉砕
原材料	海水
食塩相当量	94.4g
ナトリウム	37.1g

価格／600g入り 800円
株式会社アクアメール
神奈川県三浦郡
葉山町堀内751-23
tel.046-877-5051
http://aquamer.co.jp

海水塩

フランス料理界の巨匠が愛する完全天日塩
ノアムーティエ セルファン
フランス

大西洋に浮かぶ、ノアムーティエ島の完全天日塩。製法は「ゲランド」と同様で、薄い灰色。冷涼な気候を利用し、結晶化させるのに時間をかけている。マグネシウムたっぷりで、それが独特の味わいを生んでいる。フランス料理界の巨匠アラン・デュカス愛用の塩。

TASTE! 非常にまろやかなしょっぱさ、ほのかな土と潮の香り、甘味
おすすめ食材&料理 ごぼうなどの土もの野菜、白身魚のソテー

原産地 フランス

DATA
形 状	凝集晶
水分量	しっとり
工 程	天日
原材料	海水
食塩相当量	(88.2g)
ナトリウム	34.9g

価格／500g入り 700円
株式会社健菜
東京都渋谷区初台1-47-1
tel.03-5302-8160
http://kensai.co.jp

フランス4大

PART ❷ 海水塩、藻塩

繊細な味わいのフランス「幻の塩」

イル・ド・レ フルール・ド・セル [フランス]

ヨーロッパ有数のリゾート地として名高いレ島は、12世紀初頭から塩づくりが続く名産地のひとつ。塩田に引き入れた海水を太陽と風の力で結晶させ、塩職人の手によって収穫される。イル・ド・レのなかでも「塩の花」のみを収穫した最高級品。口に含むと潮の香りが鼻に抜ける。

TASTE! すっきりとキレのよいうまみと酸味、潮の香り
おすすめ食材&料理 白身魚のカルパッチョ

DATA
- 形　状　凝集品
- 水分量　しっとり
- 工　程　天日
- 原材料　海水
- 食塩相当量
- ナトリウム　39.5g

価格／70g入り 900円
オムニサンス株式会社
東京都港区南麻布
2-10-10-702
tel.03-6453-7688
http://www.mcocotte.jp/

原産地 フランス

海水塩

手仕事で摘まれる、太陽と風の味わい

カマルグ フルール・ド・セル [フランス]

南フランスのカマルグ地方には、約10万haにも及ぶ湿原が広がっている。そこに地中海の海水を引いた塩田で古代ローマ時代から塩づくりが行われてきた。結晶は純白で、フランス産海水塩ではもっとも濃厚で力強い味。日光をたっぷり浴びた完全天日塩らしい酸味が特徴。

TASTE! 濃厚なうまみと甘味、太陽の香りとも表現すべき酸味
おすすめ食材&料理 トマトなど酸味のある野菜、白身魚のカルパッチョ

原産地 フランス

DATA
- 形　状　凝集品
- 水分量　しっとり
- 工　程　天日
- 原材料　海水
- 食塩相当量
- ナトリウム

価格／125g入り 1100円
株式会社アルカン
東京都中央区
日本橋蛎殻町1-5-6
tel.0120-852-920
http://www.arcane-jp.com/

製塩地の塩

英国王室御用達の伝統の塩
マルドン シーソルト
イギリス

原産地 イギリス

DATA

形 状	トレミー
水分量	さらさら
食塩相当量 99.0g	工 程 平釜／乾燥
ナトリウム 39.0g	原材料 海水

TASTE!
適度な苦味、シャクシャクした食感

おすすめ食材&料理
グリルやソテーなど肉を焦がす料理

美しいピラミッド形の結晶や薄い板状のフレークが目を引く、海外では珍しい釜炊きの塩。独自の平釜を使い、手作業でていねいに結晶を集めるこの製法は、エセックス地方にある老舗・オズボーン家に200年以上にわたって受け継がれてきた。2012年には英国王室御用達の証「ロイヤルワラント」を受章。決め塩として料理の仕上げに使う料理人も多い。

価格／125g入り 430円
株式会社 鈴商
東京都新宿区荒木町23
tel.03-3225-1161
http://www.suzusho.co.jp/

地中海産の美しいピラミッド結晶
フィオッキ・ディ・サーレ
キプロス

原産地 キプロス

DATA

形 状	トレミー
水分量	さらさら
食塩相当量 97.0g	工 程 天日
ナトリウム 38.2g	原材料 海水

TASTE!
ほどよいしょっぱさで、苦味は少ない。透明感があり、シャクシャクした食感

おすすめ食材&料理
鶏肉のたたき、白身魚のオイル焼き

地中海に浮かぶキプロス島。美の女神・アフロディーテ生誕の地としても有名なこの島で生産されている完全天日塩。海水を塩田に引き入れた後、濃度を調整しながら結晶させていくことで、美しいピラミッド状の塩ができ上がる。また、結晶は指で砕けるほど薄く繊細なので、サクサクとした食感も楽しめる。そのまま料理に添えて提供すると皿を華やかに演出してくれる。

価格／28g入り 676円
株式会社アーパ・アンド・イデア
東京都文京区水道2-11-10
大都ビル2F
tel.03-5319-4455
http://www.apidea.co.jp/

海水塩

ローマ法王が愛した甘い塩

サリーナ ディ チェルビア
サーレ ディ チェルビア

イタリア

古代ローマ時代からの「塩の町」、北イタリア・チェルビアで生産される完全天日塩。国内では日差しも気候も緩やかで、海水は時間をかけて濃縮・結晶。「塩の花」だけを集めたこの塩は、「Sale di dolce（甘い塩）」とも呼ばれ、かつてはローマ法王にも献上された。

TASTE! ミネラル感が強く、甘味とうまみが濃い
おすすめ食材＆料理 赤身の肉・魚、トマトなどの濃い味の野菜に

原産地 イタリア

DATA
食塩相当量 98.0g
ナトリウム
形 状 立方体
水分量 しっとり
工 程 天日／洗浄／乾燥
原材料 海水

価格／290g入り 400円
株式会社アーク
東京都中央区
日本橋小伝馬町4-2
tel.03-5643-6444
http://www.ark-co.jp/

いわば"老舗"。古代から受け継がれる伝統製法

モティアサーレ・インテグラーレ・フィーノ

イタリア

塩の名産地として名高いシチリア最西端の港町・トラパニで生産される完全天日塩。古代フェニキア人が伝えたという伝統的な製塩法が今も受け継がれている。燦々と輝く太陽を浴びて生まれる酸味が特徴で、全体的にすっきりとした味わいの塩。

TASTE! ほのかな酸味とするどいしょっぱさが特徴。キレがよく余韻が短い
おすすめ食材＆料理 生の白身魚。肉料理に使うと脂がさっぱりする

原産地 イタリア

DATA
食塩相当量
ナトリウム
形 状 粉砕
水分量 さらさら
工 程 天日／粉砕
原材料 海水

価格／1000g入り オープン価格
モンテ物産株式会社
東京都渋谷区神宮前5-52-2
tel.0120-348566
http://www.montebussan.co.jp/

ふだん使いにおすすめの地中海天日塩

ベロ 海の塩

フランス

カマルグ地方のエグモルトに広がる塩田で生産される完全天日塩。粉砕されており、さらさらとして使いやすい。ナトリウムの構成比が高いものの、しょっぱさはそれほど強くなく、最後に少し甘味が残るが余韻は薄く短め。リーズナブルで、ふだん使いにおすすめ。

TASTE! まろやかなしょっぱさ、余韻が短い
おすすめ食材＆料理 淡泊な野菜、ごはんなど味の余韻が短い食材

原産地 フランス

DATA
食塩相当量 99.8g
ナトリウム 39.3g
形 状 粉砕
水分量 さらさら
工 程 天日／粉砕
原材料 海水

価格／600g入り 300円
株式会社オーバーシーズ
東京都世田谷区代田5-11-10
tel.03-5430-6080
http://overseas-inc.jp/

海水塩

地中海に降り注ぐ太陽の味

サルデニア島の海塩
粗塩

イタリア

積み上げられた塩の山。

イタリアの離島・サルデニア島の塩田に海水を引き入れ、天日で濃縮・結晶させた完全天日塩。流水で洗い流し不純物を取り除いた後、220℃で焼成し、粉砕しているため、さまざまな大きさの結晶がミックスされ、カリカリとした食感が楽しめる。全体的に結晶が大きめなので最初はまろやかに感じるが、溶けるにつれてしっかりとしたしょっぱさと苦みが感じられる。

原産地 イタリア

DATA
形　状　粉砕
水分量　さらさら
食塩相当量　99.6g　工　程　天日／洗浄／焼成／粉砕
ナトリウム　39.2g　原材料　海水

TASTE!
角はないが、深みのあるしょっぱさとクセになる苦味がある。最後に舌の上にうまみが残る

おすすめ食材&料理
脂身の多い豚肉、揚げ物

価格／300g入り 450円
株式会社アーパ・アンド・イデア
東京都文京区水道2-11-10
大都ビル2F
tel.03-5319-4455
http://www.apidea.co.jp/

海水塩

ローマ時代の製塩法でうまみを凝縮

プレミアム・シーソルト

ポルトガル

結晶をすくうマルノット。

機械生産に押され、ポルトガルで一度は失われかけていた塩田製法を復活させた。農薬や放射性物質などに関する厳しい基準を厳格に守りながら、ポルトガルで「マルノット」といわれる塩職人たちにより完全天日塩づくりが行われている。「塩の花」だけを集めた希少なこの塩は、スローフード協会賞、ポルトガル農業賞を受賞。『ナチュール・エ・プログレ』（フランス有機農業推進団体認定）取得。

原産地 ポルトガル

DATA
形　状　凝集晶
水分量　しっとり
食塩相当量　89.0g　工　程　天日
ナトリウム　35.1g　原材料　海水

TASTE!
濃厚なうまみと酸味、ほんのりと苦味。うまみの余韻が長い

おすすめ食材&料理
白身魚を使った料理。鶏肉のソテー。パンとオリーブオイルとともに

価格／150g入り 2000円
株式会社メルカード・ポルトガル
神奈川県鎌倉市笹目町4-6
tel.0467-24-7975
http://www.m-portugal.jp/

濃厚なうまみを誇るスロヴェニアの芸術品

ピランソルト ソルトフラワー

スロヴェニア

粒の大きさ：大〜小
しょっぱさ：強

しょっぱさ：5　酸味：5
苦味：5　うまみ：6
雑味：6　甘味：6

DATA
食塩相当量	
ナトリウム	37〜39g
カリウム	
マグネシウム	300〜400mg
カルシウム	50〜60mg
形　状	フレーク
水分量	しっとり
工　程	天日
原材料	海水

原産地　スロヴェニア

海水塩

TASTE！
ほどよいしょっぱさとミネラルがバランスよく、濃厚なうまみがあり、食材にうまみを付加してくれる

おすすめ食材＆料理
食材にうまみを付加したい時。牛肉、脂身の多い豚肉。オイルとともに食べる生野菜。そのまま酒のつまみに

ラムサール条約で認定された自然豊かな国立公園にある塩田。

価格／70g入り 1400円
株式会社塩崎ビル
東京都千代田区平河町2-7-1
tel.03-3222-8800
http://www.piranske.com/

スロヴェニアの西南・アドリア海に面した、ピラン地域のセチョビリエ塩田で生産される完全天日塩。歴史的にも貴重な塩田は、塩づくりに最高の環境といわれるスロヴェニアの国立公園のなかに位置する。周囲の環境を保ちながら、この地域に伝わる伝統的な製法を守り、工程のほぼすべてを手作業で行っている。
アドリア海の海流は一定方向に流れているため、海水が淀むことなく清浄に保たれている。さらに、海の泥を数年かけて固めてつくる「ペトラ」と呼ばれる塩田が、フィルター役として不純物を取り除くため、芸術品のような真っ白の結晶が誕生する。ソルトフラワーは、真夏の天気のよい無風の日だけにできるという「塩の花」をやさしくすくい取った特別な塩。濃厚なうまみで、塩が溶けた後の余韻も長い。食材にうまみを付加したい時に。

透明度の高い美しい海から届いた贈りもの

古都ニンの天日塩 フラワーソルト

クロアチア

中世クロアチア王国発祥の地でもある古都ニンは、かつて塩の生産で繁栄した地。昔ながらの塩田で完全天日塩がつくられており、限られた気候条件がそろわないと出現しないため、総生産量の0.1%に満たない、ごく少量しか採れない貴重な塩。濃厚なうまみ。

TASTE！ 強いうまみと硬質なミネラル感がある
おすすめ食材&料理 白身の魚、白菜などの水気の多い野菜

原産地 クロアチア

DATA
食塩相当量（92.9g）
ナトリウム 36.6g
形状 凝集晶
水分量 しっとり
工程 天日
原材料 海水

価格／100g入り 1100円
株式会社M'&Y SAN
東京都港区海岸2-1-5
tel.03-5419-8305

ふだん使いにぴったりの完全天日塩

デルタサル

スペイン

バルセロナの海沿いに位置する、国立公園内の塩田で生産される完全天日塩。塩職人の手によって収穫された塩は採塩場に積み上げられ、粉砕工程を経て出荷される。強めのストレートなしょっぱさで、雑味のないクリアな後味を持つスッキリした塩。

TASTE！ ストレートなしょっぱさ、ほのかな酸味
おすすめ食材&料理 てんぷらやとんかつなどの揚げ物、脂身が多い牛肉

原産地 スペイン

DATA
食塩相当量 99.0g
ナトリウム 39.0g
形状 粉砕
水分量 さらさら
工程 天日／粉砕
原材料 海水

価格／500g入り 300円
ウイングエース株式会社
東京都港区虎ノ門3-18-19
虎ノ門マリンビル5F
tel.03-5404-7533
http://wingace.jp/j/index.php

歴史ある塩田で生まれた塩の花

ポルトガル天日塩

ポルトガル

高級食器の産地としても有名な、ポルトガルの港町・アヴェイロ。この湿地帯に広がる塩田で生産される完全天日塩のなかから、「塩の花」だけを集めたもの。かつては塩の名産地として名を馳せていたが、残存する塩田はほんのわずか。現在では保存活動が行われている。

TASTE！ じんわりと舌に染みるようなうまみと甘味
おすすめ食材&料理 豚肉料理、特に脂身が多い部位に使うと、肉の甘味が引き立つ

原産地 ポルトガル

DATA
食塩相当量
ナトリウム
形状 凝集晶
水分量 標準
工程 天日
原材料 海水

価格／1kg入り 800円
株式会社HSコーポレーション
愛知県豊明市新栄町2-20
tel.0562-97-0888

バリ島の職人がひと粒ずつ育て上げた海の宝石

ピラミッドソルト

インドネシア

しょっぱさ:5 ⑩ 酸味:5
苦味:5 うまみ:6
雑味:6 甘味:6

DATA
食塩相当量　94.3g
ナトリウム　37.1g
カリウム　130mg
マグネシウム　290mg
カルシウム　280mg

原産地　インドネシア

形状　トレミー
水分量　さらさら

工程　天日
原材料　海水

海水塩

TASTE!
最初は甘く感じるが、溶けるとともにほどよいしょっぱさを感じる。カリカリとした食感が特徴

おすすめ食材&料理
てんぷらなどの揚げ物、牛肉料理に

生産には現地の木でつくられたボート型の木箱が使われている。

価格／40g入り 550円
有限会社おちあいどっとこむ
静岡県富士市横割6-1-12
tel.0545-30-8835
http://www.77ochiai.com/

インドネシア・バリ島の美しい海水を、伝統的な揚浜式塩田で濃縮し、その後天日で少しずつ濃縮・結晶させた完全天日塩。最大の特徴は、中が空洞の美しいピラミッド形（トレミー状）の結晶。成形したわけではなく、重力の力を借りて、適度な温度と湿度のなかで、じっくり時間をかけて育てることで、自然にこの美しい形がつくり出されている。

ほかのピラミッド形の塩と比べると、比較的厚みがある結晶で粒のバラつきも少なく、大きすぎない。カリカリとした食感と、角のないしょっぱさ、雑味のないクリアな味わいが食材そのものの味をいっそう引きたてる。きれいなピラミッド形は見た目にも華やか。おもてなし料理の仕上げの塩として、指で少し崩して料理にひと振り、もしくはそのまま皿に添えるのがおすすめ。

潮の香りが抜ける野性味のある塩
バリ島アメッドの塩
インドネシア

舟形の桶。

バリ島でもっとも高い、アグン山の麓に広がる揚浜式塩田から生まれる完全天日塩。塩田で濃縮した海水を、ヤシの木でつくられた舟形の桶に入れ、太陽と風の力だけで濃縮・結晶させた後、1年間じっくり熟成させている。薄く灰色に色づいた塩はミネラル感が強く、野性味のある雑味が、魚介類と好相性。口の中で溶けるときにフワリと潮の香りが感じられる。

海水塩

原産地 インドネシア

粒の大きさ 大／小
しょっぱさ 弱／強

DATA
形　状　凝集晶
水分量　しっとり
食塩相当量　91.6g　工　程　天日
ナトリウム　36.0g　原材料　海水

TASTE！
複雑なミネラル感があり、溶けるときに潮の香りが漂う

おすすめ食材＆料理
魚のソテー、刺身、ミネラル感の強い白ワイン

価格／100g入り 298円
有限会社プロンプト
茨城県龍ヶ崎市城ノ内3-17-3
tel.0297-64-3030
http://www.bali-sio.com/

石窯で焼き上げたまろやかな塩
カンホアの塩 石窯焼き塩
ベトナム

石窯で焼き上げる。

フランス領時代から続く塩の名産地、ベトナム・カンホアのホンコイ村。徐々に機械化が進む塩田も多いなか、専用の天日塩田で製塩を行う。注目は仕上げ。粒の大きく育った天日塩を石臼でひき、粉砕した後、最高600℃に達する石窯に入れて、3日間かけて焼き上げる。この手間により、湿気にくく使いやすい、さらさらの塩が生み出される。

原産地 ベトナム

粒の大きさ 大／小
しょっぱさ 弱／強

DATA
形　状　粉砕
水分量　さらさら
食塩相当量　90.4g　工　程　天日／粉砕／高温焼成
ナトリウム　35.6g　原材料　海水

TASTE！
まろやかで角のないしょっぱさと甘味。ほのかに鉄など金属のような味を感じる

おすすめ食材＆料理
ゆでたまご、赤身魚の刺身、牛肉など。カルシウムや鉄分の多い食材に

価格／100g入り 280円
有限会社　カンホアの塩
東京都福生市
武蔵野台1-19-7
tel.042-553-7655
http://www.shio-ya.com

PART ❷ 海水塩、藻塩

古から続く石灰石の塩田で生まれる希少塩

マルタ

マルタ フレーク海塩

自然豊かなマルタ・ゴゾ島。ローマ時代から続く石灰石の塩田で、1年かけてつくられる完全天日塩。育った結晶の上ずみのみを集めた、フレーク状の「塩の花」だけを、結晶が壊れないようマルタ製の陶器に詰めて出荷する。シャクシャクした食感と、苦味の少ないクリアな味わい。

TASTE！ するどいしょっぱさの後、ほんのりとした苦味。後味はクリア
おすすめ食材&料理 揚げ物、豆腐とオリーブオイルとともに

原産地 マルタ

DATA
食塩相当量 —
ナトリウム —
形　状 フレーク
水分量 さらさら
工　程 天日
原材料 海水

価格／65g入り 1600円
アスウォット株式会社
東京都中野区沼袋4-17-6
tel.03-6310-1165
http://maltaste.com/

大理石の塩田で生まれるコクのある塩

ベトナム

ビンハオ村の海水塩

ベトナムの塩の名産地のひとつ、ビントゥアン省にある小さな村で生産される完全天日塩。大理石を敷き詰めた塩田に海水を引き入れ、いくつかの塩田を移動させながら太陽と風の力で濃縮・結晶させている。コクがあり、全体的に角のないまるい味わい。

TASTE！ まろやかなしょっぱさで甘味とうまみがある
おすすめ食材&料理 加熱すると甘くなるたまねぎなどの根野菜、塩おにぎり

原産地 ベトナム

DATA
食塩相当量 64.1g
ナトリウム 25.2g
形　状 粉砕
水分量 標準
工　程 天日／粉砕
原材料 海水

価格／100g入り 330円
有限会社おちあいどっとこむ
静岡県富士市横割6-1-12
tel.0545-30-8835
http://www.77ochiai.com/

海洋深層水のうまみがじんわり

インドネシア

マドゥラ島の海水塩

マドゥラ島は海洋深層水が上がってくる湧昇流という潮流に面しており、その海水を入浜式塩田に引き入れて濃縮し、平釜で炊いて結晶化させている。塩田はISO9002も取得している政府の環境保護地域。濃厚なうまみで食材にアクセントを加えるのにぴったり。

TASTE！ 濃厚なうまみと甘味があり、最後に苦味を感じる
おすすめ食材&料理 加熱すると甘くなるにんじんやたまねぎなどの根野菜

原産地 インドネシア

DATA
食塩相当量 96.6g
ナトリウム 38.1g
形　状 凝集晶
水分量 標準
工　程 天日／平釜
原材料 海水

価格／100g入り 330円
有限会社おちあいどっとこむ
静岡県富士市横割6-1-12
tel.0545-30-8835
http://www.77ochiai.com/

海水塩

だしのようなうまみたっぷり
イスラエル 紅海の塩

イスラエル

鮮やかな魚が泳ぐ紅海。

原産地 イスラエル

DATA
形　状　立方体
水分量　さらさら
食塩相当量　99.8g　工　程　天日／洗浄
ナトリウム　（39.2g）　原材料　海水

TASTE!
しょっぱさはまろやか。濃厚なうまみと苦味があり、余韻が長い

おすすめ食材&料理
牛肉、野菜の浅漬け、塩おにぎり、揚げ物

周囲を陸に囲まれ流入する川もないことから、海のなかでは世界一高い塩分濃度といわれる紅海の海水を塩田に引き入れ、ほぼ手作業で、自然の力だけで濃縮・結晶させた完全天日塩。洗浄工程を経ているため、ナトリウム構成比が高いものの、しょっぱさは強くなく、だしのような濃厚なうまみを感じる。牛肉など味が強い食材に合わせたり、食材にうまみを加えたい時におすすめ。

価格／100g入り 240円
NPO法人 アガペハウス
北海道札幌市中央区
南5条3-14-7
tel.011-561-0180
http://agapehousenpo.web.fc2.com/

海水塩

中国皇帝の献上品だった逸品
水晶塩

中国

原産地 中国

DATA
形　状　粉砕
水分量　さらさら
食塩相当量　(88.6g)　工　程　天日
ナトリウム　34.9g　原材料　海水

TASTE!
ミネラル感があり、濃いうまみの後に酸味が広がる

おすすめ食材&料理
マグロやカツオなどの赤身の魚、肉のソテーやグリル、フレッシュチーズ

中国の蘇北地区・連雲にある塩田で生産される完全天日塩。かつては皇帝への献上品として生産され、市場には出回らない貴重なものだったという。海底700mから深層水が噴き上げている湧昇流にあたるエリアで、その海水を塩田に引き入れて、短期間で濃縮・結晶させ、その後1年間の熟成ののち出荷される。とてもはっきりとしたうまみと、キリッとした酸味が個性的。

価格／200g入り 800円
東昌調味品工業有限会社
愛知県名古屋市中区
千代田2-19-7
052-269-4883

PART ❷ 海水塩、藻塩

めずらしいセラミック製塩田の塩

宮廷塩

中国

玄武岩に覆われている福建省恵安の海水からできた完全天日塩。セラミックが敷き詰められた特殊な塩田で、頻繁に撹拌(かくはん)しながら濃縮・結晶させるという、一風変わった製法がとられている。採塩後、1年間寝かせて味を熟成させてから出荷される。

TASTE! 強めのしょっぱさの後、生薬のような苦味
おすすめ食材&料理 焦げ目をつけた豚肉料理、苦味のある山菜など野菜のてんぷら

原産地 中国

DATA
食塩相当量 89.6g
ナトリウム 35.3g
形状 粉砕
水分量 標準
工程 天日
原材料 海水

価格／100g入り 410円
有限会社おちあいどっとこむ
静岡県富士市横割6-1-12
tel.0545-30-8835
http://www.77ochiai.com/

800〜1200度の高温で焼成

キパワーソルト

韓国

昔から韓国で健康によいとされてきた焼塩の製法に着目し、韓国の塩田で採れた完全天日塩を、独自の特許技術・高温焼成法で焼いた塩。熱の力で、粒もごく微細なものとなっている。酸化を取る働きがあるとされる、高い酸化還元力を持つともいわれる。

TASTE! 独特の硫黄の香りが鼻に抜ける
おすすめ食材&料理 たまごやアスパラガスなど硫黄の香りを含んだ食材

原産地 韓国

DATA
食塩相当量 92.2g
ナトリウム 36.3g
形状 パウダー
水分量 さらさら
工程 高温焼成
原材料 天日塩

価格／250g入り 1500円
キパワー株式会社
東京都目黒区中目黒5-2-27
tel.03-6871-9955
http://www.qipower.co.jp/

ユネスコ指定の自然豊かな塩田

全羅南道の海水塩

韓国

全羅南道・新安郡にある国内随一の大規模塩田で生産される完全天日塩。2009年には新安郡干潟と塩田がユネスコの生物圏保存地域に指定された。しっとりとした質感。粒が大きく、ザリッとした食感があるので、揚げ物のアクセントに向いている。

TASTE! 強めのしょっぱさと苦味が特徴。後味はあっさり
おすすめ食材&料理 とんかつやコロッケなどの揚げ物。長期保存目的の漬物

原産地 韓国

DATA
食塩相当量 90.1g
ナトリウム 35.5g
形状 立方体
水分量 しっとり
工程 天日／溶解／平釜
原材料 海水

価格／100g 330円
有限会社おちあいどっとこむ
静岡県富士市横割6-1-12
tel.0545-30-8835
http://www.77ochiai.com/

海水塩

まろやかなうまみの熟成塩

越後やすづか 雪むろの塩

フィリピン

「塩の国」を意味する町、フィリピン・パンガシナンの完全天日塩を1年熟成させた後に輸入し、新潟県上越市で数年もの間寝かせてから出荷する。越後の多湿で雪深い気候により、塩が溶解と再結晶をくり返すことで、角のとれたまろやかなうまみのある塩になる。

TASTE! 上質なだしのような、しっかりしたうまみで後味すっきり
おすすめ食材&料理 お吸い物、生や蒸した白身魚、和食全般、蒸した豚肉

原産地 フィリピン

DATA
食塩相当量 81.0g
ナトリウム （31.8g）
形 状 凝集晶
水分量 標準
工 程 天日／乾燥
原材料 海水

価格／150g入り 350円
安塚の塩や
新潟県上越市安塚区小黒788
tel.025-592-2038

角のない苦味とコクが味わい深い完全天日塩

マングローブの森の海水塩

フィリピン

豊かなマングローブとサンゴ礁が広がる海沿いの町フィリピン・カラタガンには、ユニセフの賛助で塩田がつくられている。フィリピン海溝を流れる深海からの湧昇流を引き入れ、濃縮・結晶させた完全天日塩。収穫後に石蔵で一定期間寝かせてから出荷される。

TASTE! 全体的にまるみを帯びた味で、角がない。苦味とコクがある
おすすめ食材&料理 生や蒸した白身魚、豚肉のグリル

原産地 フィリピン

DATA
食塩相当量 94.8g
ナトリウム 37.3g
形 状 立方体
水分量 しっとり
工 程 天日
原材料 海水

価格／100g入り 330円
有限会社おちあいどっとこむ
静岡県富士市横割6-1-12
tel.0545-30-8835
http://www.77ochiai.com/

スリランカの名産地で採れる希少な塩

インド洋の海水塩

スリランカ

スリランカのハンバントタ県は、塩の名産地として名を馳せた地。南海岸沿いに残る塩田で昔から完全天日塩が生産されている。2004年インド洋津波の被害を受け、現在は同地域の大規模開発が行われているため、今後入手困難になる可能性が高い希少な塩。

TASTE! 強めのしょっぱさの後に苦味とほのかな酸味。余韻は短め
おすすめ食材&料理 赤身魚や牛肉の脂の少ない部位

原産地 スリランカ

DATA
食塩相当量 83.8g
ナトリウム 33.0g
形 状 凝集晶
水分量 標準
工 程 天日／洗浄／乾燥
原材料 海水

価格／100g入り 330円
有限会社おちあいどっとこむ
静岡県富士市横割6-1-12
tel.0545-30-8835
http://www.77ochiai.com/

海水塩

くせのないすっきりとした完全天日塩
南の極み

オーストラリア

広大なブライス塩田

オーストラリア最大の製塩メーカー・チータムソルト社が管理するブライス塩田で生産される完全天日塩。南極海につながる南オーストラリアの塩田に海水を引き入れ、18か月の歳月をかけてゆっくりと濃縮・結晶・熟成させている。味のバランスがよく、価格もとてもリーズナブルなので、食材をゆでたりなどふだん使いの塩におすすめ。結晶粒の大きさで大・中・小の3タイプがそろう。

原産地 オーストラリア

DATA
形 状 粉砕
水分量 さらさら
食塩相当量 99.6g　工程 天日／洗浄／乾燥／粉砕
ナトリウム 39.2g　原材料 海水

TASTE!
あっさりとした透明感のある味。後味に甘味が残る

おすすめ食材&料理
ミルクやチーズなどの乳製品、塩おにぎり。フルーツの甘味を引き立てる。ゆで塩にも

価格／500g入り オープン価格
日仏貿易株式会社
東京都千代田区
霞が関3-6-7
tel.0120-003-092
http://www.nbkk.co.jp/

海水塩

軽いフレーク状の粒は仕上げ用の塩に◎
フレーキーシーソルト

ニュージーランド

ワインの名産地でもある自然豊かなマルボロ。引き入れた海水を塩田で飽和塩水状態にした後、独自の蒸発器に移して低温で結晶化。その後さらさらになるまで低温乾燥させて、独特の粒感をつくり上げている。シャクシャクとした軽やかな舌触りがあるため、仕上げのトッピングや、結晶を残したい料理におすすめ。ニュージーランド政府のオーガニック認証を受けている。

原産地 ニュージーランド

DATA
形 状 フレーク
水分量 さらさら
食塩相当量 97〜99g　工程 天日／平釜／乾燥
ナトリウム 37.3g　原材料 海水

TASTE!
シャクシャクとした食感。鉄のような酸味とほのかな苦味

おすすめ食材&料理
マグロなどの赤身魚の炙りとレモン。乳製品の甘さを引き締める

価格／100g入り 780円
株式会社ヤカベ
福岡県北九州市
門司区下二十町5-24
tel.093-371-1475
http://www.yakabe.co.jp/

memo 飽和塩水とはこれ以上溶けない塩分濃度になった塩水。

大地のエネルギーを感じる赤い塩

アラエア 火山赤土塩

アメリカ

しょっぱさ:6.5　酸味:7
苦味:4　うまみ:6
雑味:5　甘味:5

DATA

食塩相当量　99.2g
ナトリウム　39.1g
カリウム　—
マグネシウム　—
カルシウム　40mg

原産地　アメリカ

形　状　立方体
水分量　さらさら
工　程　天日／混合
原材料　海水、赤土

海水塩

TASTE!
赤土独特の鉄由来の酸味と硫黄の香り。カリッとした食感

おすすめ食材＆料理
焼いた牛肉や赤身の魚などの赤い食材、たまごやアスパラガスなどの硫黄の香りを持つ食材

赤土の土壌を掘ってつくられる、カウアイ島の塩田。

価格／100g入り 550円
有限会社おちあいどっとこむ
静岡県富士市横割6-1-12
tel.0545-30-8835
http://www.77ochiai.com/

ハッと目を引く濃い赤茶色は、赤土ならではのもの。ハワイのカウアイ島周辺の海底には噴火でできた火山土壌（赤土）が積もっている。この土を長時間炒り、ハワイ産完全天日塩とブレンドしてでき上がったのがアラエアだ。土に含まれる酸化鉄によって、白い粒は透明感を保ちながら美しい「レッドソルト」に生まれ変わる。アンモニウムやマグネシウム、カルシウムが特に豊富で、さまざまなミネラルをバランスよく摂れるのもうれしい。

日本では土入りの塩はめずらしいが、ハワイでは古くから神への捧げものとして儀式やお清めに使われ、日々の調味料としても愛されてきた。美しい色を生かして、料理のつけ塩に使うのがおすすめ。粒が少し大きめで、カリッとした食感も楽しめる。なお、赤土が入っているため、漬け物など保存食づくりにはあまり向かない。

まろやかさと力強さのハーモニー
ハワイアン シーソルト
アメリカ

原産地 アメリカ

DATA
形　状	立方体
水分量	さらさら
食塩相当量	98.8g
ナトリウム	38.9g
工　程	天日
原材料	海水

TASTE!
最初はまろやかに感じるが溶けるにつれて力強いしょっぱさが出てくる

おすすめ食材&料理
厚切りにした牛肉のグリル、とんかつなどの揚げ物

ハワイの塩の産地のひとつ、カウアイ島で受け継がれてきた塩田で生産される完全天日塩。古代から塩には不浄を清める力があると信じられているハワイでは、儀式やマッサージなどさまざまな用途で塩が使われてきた。伝統的な製法でつくられた塩は、カリッとした心地よい歯ごたえがあり、噛むとすーっと溶けていく。塩の粒が大きめなので、トッピングにおすすめ。

価格／100g入り 430円
有限会社おちあいどっとこむ
静岡県富士市
横割6-1-12
tel.0545-30-8835
http://www.77ochiai.com/

海水塩

2年かけて結晶化する天日塩
マスコット クリスタルソルト
メキシコ

原産地 日本、メキシコ

DATA
形　状	立方体
水分量	さらさら
食塩相当量	99.8g
ナトリウム	39.3g
工　程	洗浄／乾燥
原材料	天日塩

TASTE!
するどく突き刺さるようなしょっぱさ。余韻は短くあっさりしている

おすすめ食材&料理
梅干しなど長期間保存する漬け物。脂の多い食材や料理

世界遺産の保護区にも指定されている美しい海に臨むゲレロ・ネグロ。外海から隔てられ湖沼になっている「ラグーン」を擁し、塩分が約4.5％という高い濃度を保つ、天然の製塩所だ。東京23区ほどの広大な塩田にこの海水を引き入れ、約2年の歳月をかけてじっくりと結晶化させる。粒が大きいのでミルで挽いて使うか、じっくり浸透するので、長期保存を目的とした漬け物づくりに向く。

価格／100g入り 280円
マスコットフーズ株式会社
東京都品川区
西五反田5-23-2
tel.03-3490-8418
http://www.mascot.co.jp/

すっきり、甘味、好バランスの塩

クリスマス島の海の塩

キリバス

珊瑚礁が美しいクリスマス島。

原産地 キリバス

DATA
食塩相当量	96.2g
ナトリウム	37.9g
形状	粉砕
水分量	さらさら
工程	天日／粉砕
原材料	海水

TASTE!
透明感のあるしょっぱさ。レモンのような酸味。最後に甘味が口に広がるが余韻は短め

おすすめ食材＆料理
鶏肉のソテー、フレッシュチーズを合わせたカプレーゼ、牛乳を使った塩スイーツ

世界でもっとも早く朝を迎える島、クリスマス島。太平洋の真ん中に浮かぶ珊瑚礁の島では、塩田も珊瑚礁を活用している。世界的にもきれいと名高い海水を、赤道直下の燦々と降り注ぐ天日に3か月間さらし続け、自然の力だけで結晶化させる。口の中に入れると、すっきりとした透明感のあるしょっぱさを感じ、最後に乳製品を思わせるやわらかな甘味が広がる。

価格／300g入り 649円
NPO法人 クリスマス島海の塩の会
北海道苫小牧市
元中野町2-13-16
tel.0144-34-2111
http://www.kurinet.co.jp/tomakuri/sio.htm/

カナダ初の海水塩製塩所がつくる苦味塩

カナディアンシーソルト

カナダ

大きな蒸気釜が並ぶ。

原産地 カナダ

DATA
食塩相当量	91.3g
ナトリウム	36.0g
形状	凝集晶
水分量	標準
工程	平釜
原材料	海水

TASTE!
マグネシウムの苦味に加え、雑味もあり、個性的な味わい

おすすめ食材＆料理
野性味のあるジビエ、山菜のてんぷら、野菜、揚げ物、牛肉、パンやピザ生地

シェフとして活躍していた創業者が2010年に設立した、カナダ初の海水塩の製塩所。バンクーバー島周辺を流れる冷たく澄んだ海水を満潮時に汲み上げ、3つの蒸気釜を移動させながら濃縮、さらに海水を足して再度煮詰める工程をくり返し、飽和したところで収穫する。リサイクル燃料を使用するなど、カナダの雄大な自然に配慮した塩づくりで、数々の賞を受賞している。

価格／227g入り 1450円
株式会社IRONCLAD
広島県福山市
神辺町新湯野64-4
tel.084-962-5222
http://visalt.jp/

PART ❷ 海水塩、藻塩

不純物を除去したコーシャ認定の塩
セルリアンシーソルト 〔アメリカ〕

カリフォルニア州の完全天日塩を溶解し、その上澄みの塩水を立釜で煮詰めて結晶化。有害な物を含まないコーシャ（清浄食品）の認定を受けている。

原産地 アメリカ

DATA
- 食塩相当量 99.1g
- ナトリウム 39.0g
- 形 状 立方体
- 水分量 さらさら
- 工 程 溶解／立釜／乾燥
- 原材料 海水、炭酸マグネシウム

TASTE! 強いしょっぱさ、マグネシウムの苦味とうまみ
おすすめ食材&料理 揚げ物、牛乳やクリームを使った料理

価格／411g入り 580円
日本緑茶センター株式会社
東京都渋谷区桜丘町24-4東武富士ビル
tel.0120-821-561　http://www.jp-greentea.co.jp/

カクテルの最高の引き立て役
マルガリータソルト 〔アメリカ〕

レモンやライムで湿らせたグラスの縁に塩をつける「スノースタイル」カクテル用の塩。グレープフルーツのような苦味はサラダにもおいしい。

原産地 アメリカ

DATA
- 食塩相当量 99.0g
- ナトリウム 39.0g
- 形 状 粉砕
- 水分量 さらさら
- 工 程 天日／粉砕／洗浄／乾燥
- 原材料 海水

TASTE! まろやかなしょっぱさ、草のような苦味、甘さ
おすすめ食材&料理 カクテルのスノースタイル、野菜サラダ

価格／170g入り 400円
リードオフジャパン株式会社
東京都港区南青山7-1-5 コラム南青山2F
tel.03-5464-8170　http://www.lead-off-japan.co.jp/

海水塩

カリカリの食感が楽しい完全天日塩
カリブ海 バハマ産 天日塩 〔バハマ〕

バハマの完全天日塩。美しい海と温暖な気候を活かした塩づくりは、昔から現代まで変わらず同島の主要産業のひとつ。少し大粒の結晶は、食感も楽しめる。

原産地 バハマ

DATA
- 食塩相当量 （93.9g）
- ナトリウム 37.0g
- 形 状 立方体
- 水分量 標準
- 工 程 天日
- 原材料 海水

TASTE! 強めの力強いしょっぱさの後に、甘酸っぱさ
おすすめ食材&料理 水分が多く青い香りがするフレッシュな食材や料理

価格／300g入り 1800円
有限会社崎永商店
山口県岩国市三笠町2-3-16
tel.0827-21-1487　http://www.sakinaga.com/

南大西洋の力強い天然塩
南大西洋の海水塩 〔ブラジル〕

ブラジル北東部の国内最大の塩産地。乾燥し、年間を通して風が吹く良質な完全天日塩づくりには最適な地だ。力強いしょっぱさと苦味は揚げ物に好適。

原産地 ブラジル

DATA
- 食塩相当量 99.8g
- ナトリウム 39.3g
- 形 状 粉砕
- 水分量 標準
- 工 程 天日／洗浄／粉砕
- 原材料 海水

TASTE! 強めのしょっぱさと適度な苦味。余韻は短くあっさり
おすすめ食材&料理 揚げ物、秋刀魚やブリなど脂ののった魚の塩焼き

価格／100g入り 380円
有限会社おちあいどっとこむ
静岡県富士市横割6-1-12
tel.0545-30-8835　http://www.77ochiai.com/

memo コーシャとはユダヤ教が定める、厳しい製造管理基準を持つ食の規定。

Sea salt Japan Map 北海道〜中部

冬季に豪雪に見舞われる北海道や東北エリアでは、山林の豊富な木材を活かして、薪で焚いて結晶させる平釜での製塩が一般的。日本の塩づくりの歴史を語る上では欠かせない石川県珠洲市は、能登半島の先端に位置し、揚浜式塩田での伝統製法が江戸時代から脈々と受け継がれています。

日本海に面した新潟県では、景勝地・笹川流れの周辺に製塩所が密集し、清浄な海水を原料にした平釜での製塩が行われています。また、関東や中部エリアは、太平洋を望む海沿いや、父島や大島など黒潮に囲まれた離島での製塩が盛んです。

海水塩

- 月の雫の塩 → P.57
- 庄内浜の塩 → P.58
- 塩の花 → P.69
- 海の泉の塩 → P.57
- 玉藻塩 → P.107
- 花塩 → P.67
- 奥能登揚げ浜塩 → P.65
- 能登のはま塩 → P.63
- 珠洲の海あげ浜 → P.65
- 大谷塩 → P.65
- 日本海の塩 白いダイヤ → P.67
- 笹川流れの塩 → P.68
- わじまの海塩 → P.64
- 花の塩 → P.66
- 珠洲の結晶塩 → P.64
- 佐渡藻塩 → P.110
- 輪島塩 → P.66
- 越前塩 → P.68
- 佐渡の深海塩 → P.69
- 鉢ケ崎の塩 → P.66
- 美浜の塩 → P.71
- 塩竈の藻塩 → P.107
- 遠州沖ちゃん塩 → P.70
- あらしお → P.70
- 戸田塩 → P.70

PART ② 海水塩、藻塩

- 酒田の塩 白塩 → P.58
- カムイ・ミンタルの塩 淡雪 → P.52
- 宗谷の塩 → P.52
- うすゆき自然塩 → P.54
- 釜炊き一番塩 → P.53
- 男鹿半島の塩 → P.56
- 津軽海峡の塩 → P.57
- オホーツクの塩 釜あげ塩 → P.54
- 知床の塩 極 → P.53
- 薪窯直煮製法 のだ塩 → P.56
- ラウシップ → P.54
- Flower Of Ocean シホ → P.60
- 伊達の旨塩 → P.55
- 海の精 あらしお 赤ラベル → P.59
- 深層海塩ハマネ → P.61
- 黒山海 → P.62
- あげ浜 塩田製法塩 → P.62
- ひんぎゃの塩 → P.62
- 伊豆盛田屋の 完全天日塩 → P.71
- 小笠原島塩 → P.61
- 小笠原の塩 → P.60
- ムーンソルト 粒小 → P.61
- GARDENSTYLE PRECIOUS MIX → P.71

海水塩

北海道の自然をそのまま閉じ込めて

カムイ・ミンタルの塩
淡雪

北海道

DATA
- 形状 フレーク
- 水分量 さらさら
- 食塩相当量 81.1g
- ナトリウム 31.9g
- 工程 平釜
- 原材料 海水

原産地 北海道

TASTE!
イノシン酸のような濃厚なうまみと適度な苦味

おすすめ食材&料理
牛肉や豚肉の脂ののった部位、トマトのようなうまみの強い野菜

カムイ・ミンタルとはアイヌ語で「神々の遊ぶ庭」。この名の通り手つかずの自然が残る、洞爺湖町と伊達市の境に位置するチャランケ岩の沖合い60m地点が取水地だ。工程も昔ながらの製法にこだわり、薪で焚いた3つの平釜を移しながら煮詰め、14時間ほどかけてじっくり結晶化させた塩。さらりと溶けて、そのまま酒のつまみになるほど濃いうまみが広がる。

価格／50g入り 400円

工房 帆
北海道虻田郡洞爺湖町入江88
tel.0142-76-1115
http://kamui-mintal.com/

まろやかでうまみたっぷりのにがり入り塩

宗谷の塩

北海道

パウダー状の塩

DATA
- 形状 パウダー
- 水分量 さらさら
- 食塩相当量 71.9g
- ナトリウム 28.3g
- 工程 加熱ドラム／乾燥／粉砕
- 原材料 海水

原産地 北海道

TASTE!
まろやかなしょっぱさと強めのうまみ。後味に苦味。余韻は短め

おすすめ食材&料理
野菜のグリル、浅漬け、浸透しやすいので白身魚の下ごしらえに

北海道の最北端、宗谷海峡の海底から汲み上げる清澄な海水だけでできた塩。取水口の構造を工夫し、自然の浄化作用でろ過された海水のみが地上に届く。結晶化の際、一瞬で水分を蒸発させる特許製法を使って、通常は分離するにがりを含んだまま仕上げる。ナトリウム構成比が低いため、減塩中の人にも安心。パウダー状の塩は全国のパン屋にも人気だそう。

価格／100g入り 250円

田上食品工業株式会社
北海道稚内市宝来5-4-5
tel.0162-23-6559
http://www.tagami-foods.jp/

海洋深層水100％のキレのよい塩

知床の塩 極

北海道

オホーツク海の冷たい海底に沈む海洋深層水を原料に、逆浸透膜で濃縮海水と真水に分離。濃縮海水を平釜で煮詰めて、結晶化させた塩。しょっぱみはほどよく、強めの苦味と酸味が効いている。キレのある味が揚げ物や脂を引き締めてくれる。

TASTE! 強い苦味とキレのよい酸味
おすすめ食材＆料理 白身魚のてんぷらなど中身が淡泊な食材の揚げ物

原産地 北海道

DATA
食塩相当量 90.7g
ナトリウム 35.7g

形　状 凝集晶
水分量 標準
工　程 逆浸透膜／平釜
原材料 海水

価格／50g入り 550円
有限会社 らうす海洋深層水
北海道目梨郡羅臼町春日町61-1
tel.0153-88-5470
http://www.siretoko.co.jp/

海洋深層水をフレーク状に

釜炊き一番塩

北海道

北海道南部の熊石で取水される海洋深層水を、平釜でじっくり時間をかけて炊き上げ結晶している塩。噛むほどに強いうまみが広がり、しっかりと舌に残る。フレーク状でシャクシャクとした食感も楽しめるので、食材を焼いた後の仕上げにばらっとかけるとよい。

TASTE! ほどよいしょっぱさと強めのうまみ。ほのかな苦味
おすすめ食材＆料理 牛肉や豚肉のグリル、ソテー

原産地 北海道

DATA
食塩相当量 (81.4g)
ナトリウム 32.0g

形　状 フレーク
水分量 標準
工　程 平釜／乾燥
原材料 海洋深層水

価格／100g入り 361円
熊石深層水株式会社
北海道二海郡八雲町熊石平町114-1
tel.01398-2-3131
http://www.kumaishi.jp/

海水塩

salt column

塩も「熟成」する

塩が食べ物の熟成や発酵を促すことは広く知られていますが、塩そのものも、時間の経過とともに「熟成」と呼ぶにふさわしい変化を遂げます。でき上がった塩を通気性のある容器などに入れて置いておくと、いつの間にか角がとれて、まるみのあるまろやかな味に変化することがあるのです。

化学的な解明はされていませんが、塩の中のマグネシウムが空気中の水分を吸って溶解し、乾燥して再度結晶する、この行程をくり返すことで、塩に含まれるミネラルバランスが変化し、味も変わるのではないかと考えられます。今はまだ塩の生産年数が注目されることはありませんが、いつかワインのように「○○年産のヴィンテージソルト」といった楽しみ方が一般的になるかもしれません。

新雪のようなやわらかな食味

うすゆき自然塩

北海道

年間を通じて豊富な海産物が水揚げされる、豊かな海に囲まれた日本最北端の離島・礼文島沖合いの海水を、釜で煮詰めて結晶させている。まるでふりたての新雪のようなふわふわとした純白の結晶は、舌の上でさらりと溶けて、落雁(らくがん)のような上品な甘味が広がる。

TASTE! 適度なしょっぱさとコク、上品でさらりとした甘味、キレがよい
おすすめ食材&料理 生野菜、生の白身魚、かき氷やアイスなどの冷たいスイーツ

原産地 北海道

DATA
食塩相当量 (76.2g)
ナトリウム 30.0g
形状 凝集晶
水分量 標準
工程 平釜
原材料 海水

価格／100g入り 520円
船泊漁業協同組合
北海道礼文郡礼文町船泊
tel.0120-707-931
http://www.funadomari.jp/

2000年の時を経た清浄な海水を利用

ラウシップ

北海道

グリーンランド周辺で深層に沈んだ海水が2000年もの時をかけて知床の羅臼沖で上がる。オーストラリア産の天日塩を、世界遺産・知床の海洋深層水で溶かしてつくった再製加工塩。あっさりとした味で、白身魚など繊細な食材にぴったり。

TASTE! まろやかなしょっぱさと適度なうまみ。薄く苦味の余韻
おすすめ食材&料理 白菜など淡泊な野菜の浅漬け、帆立の刺身、白身魚

原産地 北海道

DATA
食塩相当量 99.6g
ナトリウム 39.2g
形状 凝集晶
水分量 標準
工程 逆浸透膜／溶解／平釜／乾燥
原材料 天日塩、海洋深層水

価格／180g入り 367円
株式会社エスワイエスウイング
北海道札幌市中央区
北12条西20-2-1
札幌市中央卸売市場 水産棟3F
tel.011-615-8000

海の養分を凝縮したうまみ塩

オホーツクの塩 釜あげ塩

北海道

世界3大漁場のひとつ、オホーツク海からサロマ湖に流れ込んだ海水を汲み上げ、3日間かけて釜を移しながらじっくり煮詰めた後、4日目に本炊きをして結晶を採取した塩。滋養豊かな海水からできるこの塩は、うまみと甘味がぎゅーっと凝縮されている。

TASTE! イノシン酸のような濃厚なうまみと甘味、適度な苦味
おすすめ食材&料理 脂の多い豚肉、苦味のある野菜

原産地 北海道

DATA
食塩相当量 83.3g
ナトリウム 33.0g
形状 凝集晶
水分量 標準
工程 平釜
原材料 海水

価格／200g入り 500円
株式会社つらら
北海道紋別郡湧別町栄町37-25
tel.01586-5-3703
http://tsurara.jp/

塩好きを増やした人気の逸品

伊達の旨塩

宮城

宮城県の北東部・石巻市の流留地区では、江戸時代から1960年頃まで入浜式塩田による塩づくりが行われていたという。以来40年途絶えていた製塩が、地元在住の山田夫妻の手により復活。釜でじっくりていねいに海水を煮つめる製法で、現在も変わらぬ丹精込めた塩づくりが続いている。2日間煮詰めて仕上げる塩はうまみが濃厚。口の中にじゅわっとうまみが広がるこの塩をきっかけに、塩のおいしさに目覚める人も多いとか。2010年「みやぎものづくり大賞・特別賞」受賞。

TASTE！ 非常に濃厚なうまみとキレのよい酸味。心地よい苦味、ほのかに磯の香り
おすすめ食材&料理 牛肉や豚肉の脂の多い部位を焼いて、脂ののった魚の塩焼き

しょっぱさ:5　酸味:6
苦味:6　うまみ:8
雑味:6　甘味:8

海水塩

DATA

食塩相当量(88.9g)
ナトリウム　35.0g
カリウム　170mg
マグネシウム　420mg
カルシウム　200mg

原産地
宮城県

形　状　凝集晶
水分量　しっとり
工　程　平釜
原材料　海水

価格／400g入り530円
山田了作
宮城県石巻市
流留字家の前10-69
tel.0225-97-4577

三陸の海水を4日間煮詰めてつくる

薪窯直煮製法 のだ塩

岩手

白い結晶をすくう。

野田村ではかつて、生産した塩を牛の背に乗せて内陸へ運び、穀物と交換していたという。自然ろ過した地下海水を薪で熱した鉄鍋で煮詰める伝統製法で、のだ塩はつくられる。海水を少しずつ足しながら4日間かけて炊き上げるため、1.3tの海水を使ってできる塩は、たった25kgほどだ。鉄由来の酸味と苦味が油っこい料理をさっぱりとさせてくれる。

原産地 岩手県

DATA
形 状	凝集晶		
水分量	標準		
食塩相当量	96.0g	工 程	平釜／乾燥
ナトリウム	38.0g	原材料	海水

TASTE!
おいしい苦味とうまみが口の中に広がる。余韻が長め。ほのかに鉄の酸味

おすすめ食材&料理
赤身の魚の塩焼き、脂の多い牛肉、山菜や鮎のてんぷら

価格／50g入り 205円
株式会社 のだむら
岩手県九戸郡
野田村大字野田31-31-1
tel.0194-78-4171

フレーク結晶のまろやかな塩

男鹿半島の塩

秋田

風光明媚な景色で名高い男鹿半島。日本海に突き出た男鹿の沖合いで汲み取った海水を、オリジナルの多段式平釜で炊き上げている。薪でじっくり時間をかけて濃縮・結晶させるため、細かいフレーク状の塩が仕上がる。シャクシャクとした食感が生きる、添え塩にぴったり。フレーク状の塩のなかでも比較的しょっぱさがまろやかなので、生野菜にそのままのせてもおいしい。

原産地 秋田県

DATA
形 状	フレーク		
水分量	さらさら		
食塩相当量	(88.9g)	工 程	平釜／乾燥
ナトリウム	35.0g	原材料	海水

TASTE!
角のないしょっぱさと強めのうまみ。余韻は長め。シャクシャクした食感

おすすめ食材&料理
白身魚や豚肉料理、野菜サラダ

価格／40g入り 350円（ビン入り）
200円（袋）
株式会社 男鹿工房
秋田県男鹿市
船川港船川字海岸通2-9-5
tel.0185-23-3222
http://ogakoubo.com/

甘味としょっぱさのバランスが◎

津軽海峡の塩

青森

親潮と黒潮が交わる津軽海峡の海水を汲み上げ、薪で焚いた平釜でじっくりと濃縮・結晶させる。70℃程度の低めの温度でゆっくりと火を加えている。甘味がやや強めだが、全体のバランスがよい味わい。どんな料理にでも合わせやすい。

TASTE! やや甘味は強いが全体的にバランスがよい
おすすめ食材&料理 塩おにぎり、淡泊な野菜の浅漬け、油分の少ない料理

原産地 青森県

DATA
食塩相当量 (85.1g)
ナトリウム 34.0g
形状 凝集晶
水分量 さらさら
工程 平釜／焼成
原材料 海水

価格／55g入り 540円
株式会社 駒嶺商店
青森県下北郡風間浦村大字蛇浦字新釜谷2-3
tel.0175-35-2211
http://www.komamine.co.jp/

満月の日に汲み上げたミネラル豊富な塩

月の雫の塩

山形

透明度の高さで知られる、笹川流れの海水が原料。平釜で煮詰めるなかで、最初に浮かぶフレーク状の結晶「塩の花」だけを集めている。満月の日の表層水はミネラルが豊富で味が力強くなるという。力強い味に鉄のような酸味が加わった、個性的な塩。

TASTE! ほどよいしょっぱさ、濃厚なうまみと甘味、酸味、潮の香り
おすすめ食材&料理 味が濃いめの赤身魚、ほうれん草などミネラル分が多い野菜

原産地 新潟県

DATA
食塩相当量
ナトリウム
形状 フレーク
水分量 さらさら
工程 平釜
原材料 海水

価格／150g入り 600円
アル・ケッチァーノ
山形県鶴岡市下山添一里塚83
tel.0235-78-7230
http://www.alchecciano.com

イタリアンの名店のオリジナルソルト

海の泉の塩

山形

透明度の高さで知られる庄内浜の北端にある、鳥海山の伏流水が湧き出すポイントで海水を汲み上げている。その清浄な海水を平釜で濃縮・結晶させた塩。自然豊かな鳥海山の栄養を凝縮しつつ、濃厚な野菜のようなうまみと上品な甘味を感じる。

TASTE! 強いミネラル感、余韻においしい野菜のようなうまみ
おすすめ食材&料理 野菜スープなど野菜料理全般

原産地 山形県

DATA
食塩相当量 (96.5g)
ナトリウム 38.0g
形状 凝集晶
水分量 標準
工程 平釜／乾燥
原材料 海水

価格／100g入り 500円
アル・ケッチァーノ
山形県鶴岡市下山添一里塚83
tel.0235-78-7230
http://www.alchecciano.com

海水塩

日本海の栄養がたっぷり

庄内浜の塩

山形

日本海に面し、多種多様な魚介類の漁場として知られる庄内浜。沖合いの海水を平釜で煮詰めた後、焼いてさらさらに仕上げる。海の栄養が豊富な庄内浜産のこの塩は、強いうまみと甘味の後に、ふわりと潮の香りを感じる。酒のつまみにも。

TASTE! 強めのうまみと甘味を感じる。潮の香りが後をひく
おすすめ食材&料理 生の白身魚や貝類、塩おにぎり

原産地 山形県

DATA
食塩相当量 —
ナトリウム —
形状 凝集晶
水分量 さらさら
工程 平釜/乾燥/焼成
原材料 海水

価格／120g入り 360円
山形県産食品株式会社
山形県酒田市大宮町1-11-1
tel.0234-24-7161

「水分の神」からの贈りもの

酒田の塩 白塩

山形

豊富な降水量で「水分の神(みまくり)」とも呼ばれる鳥海山。伏流水の影響で大地の養分をたっぷり含んだ海水を汲み上げ、平釜で濃縮・結晶させている。薪に廃材を利用したり、煙突の熱で焼成したりと、エコにも配慮した製法。はっきりした酸味とさらりとした甘味がある。

TASTE! レモンのような酸味とあっさりした甘味
おすすめ食材&料理 鶏肉や豚肉のソテー

原産地 山形県

DATA
食塩相当量 (81.2g)
ナトリウム 32.0g
形状 凝集晶
水分量 標準
工程 平釜/乾燥/焼成
原材料 海水

価格／30g入り 362円
酒田の塩
山形県酒田市宮梅字中東14-2
tel.0234-34-2015
http://www.sakatanoshio.com/

salt column 塩にも「香り」がある

　塩は無臭だと思っていませんか？実は塩にも香りがあるんです。もっともわかりやすい香りは、藻塩に含まれる海藻の香り。使用される海藻の種類によっても若干異なりますが、「磯の香り」と表現されます。

　塩の結晶が溶ける際、海岸の近くに来たときに感じる潮の香りがふわりと鼻に抜けたり、口腔内に青い草の香りが広がるのを感じたりすること、ありませんか？これは原材料や製法、使用している器具の材質などの影響を受けるから。よく感じられるのは、「青い草」「海(潮)」「太陽」「土」「鉄」の5つの香りです。これをしっかり感じ取ることで、例えば「青い草の香り」のする塩は同じ香りを持つ野菜と合わせるなど、食材との相性を見る大きなヒントになります。

伝統海塩の復活をかけて生み出された

海の精 あらしお 赤ラベル

東京

しょっぱさ:8 酸味:6
苦味:6 うまみ:6
雑味:6 甘味:5

DATA

食塩相当量 86.4g
ナトリウム 34.0g
カリウム 240mg
マグネシウム 700mg
カルシウム 400mg

原産地 東京都

形　状 凝集晶
水分量 しっとり
工　程 天日／平釜
原材料 海水

海水塩

TASTE!
力強いしょっぱさ、強めのおいしい苦味があり、濃厚な甘味が後をひく

おすすめ食材＆料理
淡泊な白身魚の塩焼き、ねぎなど焼くと甘味が増す野菜のグリル、塩おにぎり

黒潮の海を望む伊豆大島の海際に建てられた、高さ6mのネット架流下式塩田。

価格／170g入り 430円
海の精株式会社
東京都新宿区
西新宿7-22-9
tel.03-3227-5601
http://www.uminosei.com/

1971年、専売制度の施行で全国の塩田が廃止となった。これに異を唱えた有志たちが伝統海塩復活を目指して運動を行い、そのうちの一部が後に製塩会社「海の精」を設立。創設時の理念「身土不二」「一物全体」「陰陽調和」を順守し、現在も大島の国立公園内にある製塩所で、塩づくりを続けている。

製法は自然の力と塩職人の手による伝統的なもの。黒潮を流下式塩田にかけ流して濃縮し、一定濃度になるまで平釜で煮詰め、最後に遠心分離機でにがりを脱水して結晶をつくり出す。

確固たる思想から生み出される味は、有名料理人やマクロビオティックのシェフはもちろん、全国各地にもファンが多い。にがり成分が多くしっとりしているのが特徴。シンプルに塩おにぎりに合わせると、米のうまみと甘味をグッと引き立てる。

memo マクロビオティックとは、日本の伝統食をベースにした玄米菜食など、自然に即した食生活法。

プロの料理人のためにつくられた塩

小笠原の塩

東京

原産地
東京都

DATA
形　状　フレーク
水分量　標準
食塩相当量　82.5g　工　程　平釜
ナトリウム　32.5g　原材料　海水

TASTE!
まろやかなしょっぱさ、濃厚なうまみ、ほのかな酸味

おすすめ食材&料理
トマトなどうまみの濃い野菜、発酵食品づくり、豚肉のグリル、白身魚の塩焼き

固有の自然が残る小笠原諸島の父島で、「プロの料理人のための塩」を目指した塩づくりが行われている。ろ過した海水をひとつの平釜に入れ、細かな調整をしながらていねいに煮詰める。ナトリウム構成比が低く、マグネシウムやカリウムなどのミネラルが多いため、まろやかなしょっぱさ。強めのコクとほのかな酸味を感じる結晶は、口の中でするりと溶ける。

海水塩

価格／140g入り 500円
小笠原の塩
東京都小笠原村
父島字小曲83-1
tel.04998-2-2044
http://www.ogasawaranoshio.com/

深い甘味を感じる深層地下塩水の塩

Flower Of Ocean シホ

東京

原産地
東京都

DATA
形　状　凝集晶
水分量　標準
食塩相当量　(91.1g)　工　程　天日／平釜
ナトリウム　35.9g　原材料　海水

TASTE!
しょっぱさがすぐに消え、おいしい苦味と酸味。後味に乳製品の脂肪分のようなコク

おすすめ食材&料理
牛乳や生クリームを使ったスイーツやソース、フレッシュチーズ

塩づくりひと筋40年の塩職人によって生み出される塩。1970年代に伊豆大島へ渡り、伝統海塩復活に尽力したという。海洋深層水と真水が合流する地点から取水。太陽熱や風など自然のエネルギーを利用できるよう設計した、独自のドーム型のハウス内で天日濃縮してから釜で炊き上げている。後味に乳製品のようなコクと甘味を感じる。塩スイーツづくりにおすすめ。

価格／200g入り 600円
OHSHIMA OCEAN SALT
有限会社
東京都大島町
元町字小清水267-4
tel.04992-2-2815
http://www.o-oceansalt.com/

農林水産大臣賞受賞のうまみ塩

小笠原 島塩

東京

東京から約1000km、小笠原諸島・父島産の海水塩。日本初、登り釜を使用した製塩方法を採用。温度の違う複数の釜に海水を移しながら、低温で濃縮を続けることで、海水内の石灰分を除去し、透明で美しい結晶をつくり出す。

TASTE! まろやかなしょっぱさ、非常に濃いうまみ
おすすめ食材&料理 野菜全般

原産地 東京都

DATA
食塩相当量 82.5g
ナトリウム 32.5g
形 状 立方体
水分量 標準
工 程 平釜／天日
原材料 海水

価格／200g入り 700円（税込）
有限会社 小笠原フルーツガーデン
東京都小笠原村父島字東町82-2
tel.04998-2-2534
http://www.rakuten.co.jp/ogasawara-shop/

グリーンランドから届いた海洋深層水

ムーンソルト 粒小

東京

手つかずの自然が多く残る小笠原諸島・父島産の完全天日塩。原材料の海水は、グリーンランドの氷河が溶けて深層水となり、長い年月をかけて島の東方沖で湧き上がったもの。太陽や月にあて、時間をかけてゆっくりと結晶を育て上げる。粒は大きめでうまみたっぷり。

TASTE! ほどよい甘味と苦味。うまみの余韻が長い
おすすめ食材&料理 白身魚の塩漬け、パンのトッピング、オイルとともにフォカッチャに添えて

原産地 東京都

DATA
食塩相当量 (81.2g)
ナトリウム 32.0g
形 状 立方体
水分量 標準
工 程 天日
原材料 海水

価格／100g入り 650円
株式会社小笠原自然海塩
東京都小笠原村父島時雨山
tel.04998-2-3623
http://www.ogashio.com/

伊豆大島の海の味そのまま

深層海塩ハマネ

東京

伊豆大島を覆う黒い火山岩・玄武岩層に浸透した、深層地下海水を地下300mから汲み上げ、濃縮小屋で天日に当てて濃縮してから、約85℃の平釜で結晶に仕上げる。海の味がそのまま残っているので、魚介類との相性が抜群。

TASTE! 海水そのもの。しょっぱさの後に強めの苦味、酸味、雑味
おすすめ食材&料理 魚介類全般、海藻サラダ

原産地 東京都

DATA
食塩相当量 89.2g
ナトリウム 35.1g
形 状 凝集晶
水分量 標準
工 程 天日／平釜
原材料 海水

価格／200g入り 470円
深層海塩株式会社
東京都大島町岡田字小堀123
tel.04992-2-8077
http://www.shinsoukaien.com/

海水塩

大地の力・火山の蒸気でつくる

ひんぎゃの塩

東京

東京から南に約360km離れた火山島・青ヶ島。周囲を流れる黒潮を汲み上げ、火山噴気孔から出る高温の蒸気を利用して温めながら、約3週間かけて少しずつ濃縮・結晶させている。しょっぱさはまろやかで、強い甘味と適度なうまみを感じる塩。

TASTE！ まろやかなしょっぱさで、適度なうまみ、強い甘味を感じる
おすすめ食材＆料理 野菜サラダや浅漬け、塩おにぎり

原産地 東京都

DATA
食塩相当量 90.6g
ナトリウム 35.6g
形　状 凝集晶
水分量 標準
工　程 平釜
原材料 海水

価格／60g入り 260円
株式会社青ヶ島製塩事務所
東京都青ヶ島村無番地
tel.04996-9-0241
http://hingya.jimdo.com/

清浄な黒潮でできた力強い海水塩

黒山海
（くろさんかい）

東京

黒潮が流れる八丈島のなかでも、特に流れが速い島北部の黒瀬川周辺で汲み上げた清浄な海水が原料。独自の室内低温自然蒸発で濃縮・結晶させている。全体的に力強い味わいで、しょっぱさとうまみが濃く、余韻が長く続く。粒が大きく、ガリガリとした食感も楽しい。

TASTE！ 味に厚みがあり、特にうまみが濃く、長く続く。雑味もある
おすすめ食材＆料理 赤身の肉や魚のグリル、脂ののった魚の干物

原産地 東京都

DATA
食塩相当量 80〜88g
ナトリウム 34〜38g
形　状 立方体
水分量 標準
工　程 天日
原材料 海水

価格／150g入り 600円
黒瀬川企画 黒山海
東京都八丈島八丈町三根1783-1
tel.04996-2-0256
http://kurosankai.upper.jp/

江戸時代から伝わる製塩法を復活

あげ浜塩田製法塩

千葉

かつて九十九里浜で行われていた揚浜式塩田を復活。揚浜式とは砂地の塩田に海水をまき、太陽と風の力をかりて海水を濃縮する、石川県珠洲市を除いて、今ではほとんど見られなくなった伝統の製塩法。薪火で熱した平釜で濃縮海水をじっくり煮詰めて仕上げている。

TASTE！ はっきりとしたうまみと甘味。後味にほのかな雑味と苦味
おすすめ食材＆料理 トマトなどうまみの強い野菜のグリル、塩おにぎり

原産地 千葉県

DATA
食塩相当量 85.4g
ナトリウム 34.0g
形　状 凝集晶
水分量 標準
工　程 天日／平釜
原材料 海水

価格／200g入り 780円
サンライズソルト
千葉県旭市椎名内3213
tel.0479-74-3132
http://www.sunrise-salt.com

日本最古の揚浜式製塩を継承する製塩所

能登のはま塩

石川

粒の大きさ：大
しょっぱさ：強

しょっぱさ：4　酸味：5
苦味：6　うまみ：6
雑味：5　甘味：7

DATA

食塩相当量
ナトリウム
カリウム
マグネシウム
カルシウム

原産地　石川県

形　状　凝集晶
水分量　標準

工　程　天日／平釜
原材料　海水

海水塩

TASTE!
濃厚なバターのような甘さとうまみ。するりと溶けるが余韻は長く、舌の上にうまみが残る

おすすめ食材＆料理
バターや乳製品を使った料理、脂ののった白身魚、そのまま酒のつまみ

砂を敷いた塩田に、職人自ら運んだ海水を勢いよく撒く。均等に撒くのは熟練の技だ。

価格／100g入り 400円（税込）
揚げ浜塩田 角花家
石川県珠洲市清水町1-58-27
tel.0768-87-2857

石川県珠洲市に代表される揚浜式製塩は、塩田法としては日本最古であり、国の重要無形民俗文化財にも指定されている文化的価値の高い技術だ。専売制度によって全国の塩田が廃業となるなか、角花菊太郎氏の持つ製塩技術と製法が高く評価され、研究目的として、全国で唯一、製塩の継続が許可されたという。それ以降、角花家では、江戸時代初期から続く伝統製法を先祖代々守り続けてきた。揚浜式塩田の文化的価値と角花家の塩にかける姿は、映画やドラマのモデルにもなっている。

現在は5・6代目の手によって塩づくりが行われている。天候に左右されるため、曇天や降雪が多い冬は生産が困難ゆえ、おもに春から夏に行われ、生産量が限られる。口溶けがよく、まるで上質なバターのよう。甘さと濃厚なコクがいつまでも続く特別な味わいだ。

あらゆる条件が整ってできる希少な塩
珠洲の結晶塩

石川

能登の海。

原産地 石川県

DATA
形　状	フレーク
水分量	標準
食塩相当量	93.4g
工　程	天日／平釜
ナトリウム	36.8g
原材料	海水

TASTE!
後口にほどよい苦味。余韻が長く、うまみが濃厚

おすすめ食材&料理
白身魚のソテーやグリル、刺身、イカの刺身、野菜サラダ、そのまま酒のつまみ

すだれに流しかけて濃縮した海水を、2〜3日かけて煮詰める昔ながらの製法。結晶化させる過程で釜の温度や気温差など、あらゆる条件が整ったときにだけ採れる希少な結晶、それを集めたのが珠洲の結晶塩だ。フレーク状の結晶は、シャクシャクとした軽やかな食感と、舌の上でスッと溶けてからうまみの余韻をじんわり楽しめる。料理の仕上げに振りかけたり、そのまま酒のつまみとしても味わいたい。

価格／100g入り 505円
株式会社新海産業
石川県珠洲市
長橋町15-18-11
tel.0768-87-8140

海水塩

低温で結晶を育てる独自製法の塩
わじまの海塩

石川

太陽の代わりになるライト。

原産地 石川県

DATA
形　状	凝集晶
水分量	標準
食塩相当量	88.9g
工　程	平釜
ナトリウム	35.0g
原材料	海水

TASTE!
しょっぱさの後にくる心地よい苦味とうまみ。後味がすーっと消えていく

おすすめ食材&料理
発酵食品づくり、野菜サラダ、グレープフルーツ

底浅の平釜に入れた海水に至近距離からライトを照射し、熱と風により体温程度の低温でじっくりと濃縮・結晶させる独特な製法。これはフランスの「ゲランド」のような海外の屋外塩田を日本の室内で再現しようという試みから生まれた。でき上がった塩は採取順にわけられ、最後に塩をブレンドすることで、絶妙なミネラルバランスを実現。食材の発酵・熟成を促すと評判で、一流料理人も愛用している。

価格／100g入り 500円
株式会社美味と健康
石川県輪島市
河井町23-1-97
tel.0768-22-0868
http://www.wajimanokaien.com/

奥能登揚げ浜塩

揚浜式塩田の製塩体験が可能

石川

浜士と呼ばれる塩職人によってつくられる塩。揚浜式塩田で海水を濃縮後、平釜で6時間煮詰め、ろ過してから、さらに18時間かけて炊き上げている。冬場の製塩が難しいため、生産量が少ない希少な塩。「道の駅すず塩田村」を運営し、製塩体験もできる（要予約）。

TASTE! 強めの苦味とミルクのような甘さ、余韻はそれほど長くない
おすすめ食材&料理 塩ミルクアイス、白身魚の塩焼き、塩おにぎり

原産地　石川県

DATA
- 食塩相当量 (78.7g)
- ナトリウム 31.0g
- 形状　凝集晶
- 水分量　標準
- 工程　天日／平釜
- 原材料　海水

価格／50g入り 400円（税込）
株式会社奥能登塩田村
石川県珠洲市清水町1-58-1
tel.0768-87-2040

珠洲の海 あげ浜

マグネシウムなどのミネラルが豊富な塩

石川

珠洲市にある揚浜式塩田のうちのひとつ。寒流と暖流が交じる、栄養豊富な能登沖の海水を揚浜式塩田で濃縮し、平釜で炊き上げて結晶させた塩。ナトリウムが少なくまろやかで、マグネシウムやカリウムなどのミネラル分が多く、複雑な味わい。

TASTE! かなり強めの苦味の後、濃厚なうまみと甘味が出てくる
おすすめ食材&料理 脂肪分の多い豚肉のグリル、トマトなど味の濃厚な野菜

原産地　石川県

DATA
- 食塩相当量 85.7g
- ナトリウム 33.7g
- 形状　凝集晶
- 水分量　標準
- 工程　天日／平釜
- 原材料　海水

価格／100g入り 450円
株式会社珠洲製塩
石川県珠洲市長橋町13-17-2
tel.0768-87-8080
http://www.suzuseien.jp/

大谷塩

甘味とうまみの塩は料理人にもファン多数

石川

浜士・中前賢一さんがつくる塩。いくつかの場所を試し、「やっと納得いく塩ができる場所があった」と、現在の場所に伝統的な揚浜式塩田を再現。昔ながらの製法を守った塩づくりを続けている。濃厚な甘味とバターのようなコクがあり塩スイーツづくりにぴったり。

TASTE! まろやかなしょっぱさ。バターのような甘味とうまみ、コク
おすすめ食材&料理 乳製品を使ったスイーツ、塩おにぎり、脂肪分の多い豚肉

原産地　石川県

DATA
- 食塩相当量 92.1g
- ナトリウム 32.2g
- 形状　凝集晶
- 水分量　しっとり
- 工程　天日／平釜
- 原材料　海水

価格／100g入り 400円
中前製塩
石川県珠洲市長橋町15-18-2
tel.0768-87-8020

海水塩

つまみにぴったり香ばしいフレーク塩

鉢ヶ崎の塩

石川

「日本の渚100選」にも選ばれるほどの美しさを誇る鉢ヶ崎海岸の海水を、平釜でじっくり煮詰めて濃縮・結晶させた海水塩。適度なしょっぱさがあり、小さなフレーク状の結晶は、シャクシャクとした食感も楽しめるので、トッピングやつまみにおすすめ。

TASTE!	あたたかみのある味わい、ほのかな香ばしさ
おすすめ食材&料理	火入れした日本酒のつまみ、白身魚の塩焼き

DATA
食塩相当量（97.5g）
ナトリウム 38.4g
形　状 フレーク
水分量 標準
工　程 平釜
原材料 海水

価格／100g入り 400円（税込）
鉢ヶ崎製塩
石川県珠洲市鉢ヶ崎
tel.0768-82-1266

揚げ物にぴったりのしょっぱさと苦味

花の塩

石川

「珠洲の結晶塩」（p.64）の姉妹品。釜の温度や気温差などのある条件が整ったときにだけ収穫できる、希少なピラミッド状の塩。しっかりしたしょっぱさと苦味が、とんかつなどの揚げ物の油っこさを緩和し、素材のうまみをいっそう引き立てる。シャクシャクとした食感も特徴。

TASTE!	しょっぱさと苦味が強いが、キレがよく透明感がある
おすすめ食材&料理	とんかつなどの揚げ物

DATA
食塩相当量（93.4g）
ナトリウム 36.8g
形　状 トレミー
水分量 さらさら
工　程 天日／平釜
原材料 海水

価格／100g入り 1000円
有限会社 新海塩産業
石川県珠洲市長橋町15-18-11
tel.0768-87-8140

清浄な冷泉からつくられる甘味ある塩

輪島塩

石川

海底から冷泉が湧き出ているという言い伝えのある輪島沖のポイントから海水を汲み上げ、伝統的な揚浜式塩田で塩づくりを行う。うまみと甘味が強いが、酸味の影響でキレがよく、後味はすっきり。製塩所では塩づくり体験も受け付けている。

TASTE!	酢酸のような酸味、こってりしたうまみ。乳製品のような甘味も
おすすめ食材&料理	脂肪分の多い牛肉のグリル、乳製品を使ったスイーツ

DATA
食塩相当量（91.9g）
ナトリウム 36.2g
形　状 凝集晶
水分量 標準
工　程 天日／平釜
原材料 海水

価格／80g入り 389円
株式会社輪島製塩
石川県輪島市町野町大川ハ17-2
tel.0768-32-1177
http://www.wajimashio.jp／

やわらかい、純白の結晶
日本海の塩 白いダイヤ

新潟

自慢の薄型平釜。

原産地
新潟県

DATA		
	形　状	凝集晶
	水分量	標準
食塩相当量 89.5g	工　程	平釜
ナトリウム 35.2g	原材料	海水

TASTE!
ほどよいしょっぱさ、やわらかな甘味とうまみ、潮の香り

おすすめ食材＆料理
白身魚の塩煮や刺身、魚の塩焼き

新潟県の最北部、山形県との県境にある海沿いで、父の志を継ぎ塩職人となった富樫秀一さんが生み出す塩。その名の通りダイヤのように輝く純白の粒は、ミネラル豊富な日本海の海水を、薪で焚き上げながらじっくり煮詰め、湯煎で温めた薄型平釜でゆるやかに結晶させたもの。釜炊きの間に寝かせる工程をおいて、不純物を除去している。結晶は指でつぶせるほどふわりとした感触。

価格／120g入り 400円
ミネラル工房
新潟県村上市中浜1076-2
tel.0254-77-2993
http://www.shiroi-diya.com/

海水塩

花びらのような結晶を集めた希少な塩
花塩

新潟

清浄な山北の海。

原産地
新潟県

DATA		
	形　状	フレーク
	水分量	標準
食塩相当量 86.2g	工　程	平釜
ナトリウム 33.9g	原材料	海水

TASTE!
しっかりしたしょっぱさと心地よい苦味。潮の香り

おすすめ食材＆料理
マグロやカツオなど脂ののった赤身魚の塩焼き、脂ののった魚の干物

村上市でいち早く塩づくりに取り組んだ故・佐藤寛さんの思いと技術を引き継ぐ製塩所。景勝地として名高い笹川流れにほど近い、山北の海から海水を汲み上げ、薪で焚いた平釜で、じっくり炊き上げて結晶させている。なかでも条件がそろったときにだけできる、花びらのような結晶だけを集めた希少品。大きめのカリカリとした粒と、細かな粒が混ざった独特の食感が特徴。

価格／400g入り 500円
有限会社中浜観光物産
新潟県村上市中浜528-1
tel.0254-77-2714

高い技術力から生まれる日本海の結晶
笹川流れの塩

新潟

店主の佐藤柏さんが独自に研究を重ねたオリジナルの釜が、シャクシャクとしたフレーク状の結晶を生み出す。滋味豊かな日本海の海水を汲み上げ、特許製法の連続式平釜で沸騰させずに、少しずつ結晶化に導く。釜をコントロールすることで、1度に少量しかできない塩の結晶を安定してつくることができるという。思い通りの結晶をつくり出す、技術力の高さはピカイチ。

原産地　新潟県

DATA
形状	フレーク
水分量	さらさら
食塩相当量	88.4g
ナトリウム	34.8g
工程	天日／平釜
原材料	海水

TASTE!
潮の香り、海水の味。ミネラル感と濃厚なうまみ

おすすめ食材＆料理
てんぷらなど揚げ物のつけ塩、漬け物、白身魚の刺身、辛口の日本酒のつまみ

価格／200g入り 280円
吉野屋
新潟県村上市中浜723
tel.0254-77-3240

食材を生かすうまみたっぷりの塩
越前塩

福井

食材の宝庫である地元福井で、食材のおいしさを生かす塩をつくりたいと、若い生産者ふたりが試行錯誤の末、つくり上げた海水塩。日本海有数の漁場である越前海岸の海水を、温室ですだれに噴霧し、日光と風の力で濃縮。その後煮詰めて不純物を取り除き、攪拌しながら1日かけて結晶をつくる。手間暇かけてつくるため、大量生産が難しい希少な塩。

原産地　福井県

DATA
形状	凝集晶
水分量	標準
食塩相当量	(86.3g)
ナトリウム	34.0g
工程	天日／平釜
原材料	海水

TASTE!
適度なしょっぱさと心地よい苦味。余韻の長い濃厚なうまみ

おすすめ食材＆料理
塩おにぎり、野菜の浅漬け

価格／150g入り 600円
有限会社越前塩
福井県丹生郡越前町厨26-27
tel.0778-37-2553
http://www.echizensio.jp/

佐渡の深海塩
日本海固有の海洋深層水100％

新潟

原産地 新潟県

DATA
形　状	凝集晶
水分量	標準
食塩相当量	87.3g
ナトリウム	34.3g
工　程	平釜
原材料	海水

TASTE!
まろやかなしょっぱさ。粘度を感じる甘さ。はっきりとしたうまみ。苦味がありキレがよい

おすすめ食材＆料理
白身魚、帆立、トマトなど味の濃い野菜、たまご料理、はちみつ

佐渡島多田沖、水深330m以深から汲み上げた海洋深層水を、いくつかの釜を移動させながらじっくり煮詰めて濃縮・結晶させている。佐渡海洋深層水は「日本海固有水」ともいわれ、太平洋側よりも平均水温が通年1℃前後と低めで、酸素を多く含むフレッシュな深層水だ。口に含むと、結晶は溶けるにつれさまざまな味わいが広がる。複雑な味わいを楽しみたい。

価格／70g入り 250円
佐渡海洋物産株式会社
新潟県佐渡市多田字大平43
tel.0259-81-2222
http://sado-kaiyo.shop-pro.jp/

海水塩

塩の花
海水の後味そのままに

新潟

原産地 新潟県

DATA
形　状	フレーク
水分量	さらさら
食塩相当量	―
ナトリウム	―
工　程	平釜
原材料	海水

TASTE!
海水の苦味、適度なしょっぱさとキレのよいうまみと甘味

おすすめ食材＆料理
脂ののった魚の塩焼き、オイルとともに調理した魚、牛肉のグリル

国の名勝にも指定される美しい海岸、笹川流れ沿いに立つ製塩所では、日本海の海水だけを使って15時間炊き続け、結晶にしている。いちばん初めにできる結晶「塩の花」だけを集めているため結晶は大きめ。口の中でほどけるにつれ、適度なしょっぱさ、苦味、鉱物的な酸味を順に感じる豊かな味わいだ。フレーク結晶で、カリッとした食感が楽しめる。

価格／170g入り 700円
有限会社日本海企画
新潟県村上市勝木63-2
tel.0254-77-3009
http://www.isosio.com/index.html

天皇家への献上品の塩を復活

戸田塩（へだしお）

静岡

1500年前、安康天皇が病気療養のために用いられたといわれる戸田塩を、地域婦人会の有志によって復活させた。でき上がった結晶は1週間クラシック音楽を聞かせながら寝かせ、にがりを切っている。2016年「総務省ふるさとづくり大賞」受賞の逸品。

TASTE：まろやかなしょっぱさ、濃厚な甘さとうまみ。余韻はあっさり短め
おすすめ食材&料理：塩おにぎり、たまご料理、キャベツなど熱すると甘くなる野菜

原産地：静岡県

DATA
食塩相当量（86.6g）
ナトリウム 34.1g
形状 凝集晶
水分量 しっとり
工程 平釜
原材料 海水

価格／180g入り 650円（税込）
NPO戸田塩の会
静岡県沼津市戸田3705-4
tel.0558-94-5138
http://www.npo-hedashio.jp/

味のバランスがよいフレークの塩

あらしお

静岡

オーストラリアの美しい海シャークベイまたは、メキシコ・カリフォルニア半島に位置するエル・ビスカイノ湾の塩田で生産された完全天日塩を、南アルプスの伏流水で溶かして再結晶させた再製加工塩。味のバランスがよく、価格もお手頃なので、ふだん使いにおすすめ。

TASTE：適度なしょっぱさ、ほどよい苦味としょっぱさ、甘味
おすすめ食材&料理：塩おにぎり、野菜の浅漬け

原産地：静岡県

DATA
食塩相当量 91.7g
ナトリウム 36.1g
形状 フレーク
水分量 しっとり
工程 溶解／平釜
原材料 天日塩

価格／400g入り 155円
あらしお株式会社
静岡県静岡市駿河区広野2308
tel.054-259-3118
http://www.arashio.co.jp/

山のミネラルたっぷりの自然塩

遠州沖ちゃん塩（えんしゅうおきちゃんしお）

静岡

漁師町として栄えた遠州灘・沖之須には、かつて塩づくりが行われていた浜があったという。近年、町の復興を望む有志が「遠州沖ちゃんクラブ」を立ち上げ、塩づくりを復活。アルプスの雪解け水が天龍川を通って海に流れ込むため、塩には山のミネラルがたっぷり。

TASTE：まろやかな甘味、ほのかな苦味。余韻は短め
おすすめ食材&料理：野菜、白身魚のフリット

原産地：静岡県

DATA
食塩相当量（91.1g）
ナトリウム 35.9g
形状 凝集晶
水分量 標準
工程 平釜／乾燥
原材料 海水

価格／100g入り 300円
遠州沖ちゃんクラブ
静岡県掛川市沖之須379-1
コミュニティセンター「いこい」内
tel.0537-48-5058

豊かな西伊豆の海からできた結晶塩

伊豆盛田屋の完全天日塩

静岡

豊富な海産物の水揚げを誇る西伊豆に店を構える、心太(ところてん)の有名店「盛田屋」がつくる完全天日塩。ネット式塩田で濃縮した海水を結晶箱に入れて、数か月もの時間をかけて結晶させるため、一度にたくさんはつくれない。やや大きめの結晶のザクザクした食感が楽しい。

TASTE 強いしょっぱさとしっかりした甘味。最後にキレのよい酸味
おすすめ食材&料理 塩おにぎり、脂ののったマグロやカツオの炙り

原産地 静岡県

DATA
食塩相当量(86.8g)
ナトリウム 34.2g
形 状 立方体
水分量 標準
工 程 天日
原材料 海水

価格／200g入り 650円
伊豆の心太 盛田屋
静岡県伊豆市八木沢1297
tel.0558-99-0014

世界4地域のこだわり塩をブレンド

GARDENSTYLE PRECIOUS MIX
ガーデンスタイル プレシャス ミックス

静岡

静岡県の水産加工品メーカーが生み出しためずらしいブレンドソルト。フランス産海水塩、ヒマラヤ産岩塩、沖縄県産パウダー塩、イギリス産海水塩という、味も食感も異なる4種類を絶妙なバランスで混ぜ合わせている。料理の仕上げ塩としておすすめ。

TASTE 複雑な食感、味のバランスがよい
おすすめ食材&料理 野菜サラダやカルパッチョに上から振りかけて

原産地 静岡県

DATA
食塩相当量 91.4g
ナトリウム 36.0g
形 状 粉砕
水分量 さらさら
工 程 混合
原材料 海塩、岩塩

価格／70g入り 500円
有限会社 三角屋水産
静岡県賀茂郡
西伊豆町仁科1190-2
tel.0558-52-0132
http://sankakuya.shop-pro.jp/

枝条架式塩田で濃縮した甘味塩

美浜の塩

愛知

古墳時代から塩づくりが行われていたという、知多半島の先端にほど近い美浜町産の塩。伊勢湾の海水を枝条架式塩田で濃縮し、さらに4時間煮詰めて仕上げる。クリーム色がかった粒はカルシウムが多く、まろやかなしょっぱさ、甘味、苦味、雑味のバランスがとれた味。

TASTE ミネラル感、まろやかなしょっぱさ、あっさりした甘味、苦味、雑味
おすすめ食材&料理 豆のサラダ、じゃがいもを使った料理、揚げ物

原産地 愛知県

DATA
食塩相当量 88.4g
ナトリウム 34.8g
形 状 凝集晶
水分量 標準
工 程 天日／平釜／乾燥
原材料 海水

価格／100g入り 350円
食と健康の館
愛知県知多郡
美浜町大字小野浦字西川1
tel.0569-83-3600
http://www.shio-yakata.com/

海水塩

Sea salt *Japan Map* 近畿〜四国

海水塩

- 出雲 鵜鷺の藻塩 → P.111
- Salann Oki サランオキ → P.78
- ローソク島の藻塩 → P.110
- 浜守の荒塩 → P.77
- 百姓の塩 → P.78
- 感謝の塩 → P.77
- 御塩 → P.80
- 伯方の塩 粗塩 → P.83
- SOLASHIO → P.80
- 海人の藻塩 → P.108
- 海の愛 → P.83
- 弓削塩 → P.111
- あまみ → P.79
- りぐる → P.81
- 土佐の塩丸 → P.79
- 海一粒 → P.82
- 室戸の塩 → P.82
- いごてつの天日塩 → P.81
- 黒潮町の黒塩 → P.111
- 室戸の海洋深層水 マリンゴールドの塩 → P.82
- 山塩小僧 → P.81

PART ❷ 海水塩、藻塩

製塩所数はそれほど多くはないものの、気候や環境がさまざまで、地域性を生かした個性豊かな塩が見られるエリア。

瀬戸内海沿岸は江戸時代、赤穂をはじめ日本の製塩の中心地でした。今では瀬戸内海に浮かぶ島々でその名残りを目にします。太古の藻塩づくりを復活させた製塩所もここにあります。

外洋に面した高知県では、国内ではめずらしく完全天日塩を手掛ける製塩所がいくつもあります。日照時間が長いため、天日だけで結晶させるには最適な環境だからです。香川県では貴重な入浜式塩田があり、伝統的な製法が受け継がれています。

海水塩

赤穂の焼き塩 窯焚き塩 → P.76

琴引の塩 → P.75

赤穂の天塩 → P.76

家島の天然塩 → P.76

自凝雫塩 → P.75

淡路島の藻塩（茶）PREMIUM → P.109

岩戸の塩 → P.74

しお学舎のやさしいお塩 → P.74

宇多津 入浜式の塩 → P.80

海部乃塩 → P.83

かいふ藻塩 → P.109

ミネラルが豊富なクリーム色の焼き塩

岩戸の塩

三重

夫婦岩で知られる伊勢市二見浦の宿・岩戸館の女将が、家族の健康のために考えた自家製塩を由来とする。かつて伊勢神宮の御塩の原料となった、神前海岸の海水を汲み上げ、鉄製の登り釜で約15時間煮詰めている。伏流水と海水が交わるポイントなど、取水地にもこだわる。海水を最後まで結晶させて焼くことで、マグネシウムたっぷりの塩に仕上がり、淡いクリーム色に色づく。

釜は薪で焚く。

海水塩

原産地 三重県

DATA
形　状　凝集晶
水分量　さらさら
食塩相当量（71.6g）　工　程　平釜／焼成
ナトリウム　28.2g　原材料　海水

TASTE!
するどいしょっぱさ、強い苦味と鉄のような酸味、雑味。余韻は短め

おすすめ食材＆料理
ビーフカツレツ、大トロの炙り、牛肉のカルパッチョ

価格／125g入り 820円
株式会社岩戸館
三重県伊勢市
二見町茶屋566-9
tel.0596-43-2122
http://www.iwatokan.com/

低ナトリウムでマグネシウムが多い塩

しお学舎のやさしいお塩

三重

美しいリアス式海岸

緑豊かなリアス式海岸が続く尾鷲市の熊野灘沖、水深415mから汲み上げた海洋深層水が原料。ミネラルなど海水の成分を結晶にすべて含ませるため、塩を焼成して仕上げている。これにより、ナトリウム構成比がとても低く、しょっぱさよりも、酸味や苦味、雑味やうまみが際立つ塩になる。焼釜は職人の手仕事のため、一度にできる量が限られている希少な塩。

原産地 三重県

DATA
形　状　粉砕
水分量　さらさら
食塩相当量　66.0g　工　程　立釜／焼成
ナトリウム　26.0g　原材料　海水

TASTE!
強い苦味と雑味。はっきりとした酸味

おすすめ食材＆料理
ゴーヤなど苦味のある野菜のフリット。塩キャラメル。牛乳といっしょに摂るとカルシウムの吸収率がアップ

価格／50g入り 429円
株式会社モクモクしお学舎
三重県尾鷲市古江町192
tel.0597-27-3030
http://www.shiogakusha.com/

丹後半島で生まれた純白の塩

琴引の塩

京都

鳴き砂で知られる琴引浜近くにある旅館が手がける塩。透明度の高い丹後半島の海水を、薪で焚いた平釜で煮詰め、ていねいに石灰を除去しながら濃縮・結晶させている。魚介類との相性がよい。丹後産の海藻・神葉（ホンダワラ）を使った藻塩も人気。

TASTE! 適度なしょっぱさと酸味、後味に強めのコク
おすすめ食材&料理 刺身用のイカやタコ、白身魚、貝類

原産地 京都府

DATA
食塩相当量
ナトリウム

形　状　凝集晶
水分量　標準
工　程　逆浸透膜／平釜／乾燥
原材料　海水

価格／100g入り 278円
西晶株式会社
京都府京丹後市網野町三津139 丹後半島海遊
tel.0772-72-5566
http://www.tango-kaiyu.com/

淡路島の海水を凝縮したこだわりの製法

自凝雫塩（おのころしずくしお）

兵庫

社名の通り、脱サラした若手製塩者がつくり上げる、まろやかなしょっぱさとはっきりとした酸味が特徴の塩。淡路島播磨灘の五色の浜の海水を濃縮した後、特注の鉄釜で40〜50時間煮詰める。最後に杉樽の中で寝かせ、にがりを切って仕上げている。

TASTE! 苦味。鉄由来の酸味。後味にあっさりした甘味
おすすめ食材&料理 焼肉のつけ塩、炙りマグロ、鰹のたたき

原産地 兵庫県

DATA
食塩相当量
ナトリウム

形　状　凝集晶
水分量　標準
工　程　逆浸透膜／平釜
原材料　海水

価格／180g入り 602円
株式会社脱サラファクトリー
兵庫県洲本市五色町鮎原鮎の郷452-31
tel.0799-30-2501
http://hamashizuku.com/

海水塩

salt column 「食塩」は商品名でもある

食用の塩の総称は「食塩」または「塩」で、商品パッケージの裏面の「品名」のところにもそのように記載されていますが、実は「食塩」は商品名でもあります。(財)塩事業センターでは、国産海水を原料にイオン膜で濃縮し、立釜で結晶させたあと乾燥させた、塩化ナトリウム99％以上の塩を「食塩」という名称で販売しています。

Topics 希少な「塩の花」

濃縮海水（かん水）を結晶させる際、表面に最初に成長する結晶を「塩の花」といいます。薄いフレーク状の結晶が多く、全体に占める収穫量が少ないため、とても貴重な塩として扱われます。花びらのような姿から、フランスでは「フルール・ド・セル（fleur de sel）」、ポルトガルでは「フロール・デ・サル（flor de sal）」などと呼ばれています。

高熱処理でマイルドな味わい

赤穂の焼き塩 窯焚き塩

兵庫

国内産海水塩を400℃以上の高熱で焼成することで、苦味の元となるマグネシウムを変化させているため、苦味がなく、ほどよいコクを感じる。粒が小さくさらさらしているため、食材にまんべんなく付着する。バランスのよい味わいでふだん使いにおすすめ。

TASTE! 角のないしょっぱさ、ほどよいうまみ。余韻は短め
おすすめ食材&料理 塩おにぎり、生野菜サラダ

原産地 兵庫県

DATA
食塩相当量 99.1g
ナトリウム 39.0g

形 状 粉砕
水分量 標準
工 程 焼成
原材料 海水塩

価格／1kg入り 300円
ミヤザキ食塩工業株式会社
兵庫県赤穂市
中広東沖1352-1
tel.0791-43-1815

にがりを加えた赤穂伝統の製法

赤穂の天塩

兵庫

播磨赤穂では江戸時代からにがりを大切にした差塩製法が行われていた。その伝統を受け継ぎ、オーストラリア産の完全天日塩に、日本国内でにがりを加えた再製加工塩。専売制度の時代に、自然塩復活に力を注いだ功績は、日本の塩史に刻まれている。

TASTE! 角のないしょっぱさ。ほのかな苦味。ほどよいうまみと甘味
おすすめ食材&料理 塩おにぎり、野菜の浅漬け、長期保存の漬物

原産地 兵庫県

DATA
食塩相当量 92.0g
ナトリウム 36.0g

形 状 立方体
水分量 しっとり
工 程 洗浄／粉砕と溶解／立釜を混合
原材料 天日塩、粗製海水塩化マグネシウム（にがり）

価格／1kg入り 350円
株式会社天塩
東京都新宿区
百人町2-24-9
tel.03-3371-1521

元漁師の親子がつくる播磨の海の恵み

家島の天然塩

兵庫

瀬戸内海に浮かぶ家島諸島のひとつ西島で、元漁師の親子によって生産される海水塩。瀬戸内海の播磨灘の海水を取水し、薪を使って焚いた釜で、不純物を取り除きながら約15時間かけて結晶させている。全体的に味が濃く、複雑な味わい。

TASTE! 全体的に味が濃い。しょっぱさと苦味の後に酸味
おすすめ食材&料理 マグロのカマ焼き、脂ののった魚の塩焼き

原産地 兵庫県

DATA
食塩相当量 (95.2g)
ナトリウム 35.7g

形 状 凝集晶
水分量 標準
工 程 平釜
原材料 海水

価格／200g入り 500円（税込）
有限会社ヤマニ水産
兵庫県姫路市
家島町宮1422-2
tel.079-325-1673

海水塩

海とともに生きるライフセーバーがつくる塩

浜守の荒塩

島根

ライフセーバーの活動を通じて感じた海の大切さを人々に伝えたいと、仲間を集めて塩づくりをスタート。広島や沖縄などを巡って塩づくりを学び、そのなかで浜田の海水に合った現在の製法にたどりついた。地下に浸透した清浄な海水を原料に釜炊きで仕上げている。

TASTE!	ほどよいしょっぱさとうまみ、甘味のバランスがよい
おすすめ食材&料理	白菜やきゅうりなどの昆布漬け、白身魚の刺身

原産地 島根県

DATA
食塩相当量（96.5g）
ナトリウム 38.0g
形　状　凝集晶
水分量　標準
工　程　平釜
原材料　海水

価格／100g入り 400円
浜田の塩で生活する会
島根県浜田市瀬戸ヶ島町138-6
tel.0855-28-7212
http://hamamori-shop.com/

パワースポットの海水からできた塩

感謝の塩

広島

瀬戸内海国立公園の中心にある、パワースポットとしても有名な仙酔島でつくられている塩。満潮時の海水と、五色岩から流れる水の恵みを塩の中に閉じ込めている。豆腐などの淡泊で甘い食材に◎。ほかに、新月、満月の日につくった塩もそろう。

TASTE!	適度なしょっぱさの後にさらりとした薄い甘味
おすすめ食材&料理	豆腐、ひよこ豆のペースト、白身魚の刺身

原産地 広島県

DATA
食塩相当量（83.8g）
ナトリウム 33.0g
形　状　凝集晶
水分量　標準
工　程　平釜
原材料　海水

価格／400g入り 1200円
株式会社食は生命なり
広島県福山市曙町1-16-18
tel.084-954-4188
http://www.kansha.co.jp/

海水塩

salt column　「にがり」のじょうずな使い方

「にがり（苦汁）」とは塩を収穫した後に残る液体のこと。マグネシウムとカリウム、少しのナトリウムから構成されるミネラルの濃縮液で、「粗製海水塩化マグネシウム」という名で商品に使用される。とても苦いですが、少量では味に影響を与えないため、たんぱく質の凝固作用を利用して豆腐づくりによく使われます。また、炊飯時に3合に対して4～5滴加えるとご飯がふっくら炊き上がったり、浸透圧が高いので煮物に少量入れると、食材への味の染み込みがよくなったりなどの使い方があります。保湿力も高いため、バスソルト代わりに使うのもおすすめ。

自然との調和を大切にした塩
百姓の塩

山口

結晶を寝かせる杉樽。

原産地　山口県

DATA
形　状　凝集晶
水分量　しっとり
食塩相当量　——
ナトリウム　——
工　程　天日／平釜
原材料　海水

TASTE!
強めのしょっぱさ、厚みのある味。土の香り、あっさりした酸味

おすすめ食材&料理
大根の漬け物、根野菜など土もの野菜、焼おにぎり、野菜スープ

自然豊かな油谷島で自給自足を目指しながら、自然塩づくりに取り組む百姓庵。海と森の栄養が混ざり合う汽水域の海水を、流下式塩田と平釜で約20日間かけて濃縮・結晶させている。よく混ぜてミネラルバランスを整え、杉樽で寝かせて完成。自然の移ろいのままに、季節によって変わる塩の味わいを大切にしているという。ビーチクリーンや廃材利用など環境への配慮も欠かさない。

海水塩

価格／100g入り 1000円
百姓庵
山口県長門市
油谷向津具下1098-1
tel.0837-34-0377
http://hyakusho-an.com/

食材を包む口溶けのよい塩
Salann Oki サランオキ

島根

自然豊かな中ノ島。

原産地　島根県

DATA
形　状　凝集晶
水分量　標準
食塩相当量　91.4g
ナトリウム　36.0g
工　程　天日／平釜／天日
原材料　海水

TASTE!
強いが心地よい苦味、あっさりしたうまみ。余韻は短め

おすすめ食材&料理
塩鶏、生野菜にオイルとともに

島根半島沖60kmに浮かぶ隠岐諸島の中ノ島がこの塩の産地だ。「Salann」とはアイルランド語で塩のこと。明治時代この地を訪れ、こよなく愛したアイルランド人文学者・小泉八雲にちなんで命名された。対馬暖流の豊かな海から生まれた大きめの結晶は、口の中に入れるとふわりと溶け、ほどよいしょっぱさの後に、心地よい苦味とあっさりとしたうまみが広がり、スッと消える。

価格／35g入り 400円
株式会社 ふるさと海士
島根県隠岐郡
海士町福井1524-1
tel.08514-2-1105
http://www.shimakazelife.com/

あまみ

日本の完全天日塩づくりの先駆け

高知

専売制度の下、試験製造の許可を得て、塩職人・小島正明さんが1982年に創業。太平洋に臨む海岸線に建つ製塩所で、ネット式塩田を使って濃縮、その後ハウス内にずらりと並べた結晶箱に移し、毎日塩の様子をうかがいながら、太陽と風の力だけで結晶させている。しっかりとした甘味とうまみのなかにほどよい雑味がある、複雑で厚みのある味わい。

原産地 高知県

DATA
形状　立方体
水分量　しっとり
食塩相当量　89.0g
ナトリウム　35.0g
工程　天日
原材料　海水

TASTE!
しっかりとした甘味とうまみ、雑味

おすすめ食材&料理
乳製品や鶏肉などの白い食材を使った料理

価格／150g入り 457円
土佐のあまみ屋
高知県幡多郡黒潮町佐賀34
tel.0880-55-3402

土佐の塩丸

土佐の海を丸ごと閉じ込めたような力強さ

高知

雄大な自然を臨む製塩所。

カツオの1本釣りでも知られる土佐の黒潮町で、父の跡を継いだ2代目の吉田拓丸さんが手塩にかけて育てる完全天日塩。海水をすだれにかけ流して濃縮し、結晶箱の中で毎日撹拌しながら、太陽と風の力だけで結晶させる。火入れをしないため、マグネシウムがたっぷり残った塩は、しっかりした苦味と酸味を感じる。うまみもあり、野菜や発酵食品づくりに最適。

原産地 高知県

DATA
形状　フレーク
水分量　しっとり
食塩相当量　77.2g
ナトリウム　30.4g
工程　天日
原材料　海水

TASTE!
強めのしょっぱさ、しっかりした酸味と苦味。余韻にマグネシウム由来のうまみ

おすすめ食材&料理
野菜のグリル、発酵食品づくり、野菜の揚げ物

価格／200g入り 650円
有限会社ソルティーブ
高知県幡多郡黒潮町灘333
tel.0880-55-3226

海水塩

全国でも希少な入浜式塩田を復活

宇多津 入浜式の塩

香川

明治時代、宇多津町では塩づくりが盛んに行われていた。1988年に当時のシンボルでもあった入浜式塩田を復元。瀬戸内海の海水を使い、昔ながらの製法でつくられている。角がなくまろやかな味わいで、口の中でしっかり味が続く。

TASTE まろやかなしょっぱさ、長く続くしっかりした酸味。余韻には甘味
おすすめ食材&料理 乳製品を使った料理、鶏肉や少し脂ののった白身魚のソテー

原産地 香川県

DATA
食塩相当量（93.4g）
ナトリウム 36.8g
形 状 凝集晶
水分量 標準
工 程 天日／平釜
原材料 海水

価格／200g入り 482円
一般財団法人
宇多津町振興財団
香川県綾歌郡宇多津町浜一番丁4
tel.0877-49-0860
http://www.uplaza-utazu.jp/umihotaru

小豆島で塩づくりを復活

御塩
(ごえん)

香川

瀬戸内海に浮かぶ小豆島は、かつて赤穂に次ぐ製塩の地だったが、時代とともに衰退。近年、地元在住の蒲夫妻が復活させ、二人三脚で塩づくりを行っている。流下式塩田で濃縮した海水を平釜で仕上げた塩は、食材によくなじむよう粒の形にもこだわっている。

TASTE 一瞬強いしょっぱさがあり、酸味、甘味、うまみが続く
おすすめ食材&料理 トマトのフライなど濃厚な野菜の揚げ物、牛肉のステーキ

原産地 香川県

DATA
食塩相当量
ナトリウム
形 状 凝集晶
水分量 標準
工 程 天日／平釜
原材料 海水

価格／100g入り 520円
波花堂
香川県小豆郡
小豆島町田浦甲124
tel.0879-82-3665

力強く濃厚な甘味に圧倒される

SOLASHIO
(ソラシオ)

香川

古くは卑弥呼の時代から塩づくりが行われていたという、瀬戸内海の直島諸島でつくられる完全天日塩。高さ7mのタワーの中で、海水を噴霧し濃縮した後、ずらりと並んだ結晶箱の中に入れて結晶させている。にがりを多く含むため、まろやかで強い甘味が印象的。

TASTE 非常に強くて濃厚な甘味が長く続く
おすすめ食材&料理 塩スイーツ、塩パン、加熱すると甘くなる野菜、牛乳

原産地 香川県

DATA
食塩相当量 86.3g
ナトリウム 34.0g
形 状 立方体
水分量 しっとり
工 程 天日
原材料 海水

価格／100g入り 500円（税込）
NPO法人直島町観光協会
香川県香川郡
直島町2249-40
tel.087-892-2299
http://www.naoshima.net/omiyage/tokusan/

PART ❷ 海水塩、藻塩

四万十の山でできる完全天日海水塩

山塩小僧

高知

塩づくりに理想の環境を探し続けたどり着いたのは、四万十川中流の山奥の村。海水を山中まで運び、生い茂る木々によって適度にさえぎられたやわらかな光で、ゆっくりと濃縮・結晶させている。天日のみで仕上げるため、季節によっては収穫まで3か月かかる貴重な塩。

TASTE! 強めのしょっぱさ、強いがまるみのあるうまい苦味
おすすめ食材&料理 根菜の素揚げ、牛肉のカツレツ

原産地 高知県

DATA
食塩相当量　—　　形状　凝集晶
　　　　　　　　　水分量　しっとり
ナトリウム　—　　工程　天日
　　　　　　　　　原材料　海水

価格／240g入り 600円
塩の邑
高知県高岡郡
四万十町上岡95
tel.0880-26-0369

海水と天日と潮風だけでつくる

いごてつの天日塩

高知

土佐弁で酒豪や頑固で気骨のある男を意味する「いごっそう」な生産者、浜田哲男さんがつくり上げる完全天日塩。海水を山の上まで運び、ネット式塩田に流した後、毎日手で揉み込みながら、天日の力で濃縮・結晶させている。海そのままの力強い味。

TASTE! 強い酸味、しっかりしたしょっぱさ。後味においしい苦味
おすすめ食材&料理 脂の多い赤身、さつまいもの塩煮、ツナつくり

原産地 高知県

DATA
食塩相当量 86.0g　　形状　立方体
　　　　　　　　　　水分量　標準
ナトリウム 34.0g　　工程　天日
　　　　　　　　　　原材料　海水

価格／160g入り 500円
天日塩 いごてつ
高知県幡多郡
黒潮町佐賀上灘山3213-5
tel.0880-55-2828

柑橘のようなさわやかな酸味

りぐる

高知

太平洋に面した土佐の玉無しの浜の海水を、ネット式塩田で濃縮。その後、粗焚きしてカルシウムを取り除いてから、再度平釜に入れて、丸1日攪拌(かくはん)を続けながら結晶させるという、試行錯誤の末たどり着いた製法を採用している。酸味や甘味などバランスのよい塩。

TASTE! 柑橘のような甘酸っぱさ、心地よい苦味、ほどよいうまみ
おすすめ食材&料理 生の白身魚、豚肉や鶏肉のソテー、フルーツ

原産地 高知県

DATA
食塩相当量 91.3g　　形状　凝集晶
　　　　　　　　　　水分量　標準
ナトリウム 35.9g　　工程　天日／平釜
　　　　　　　　　　原材料　海水

価格／230g入り 400円
有限会社 海工房
高知県幡多郡
黒潮町浮鞭3369-13
tel.0880-43-1432

海水塩

まろやかなうまみと甘味の自然塩

海一粒

高知

黒潮町在住の女性たちによって結成された企業組合が手がける完全天日塩。ネット式塩田で濃縮した海水を、天日の力で少しずつ濃縮・結晶させる。濃度30%くらいまで高めてから収穫しているため、マグネシウムやカリウムがやや多めで、まろやかな甘味がある。

TASTE：まろやかな甘さ、濃厚なうまみ、ほどよい酸味、少しの苦み
おすすめ食材&料理：冷やしトマト、豚肉のグリルやソテー

原産地 高知県

DATA
食塩相当量（86.3g）
ナトリウム 34.0g
形 状 立方体
水分量 標準
工 程 天日
原材料 海水

価格／100g入り 360円（税込）
企業組合 ソルトビー
高知県幡多郡黒潮町熊野浦
tel.0880-55-2040
http://salt-bee.net/

原料は室戸岬沖1000mの深層水

室戸の塩

高知

原料の室戸海洋深層水は、室戸岬沖の深さ1000m地点を流れる深層水が壁にぶつかり、深さ約300m地点まで湧き上がってくる深層流を取水したもの。逆浸透膜と濃縮装置で濃縮し、さらに釜で1日かけて結晶させる。味は濃いがキレがよく後味はさっぱり。

TASTE：濃厚なうまみと甘味、まろやかなしょっぱさ、キレのよい酸味
おすすめ食材&料理：皮つきの鶏肉、脂ののった白身魚、スイカなどのウリ

原産地 高知県

DATA
食塩相当量 89.0g
ナトリウム 35.1g
形 状 凝集晶
水分量 標準
工 程 逆浸透膜／平釜
原材料 海水

価格／1000g入り 700円
室戸海洋深層水株式会社
高知県室戸市
室戸岬町3476-1
tel.0887-22-3202
http://www.e-mks.jp/

野菜に合う甘味とまろやかさ

室戸の海洋深層水 マリンゴールドの塩

高知

室戸岬沖の水深374m地点から汲み上げた海洋深層水の塩。逆浸透膜と平釜で結晶化した後、遠赤外線で加熱してフレーク状に仕上げている。マグネシウムが豊富なものの、苦味はなく、濃厚なうまみが印象的。キレのよい酸味で味の余韻は短めだ。

TASTE：まろやかなしょっぱさ、強めの酸味と甘味、濃厚なうまみ
おすすめ食材&料理：ドライ野菜、トマト、脂身の少ない赤身の肉や魚

原産地 高知県

DATA
食塩相当量 96.4g
ナトリウム 37.9g
形 状 フレーク
水分量 標準
工 程 逆浸透膜／平釜／乾燥
原材料 海水

価格／100g入り 380円
マリンゴールド株式会社
高知県室戸市
室戸岬町3507-22
tel.0887-23-3377
http://www.marine-gold.co.jp/

海の恵み"にがり"をほどよく残した塩

伯方の塩（粗塩）

愛媛

専売制度の下、オーストラリアやメキシコの天日塩を、昔ながらの枝条架式塩田でつくられた塩に近づけようと、日本の海水で溶かしてから濃縮・結晶させ、ほどよくにがりを含ませた。比較的低価格なので、漬け物などたくさん使いたい時にぴったり。

TASTE！ やや強めのしょっぱさ、後味にしっかりした苦味とうまみ
おすすめ食材&料理 とんかつや挽肉を使ったコロッケなどの揚げ物、漬け物

原産地 愛媛県、メキシコ、オーストラリア

DATA
食塩相当量 95.2g
ナトリウム 37.5g

形状 凝集晶
水分量 しっとり
工程 溶解／立釜／平釜
原材料 天日塩、海水

価格／1kg入り 370円
伯方塩業株式会社
愛媛県松山市大手町2-3-4
tel.089-943-4140
http://www.hakatanoshio.co.jp/

古代から伝わる直火製法を再現

海の愛（めぐみ）

愛媛

瀬戸内海で古墳時代初頭から行われていた直煮製法を忠実に再現し、瀬戸内海の海水を薪で焚いた平釜でじっくり濃縮・結晶させている。小さなフレーク状の結晶で、シャクシャクした食感が楽しい。強めの苦味は揚げ物に合わせたい。

TASTE！ かなり強いしょっぱさの後に生薬のような苦味。後味はすっきり
おすすめ食材&料理 とんかつなどの揚げ物、山菜のてんぷら

原産地 愛媛県

DATA
食塩相当量
ナトリウム

形状 フレーク
水分量 さらさら
工程 平釜
原材料 海水

価格／60g入り 380円
株式会社トモ企画
愛媛県松山市喜与町2-4-11
tel.089-931-4447
http://www.himenosato.com/

潮の香りがするサクサクの小さなフレーク塩

海部乃塩

徳島

黒潮の流れる雄大な太平洋を目の前に臨む製塩所。特製の多段式平釜を使用し、約1週間かけてじっくりと煮詰め、細やかなフレーク状の結晶を生み出す。サクサクとした食感で、噛むとふんわりと潮の香りが広がる。海藻を使った「かいふ藻塩」（p.109）も人気。

TASTE！ ほどよいしょっぱさ、潮の香り、雑味がなくクリア
おすすめ食材&料理 海藻を使った料理、青魚

原産地 徳島県

DATA
食塩相当量 81.3g
ナトリウム 32.0g

形状 フレーク
水分量 さらさら
工程 平釜
原材料 海水

価格／80g入り 600円
かいふ・そると
徳島県海部郡海陽町中山字チウゲ5
tel.0884-73-4140
http://www.kaifusalt.com/

海水塩

Sea salt Japan Map 九州〜沖縄

長い日照時間や海沿いの地理的利点から、塩づくりがもっとも盛んなエリアで、小規模でもこだわりの塩を手掛ける製塩所がいくつもあります。
長崎県の五島列島や熊本県の天草周辺、宮崎県の日向周辺では、平釜や天日を活用した製塩が多く行われています。また、製塩所数が全国一の沖縄県では、100種類以上の塩が生産されており、離島では生活排水に影響されない清浄な海水を得やすいことから、ひとつの島のなかに複数の製塩所があることもめずらしくありません。

海水塩

- 湧出の塩 →P.102
- 粟國の塩 釜炊き →P.97
- 海のほほえみ →P.105
- 球美の塩 →P.104
- 白銀の塩 厳選特上 →P.100
- 青い海 →P.102
- シママース →P.103
- まぐねしお →P.105
- あっちゃんの紅塩 →P.102
- 北谷の塩 →P.103
- うるわしの花塩 →P.103
- 太陽ぬ真塩 →P.104
- くがにまーしゅ 細塩 →P.99
- 石垣の塩 →P.98
- 雪塩 →P.100
- 屋我地島の塩 →P.101
- 屋我地マース →P.101
- もずくしお →P.109
- ぬちまーす →P.98
- 浜比嘉塩 →P.99
- ノエビア 南大東島の海塩N →P.104
- 満月の塩 福塩 →P.99

PART ❷ 海水塩、藻塩

- 浜御塩 → P.86
- 錦塩 → P.89
- 壱岐の塩 → P.89
- 海んまんま一の塩 さらさらタイプ → P.89
- 最進の塩 → P.88
- んまか塩 → P.87
- 梅花石の恵 関門の塩 → P.88
- 矢堅目の藻塩 → P.108
- つるみの磯塩 → P.91
- とっぺん塩 → P.87
- 月の塩 ダイヤモンド → P.91
- 五島灘の塩 本にがり仕立て → P.88
- 海みたま → P.92
- 通詞島の天日塩 → P.90
- 満潮の塩 → P.93
- はやさき 極上 → P.90
- 青島の塩 → P.93
- 天草の塩 小さな海 → P.90
- ロザリオ塩 → P.92
- 楽塩 → P.96
- 夢の塩 → P.93
- 百年の海 → P.92
- 猿蟹川の塩 → P.96
- 加計呂麻の塩 → P.95
- まぁさましゅ → P.96
- 屋久島永田の塩 えん → P.94
- ヨロン島の塩 じねん → P.94
- ヨロン島の塩 星の砂塩 → P.95

海水塩

対馬国定公園の清浄な海水でできた塩

浜御塩

長崎

専売制度の時代から塩づくりに携わってきた生産者が、その頃から培った製塩技術で、多彩な種類の塩を生産している。浜御塩の原料となる海水は、壱岐対馬国定公園内の、天然の海藻が生い茂る久須保の海から汲み上げている。外海に面しているため流れが早く、つねに清浄な海水が取水できるという。

海水を逆浸透膜で濃縮し、その後、数日間かけてネット式塩田に噴霧しながら太陽と風の力でさらに濃縮。塩職人の手で一昼夜かけて平釜で煮詰めて結晶させる。結晶を採取する濃度がやや高めなので、ナトリウム構成比が低く、マグネシウムやカルシウムを多めに含む。このエリアの塩には珍しく、油脂の多い乳製品のような甘味とうまみがあるため、塩スイーツづくりや、甘く仕上げたい塩おにぎりにおすすめ。アラメ、ホンダワラと合わせた藻塩や、フレーク状の結晶を集めたセルドフレークなどもある。

海水塩

DATA

食塩相当量	86.7g
ナトリウム	34.1g
カリウム	223mg
マグネシウム	953mg
カルシウム	640mg

原産地　長崎県
形　状　凝集晶
水分量　しっとり
工　程　逆浸透膜／天日／平釜
原材料　海水

TASTE!
適度なしょっぱさの後、バターのような油脂を感じる甘味とうまみ、厚みがある

おすすめ食材&料理
たまごや乳製品を使った料理、ミルクアイス、ブリなど青魚の塩焼き、塩おにぎり

価格　140g入り 250円
株式会社白松
長崎県対馬市
美津島町竹敷深浦4-133
03-5570-4545(東京本社)
http://www.hakumatsu.co.jp/

PART ❷ 海水塩、藻塩

対馬海流の黒潮の天日塩

とっぺん塩

長崎

清澄な海水が原料。

原産地
長崎県

DATA

形　状	凝集晶
水分量	標準
食塩相当量	89.0g
ナトリウム	35.0g
工　程	天日
原材料	海水

TASTE!
ほどよいしょっぱさ、強めの苦味と酸味の後にうまみがじんわり

おすすめ食材&料理
脂ののった魚の塩焼き、白身魚のフライ

「とっぺん」とは、長崎県五島列島の方言で「頂上」「一番」という意味。対馬海流のなかに位置する五島列島を流れる黒潮を取水し、ネット式塩田にかけ流して濃縮した後、温室ハウス内のパレットに入れて、太陽の熱だけで結晶させている。1tの海水から15kgほどしかとれない希少な完全天日塩。苦味と酸味を感じる塩は魚介類や揚げ物に。余韻にうまみが広がる。

価格／140g入り 278円
とっぺんフーズ
長崎県佐世保市
牧の地町1499-5
tel.0956-41-4104

海水塩

にがりが残る五島灘のフレーク塩

んまか塩

長崎

原産地
長崎県

DATA

形　状	フレーク
水分量	さらさら
食塩相当量	81.4g
ナトリウム	（32.0g）
工　程	天日／平釜
原材料	海水

TASTE!
強めのしょっぱさ、おいしい苦味、後味に薄い甘味があり、余韻は短め

おすすめ食材&料理
山菜のてんぷら、とんかつや白身魚のフライ、海藻を使った料理

1年中海風がふき、きれいな海水が取水できるため、古くから塩づくりが行われてきた五島列島。中通島と頭ヶ島の間の海峡から、上げ潮の際にたっぷり流れてくる新鮮な海水を汲み上げている。立体式塩田を使って濃縮し、弱火でじっくりと結晶させる。適度ににがりを残しているので、おいしい苦味を感じられる。カルシウムが多く、細かなフレーク状の結晶でシャクシャクした食感も楽しい。

価格／180g入り 400円
ユリヤ製塩所
長崎県南松浦郡
新上五島町榎津郷145-1
tel.0959-54-2407
http://www.salt-meister.com/

揚げ物と相性バッチリのしょっぱさと酸味

最進の塩

福岡

本州最西端に位置する玄界灘、下関吉母ヶ浜沖の入江から汲み上げた海水100％の自然塩。特許製法の多段式平釜で時間をかけて濃縮・結晶させている。舌先でシュワッと素早く溶け、最初に強めのしょっぱさとしっかりした酸味を感じる。

原産地 福岡県

DATA
食塩相当量 84.1g
ナトリウム 33.1g
形　状 凝集晶
水分量 標準
工　程 平釜
原材料 海水

TASTE：強めのしょっぱさ、しっかりした酸味、あっさりしたうまみ
おすすめ食材&料理：とんかつなどの揚げ物、牛肉の下味、さんまの塩焼き

価格／300g入り 580円
株式会社最進の塩
福岡県北九州市小倉北区西港町94-22
tel.093-571-4140
http://www.saishinnosio.com/

天然記念物の岩層下に眠る深層水の塩

梅花石の恵 関門の塩

福岡

福岡県の天然記念物に指定される、約3億年前の岩層・梅花石下の深層1200mに沈む海洋深層水が原料。逆浸透膜で濃縮した後、立釜で濃縮・結晶させた塩は、ほどよくにがりが残り、まろやかなしょっぱさの後に、ほのかな苦味を感じる。

原産地 福岡県

DATA
食塩相当量 86.1g
ナトリウム 33.9g
形　状 立方体
水分量 標準
工　程 逆浸透膜／立釜
原材料 海水

TASTE：まろやかなしょっぱさ、ほのかな苦味、余韻の短いうまみ
おすすめ食材&料理：塩焼きおにぎり、野菜のグリル

価格／100g入り 360円
ヤロン株式会社
福岡県北九州市門司区白野江546-1
tel.093-341-3322
http://www.baikaseki.jp/

後味さっぱり、赤身や揚げ物向けの塩

本にがり仕立て 五島灘の塩

長崎

長崎県西端の五島灘に面した崎戸町の海水をイオン膜に通して濃縮し、立釜で結晶させてできた海水塩に、クエン酸鉄アンモニウムをブレンドしている。クエン酸鉄由来の強い酸味と苦味が、赤身の肉や魚、揚げ物にぴったり。

原産地 長崎県

DATA
食塩相当量 94.0g
ナトリウム 37.0g
形　状 立方体
水分量 しっとり
工　程 イオン膜／立釜／混合
原材料 海水、クエン酸鉄アンモニウム

TASTE：適度なしょっぱさ、強い酸味と苦味、後味に薄く苦味が続く
おすすめ食材&料理：梅干しづくり、脂ののったマグロやカツオの炙り、牛肉のグリル

価格／500g入り 150円
株式会社菱塩
長崎県西海市崎戸町蛎浦郷字1517-3
tel.0959-35-3540

壱岐島でできた昔ながらの海水塩

壱岐の塩

長崎

九州の北、玄界灘に浮かぶ壱岐島の海水塩。壱岐沖のきれいな海水を汲み上げ、逆浸透膜で濃縮した後、平釜で濃縮・結晶させている。粒に含まれるマグネシウムから苦味を強く感じるため、揚げ物の油っこさが緩和され、さっぱりと食べられる。

TASTE！ やや強めのしょっぱさ、後味に長く続く苦味
おすすめ食材&料理 山菜や癖のある葉野菜、揚げ物

原産地 長崎県

DATA
食塩相当量（90.6g）
ナトリウム 35.7g
形状 凝集晶
水分量 標準
工程 逆浸透膜／平釜
原材料 海水

価格／160g入り 550円（税込）
株式会社なかはら 食品事業部
長崎県壱岐市
芦辺町瀬戸浦1245
tel.0120-611-401

雑味のないクリアな味わい

錦塩（きんじお）

長崎

環境王国にも認定されるほどの美しい海と豊富な魚類に恵まれた対馬で生産される海水塩。専売制度前の製法を再現し、平釜で濃縮した後、天日で結晶させている。雑味が少なくすっきりとした透明感がある味わい。口に含むとさわやかな潮の香りが鼻に抜ける。

TASTE！ 適度なしょっぱさ、潮の香り、透明感がある
おすすめ食材&料理 白身魚や貝を使ったスープ、白身魚の塩煮

原産地 長崎県

DATA
食塩相当量
ナトリウム
形状 粉砕
水分量 標準
工程 平釜／天日
原材料 海水

価格／140g入り 400円（税込）
富浦天然塩工房
長崎県対馬市
上対馬町唐舟志565-1
tel.0920-86-3320

甘味とうまみを感じる対馬暖流の海水塩

海んまんま 一の塩 さらさらタイプ

佐賀

佐賀県加唐島（かから）にある製塩所がつくる海水塩。呼子沖を流れる暖流の対馬海流の海水を汲み上げ、成分を損なわないよう60℃の低温で結晶させ、さらに140℃の温風でさらさらに仕上げている。ねっとりとした甘味が特徴で、たまごの黄身と相性がよい。しっとりタイプも。

TASTE！ 適度なしょっぱさ、粘度を感じる甘味、後味にうまみ
おすすめ食材&料理 ゆでたまご、加熱すると甘くなる野菜、日本酒

原産地 佐賀県

DATA
食塩相当量 91.5g
ナトリウム 36.0g
形状 凝集晶
水分量 さらさら
工程 逆浸透膜／立釜／乾燥
原材料 海水

価格／250g入り 534円
一の塩株式会社
佐賀県唐津市
鎮西町加唐島730-2
tel.0955-51-1140
http://www.ichinoshio.jp/

海水塩

だしのようなうまみたっぷりの完全天日塩

はやさき 極上

熊本

イルカが生息する自然豊かな天草・通詞(つうじ)島の完全天日塩。高さ6mの立体式塩田で濃縮し、ハウス内で太陽の力だけで結晶させる。海水の有機物を加熱で損なうことなく、まるごと結晶にした塩は、だしのようなうまみと乳製品のような甘さがある。

TASTE：やや強めのしょっぱさ、だしのようなうまみ、おいしい苦味と甘味
おすすめ食材&料理：乳製品や白身の魚・鶏肉など白い食材、汁物の味つけ

原産地 熊本県

DATA
食塩相当量 ー
ナトリウム ー
形 状 立方体
水分量 標準
工 程 天日
原材料 海水

価格／250g入り 760円
自然食品研究会
熊本県天草市五和町二江106
tel.0969-33-0610
http://hayasaki-shio.sakura.ne.jp/

摘みたての草のようなフレッシュな香り

通詞(つうじ)島の天日塩

熊本

通詞島沖250mを流れる海水を汲み上げ、ネット式塩田と結晶箱を使い、太陽と風の力だけで濃縮・結晶させた完全天日塩。フレッシュな青い草の香りを感じる独特の味わいで、オリーブオイルと相性抜群。粒が大きいので、ミルで挽くか、食感を活かして仕上げの塩に。

TASTE：かなり強いしょっぱさ、酸味、ほどよい苦味、草の香り
おすすめ食材&料理：フォカッチャ、白身魚の刺身や野菜にレモンとオイルとともに

原産地 熊本県

DATA
食塩相当量 (93.4g)
ナトリウム 36.8g
形 状 立方体
水分量 さらさら
工 程 天日
原材料 海水

価格／200g入り 700円
有限会社ソルト・ファーム
熊本県熊本市中唐人町29
tel.096-355-4140

1週間かけて炊き上げる天草の自然塩

天草の塩 小さな海

熊本

天草下島の西海岸・東シナ海の海水を汲み上げ、ネット式塩田で10%まで濃縮、かん水(濃縮海水)を足しながら1週間かけて鉄釜で炊き上げている。角のないしょっぱさにうまみが重なる味で、味噌などの発酵食品づくりにもおすすめ。

TASTE：適度なしょっぱさとうまみ、酸味に加え、海水の苦味もある
おすすめ食材&料理：脂肪分をやや含んだ赤身の魚、白身の魚、発酵食品づくり

原産地 熊本県

DATA
食塩相当量 (88.9g)
ナトリウム 35.0g
形 状 立方体
水分量 しっとり
工 程 平釜
原材料 海水

価格／240g入り 470円
天草塩の会
熊本県天草市天草町大江1448
tel.0969-42-5477

新雪のような純白の結晶

つるみの磯塩

大分

原産地 大分県

DATA
形　状　凝集晶
水分量　標準
食塩相当量（86.3g）　工　程　平釜
ナトリウム　34.0g　原材料　海水

TASTE!
適度なしょっぱさ、はっきりした甘味。ミルキーな印象

おすすめ食材&料理
乳製品を使った料理、白子のてんぷら、加熱したたまねぎ

サンワールドつるみ、大分大学、佐伯メカトロセンターの産学官の連携によって誕生した海水塩。鶴見町丹賀浦の海岸で汲み上げた海水を、蒸気の熱で温めながら濃縮・結晶させている。石灰質などの不溶解分を徹底して取り除いているため、結晶は白く、舌ざわりがなめらか。微粒でふわふわとした結晶は、水に溶けやすく、素材への浸透も早いので、下ごしらえにも適している。

価格／185g入り 540円
有限会社サンワールドつるみ
大分県佐伯市
鶴見大字丹賀浦577
tel.0972-34-5522

九州No.1の水質を誇る下阿蘇生まれ

月の塩 ダイヤモンド

宮崎

原産地 宮崎県

ていねいに灰汁をすくう。

DATA
形　状　凝集晶
水分量　標準
食塩相当量（96.5g）　工　程　逆浸透膜／平釜
ナトリウム　38.0g　原材料　海水

TASTE!
適度なしょっぱさ、ほのかな甘味。透き通った味で、余韻はすーっと消えていく

おすすめ食材&料理
白身の魚の刺身、淡泊な野菜。辛口の日本酒のつまみ

かつて揚浜式塩田で知られた延岡市北浦町の海岸沿いに、「道の駅北浦」併設の製塩施設と塩の博物館が誕生した。環境省の「全国快水浴場百選・海の部特選」にも選定され、水質が九州一ともいわれる下阿蘇ビーチの海水を、逆浸透膜で濃縮。海水を足しながら平釜で煮詰めている。少量しか採れない大粒の結晶は、繊細で、透明感のあるすっきりした味わい。

価格／100g入り 555円
道の駅 北浦
北浦産業株式会社
宮崎県延岡市
北浦町古江3337-1
tel.0982-45-3811
http://michinoeki-kitaura.com/

海水塩

山のミネラルも含んだ力強い塩

ロザリオ塩

熊本

東シナ海から流れる黒潮に、天草の山々から川を通じて山のミネラルが流れ込む場所で塩づくりを行っている。ネット式塩田で濃縮し、その後天日で結晶させたこの塩は、強めのしょっぱさと、日光をいっぱい浴びた天日塩らしい酸味を感じる。

TASTE! 強めのしょっぱさと酸味、後口にうまみ
おすすめ食材&料理 大トロなど脂ののった赤身魚、トマト

原産地 熊本県

DATA
食塩相当量 (86.3g)
ナトリウム 34.0g
形状 凝集晶
水分量 標準
工程 天日
原材料 海水

価格／180g入り 600円
天草ロザリオ塩
熊本県天草市河浦長今富516
tel.0969-79-0400

天草の海水から生まれた完全天日塩

百年の海

熊本

「ナトリウム以外のミネラルを含む人間の身体に優しい塩がつくりたい」との思いから生まれた完全天日塩。天草の海水を天日で濃縮・結晶させた塩は、余韻が短くスッと消えていくきれいな味。口の中で次々と味が変化し、さわやかな潮の香りが鼻に抜ける。

TASTE! 適度なしょっぱさと少しの苦み。強めの酸味とうまみ
おすすめ食材&料理 ドライ野菜、トマト、赤身魚の揚げ物

原産地 熊本県

DATA
食塩相当量 97.5g
ナトリウム 38.4g
形状 立方体
水分量 しっとり
工程 天日
原材料 海水

価格／100g入り 500円
ユア・ハーベスト株式会社
福岡県福岡市博多区店屋町6-3
tel.0120-35-0821

山と海のミネラル豊富なしっとり塩

海みたま

宮崎

漁業も営む生産者が、山から水が流れ込む無人島の砂浜まで船を出し、清澄な海水を取水。ネット式塩田で太陽と風の力を活用して濃縮し、薪で熱した鉄釜で煮詰めている。小粒のしっとりした質感で、鉄由来の酸味をはっきりと感じる。脂ののったマグロに合わせたい。

TASTE! 後味に強めの鉄由来の酸味。ほどよい苦みと雑味
おすすめ食材&料理 脂ののった牛肉やマグロなど、赤身の肉や魚

原産地 宮崎県

DATA
食塩相当量 90.5g
ナトリウム 35.6g
形状 凝集晶
水分量 しっとり
工程 天日／平釜
原材料 海水

価格／150g入り 400円
株式会社 日高純塩
宮崎県延岡市北浦町古江3175
tel.0982-45-2709
http://umimitama.jimdo.com／

男のロマンを実現した宮崎の海水塩

夢の塩

宮崎

県の南端・串間市でヒラメ養殖業を営む傍ら、かねてからの夢である自然塩づくりを実現。都井岬沖を流れる黒潮の海水を、薪で焚いた平釜で1週間じっくり煮詰めて仕上げている。昔ながらの製法ででき上がった塩は、しょっぱさと適度な甘味が共存する。

原産地 宮崎県

DATA
食塩相当量 (93.9g)
ナトリウム 37.0g
形 状 凝集晶
水分量 標準
工 程 平釜
原材料 海水

価格／90g入り 278円
有限会社 大田商店
宮崎県串間市大字西方14934
tel.0987-72-0626

TASTE! しっかりした甘み。雑味の後、濃いめのうまみ、余韻は短め
おすすめ食材&料理 塩おにぎり、加熱すると甘くなる野菜のグリル

満潮時の海水をじっくり炊き上げる

満潮の塩

宮崎

日向市の平岩海岸で、満潮時の海水を汲み上げ、逆浸透膜で濃縮した後、平釜で45時間煮詰めて濃縮・結晶させた海水塩。口の中ですーっと溶ける、ふわふわしたやわらかな結晶で、雑味がなくクリアな味わい。焼成で仕上げたさらさらの焼塩もある。

原産地 宮崎県

DATA
食塩相当量 88.6g
ナトリウム 34.9g
形 状 凝集晶
水分量 標準
工 程 逆浸透膜／平釜
原材料 海水

価格／400g入り 660円
宮崎サン・ソルト株式会社
宮崎県日向市大王町2-23-2
tel.0982-53-1713
http://www.sun-salt.co.jp/

TASTE! 適度なしょっぱさ、まるみのある甘味と苦味。余韻はすっきり
おすすめ食材&料理 脂のあまりない白身の魚の塩釜焼き、きゅうりの浅漬け

日向灘の海を炊き上げた力強い塩

青島の塩

宮崎

日向灘に面した青島は、古くは青島神社の神職しか入島できなかったという。波の形に連なる奇岩「鬼の洗濯板」に囲まれた聖なる青島の沖合いで汲み上げた海水が原料。平釜で煮詰めて濃縮・結晶させた塩は、雑味や苦味のある力強い味わいに仕上がっている。

原産地 宮崎県

DATA
食塩相当量
ナトリウム
形 状 凝集晶
水分量 標準
工 程 平釜
原材料 海水

価格／85g入り 300円
塩工房
宮崎県宮崎市青島5-11-1
tel.0985-65-1616

TASTE! 生薬のような苦味、はっきりとした酸味、尖った雑味がある
おすすめ食材&料理 赤身の魚や肉の揚げ物やオイルを使ったソテー

海水塩

静かな屋久島の集落でつくる海水塩

屋久島永田の塩 えん

鹿児島

原産地 鹿児島県

DATA
形 状	凝集晶
水分量	標準
食塩相当量	87.2g
ナトリウム	34.3g
工 程	平釜
原材料	海水

TASTE!
強めのしょっぱさと雑味。鉄のような酸味と苦味

おすすめ食材＆料理
牛肉のグリル、マグロやカツオの刺身

永田岳を臨む屋久島の北西部の小さな集落にある製塩所。ウミガメが産卵に訪れる浜としても知られる永田浜の海水を汲み上げ、屋久島の杉などの木材でステンレス釜を熱して濃縮・結晶している。やや大きめの粒を口に入れると、しっかりとした強いしょっぱさの後に鉄のような酸味がじんわり広がる。焼いた赤身の肉に振りかけたり、マグロなど赤身の刺身につけるとうまみが引き立つ。

価格／150g入り 430円
塩作りのわ 渡辺 忠
鹿児島県熊毛郡
屋久島町永田369-8
tel.0997-45-2338
http://www.shiotsukuri00.jp/

珊瑚礁の島与論島生まれの純白の結晶

ヨロン島の塩 じねん

鹿児島

原産地 鹿児島県

DATA
形 状	凝集晶
水分量	標準
食塩相当量	92.2g
ナトリウム	36.2g
工 程	平釜／乾燥
原材料	海水

TASTE!
はっきりとした酸味、ほどよいしょっぱさ、後味に甘味。焦げのような風味

おすすめ食材＆料理
牛肉・マグロなどの赤身の食材で、特に脂肪の多い部位

珊瑚礁の楽園といわれる与論島で、満潮時の海水を原料につくる自然塩。工程は珊瑚の白砂の下に通したパイプから海水を汲み上げることからはじまる。これは砂に海水を通すことで不純物が自然にろ過されるからだ。平釜で炊き上げた後、さらに不純物を取り除いて美しい純白の結晶に仕上げる。珊瑚由来のカルシウムをたっぷり含むので、甘さのある後味とはっきりした酸味に加え、ざらっとした舌触りがある。

価格／150g入り 420円
株式会社ヨロン島
鹿児島県大島郡
与論町古里64-1
tel.0997-97-3599
http://www.yoronto.net/

クリアな味わいの海洋深層水の塩

ヨロン島の塩 星の砂塩

鹿児島

美しい与論島の海

鹿児島県の最南端、与論島沖の水深500mから汲み上げた海洋深層水からつくられた塩。良質な水を求めて、島から20〜40kmの海域へ船を出し取水するという。逆浸透膜で濃縮した後、平釜に入れ沸騰させずに約30時間じっくり炊き上げると、フレーク状の大きな結晶ができ上がる。カルシウム分が多めで、ざらっとした食感。柑橘類を思わせるさわやかな苦味と厚みのあるしょっぱさがある。

原産地　鹿児島県

DATA

形　状	フレーク
水分量	標準
食塩相当量	86.7g
工　程	逆浸透膜／平釜／乾燥
ナトリウム	34.1g
原材料	海水

TASTE!
厚みのあるしょっぱさ、柑橘の皮のような苦味。雑味の後に甘味がくる。キレがよく後味すっきり

おすすめ食材&料理
グレープフルーツやレモンなど酸味と苦味のあるフルーツ、苦味のある野菜、揚げ物

価格／85g入り 380円
株式会社福山物産
鹿児島県霧島市
溝辺町崎森2770-3
tel.0995-58-2905
http://www.kurozuya.co.jp/

海水塩

奄美群島の小さな島から届く海水塩

加計呂麻(かけろま)の塩

鹿児島

奄美群島のひとつ、人口1400人ほどの小さな島・加計呂麻島。島内の集落がないエリアを選んで製塩所をつくり、生活排水が入り込まない沖合い800mを流れる黒潮を水深30m地点から汲み上げる。清澄な海水は1週間かけ太陽と風の力で濃縮、平釜で4日間炊いて結晶させている。手間をかけてつくられた塩は、甘味とうまみがじんわり広がり、味わい深い。食感も楽しめる形状。

原産地　鹿児島県

DATA

形　状	フレーク
水分量	さらさら
食塩相当量	(76.7g)
工　程	平釜
ナトリウム	30.2g
原材料	海水

TASTE!
ほどよいしょっぱさ、おいしい苦味と雑味、うまみと甘味の余韻が続く

おすすめ食材&料理
葉野菜のサラダ、イカやタイなど白身の刺身、たけのこ、きのこ類

価格／250g入り 700円
加計呂麻塩技研
鹿児島県大島郡
瀬戸内町嘉入241
tel.0997-75-0071

一風変わった製法の珊瑚礁の塩

まぁさましゅ

鹿児島

奄美群島の中央、闘牛で知られる徳之島。この塩は、珊瑚礁の干潟にできた潮だまりの海水を、太陽で熱せられた岩にかけて濃縮し、平釜で煮詰める一風変わった製法でつくられている。強いしょっぱさのなかに酸味やうまみを感じる、揚げ物にぴったりの塩。

TASTE！ 強い酸味の後にうまみ。すっきりした甘さで、短めの余韻
おすすめ食材&料理 ビーフカツレツ、とんかつ、揚げだし豆腐

原産地 鹿児島県

DATA
食塩相当量 (93.2g)
ナトリウム 36.7g
形 状 凝集晶
水分量 標準
工 程 天日／平釜
原材料 海水

価格／100g入り 665円
ジャパンソルト株式会社
東京都中央区京橋1-1-1
八重洲ダイビル5F
tel.0120-16-4083

種子島の太陽を浴びて生まれた海の結晶

猿蟹川（さるかんごう）の塩

鹿児島

種子島の障がい者の自立を目指す支援施設で、4～10月の間だけつくられている完全天日塩。太平洋に面した乗浜海岸沖で海水を汲み上げ、枝条架式塩田で濃縮。天日ハウスに移して太陽の力だけで結晶させている。海水そのものの、やさしい酸味と甘味のある塩。

TASTE！ 適度なしょっぱさ、心地よい酸味と甘味が続く
おすすめ食材&料理 冷やしトマト、ゆでたまご、海老の塩焼き、手羽先のから揚げ

原産地 鹿児島県

DATA
食塩相当量 86.3g
ナトリウム 34.0g
形 状 凝集晶
水分量 しっとり
工 程 天日
原材料 海水

価格／100g入り 500円
社会福祉法人 百合砂
共生工房 猿蟹川
鹿児島県熊毛郡
中種子町納官4093-7
tel.0997-24-8121

しょっぱさ、うまみ、苦味の三拍子がそろう

楽塩（らくえん）

鹿児島

九州最南端、佐多岬沖の海水を、薪で焚いた平釜で約30時間沸騰させずに加熱しながら、濃縮・結晶させている。しっかりと灰汁抜きして仕上げた塩は、ふわっとした食感で口溶けも◎。食材の宝庫鹿児島で「食を楽しんでほしい」という思いが名に込められている。

TASTE！ 弱めのしょっぱさ、心地よい甘味と酸味
おすすめ食材&料理 乳製品を使った料理、野菜の素揚げ

原産地 鹿児島県

DATA
食塩相当量 82.2g
ナトリウム 32.0g
形 状 凝集晶
水分量 標準
工 程 平釜
原材料 海水

価格／100g入り 287円
株式会社 サウスマックス
鹿児島県肝属郡
南大隅町根占山本4108
tel.0994-24-5308

粟國の塩 釜炊き

40年かけて育まれた体にやさしい塩

沖縄

しょっぱさ：7　酸味：6
苦味：7　うま味：8
雑味：6　甘味：6

海水塩

DATA

食塩相当量	71.7g
ナトリウム	28.2g
カリウム	550mg
マグネシウム	1530mg
カルシウム	550mg

原産地　沖縄県

形　状　凝集晶
水分量　しっとり
工　程　天日／平釜
原材料　海水

TASTE!
しょっぱさ、うまみ、甘味、酸味、苦味、雑味が次々と口の中で広がる。どっしりと厚みのある味

おすすめ食材＆料理
豚肉の塩漬け、秋刀魚の塩焼き。スポーツドリンクづくりに、塩おにぎり

大きな平釜を薪で焚く。濃縮海水が焦げないよう、常にかき混ぜながら、30時間かけて炊き上げる。

価格／160g入り 500円
株式会社 沖縄海塩研究所
沖縄県島尻郡粟国村字東8316
tel.098-988-2160
http://www.okinawa-mineral.com/

　専売制度の下、全国の有志とともに自然塩復興運動に尽力した読谷村出身の小渡幸信さんが、理想の環境を探してたどり着いたのが沖縄本島からおよそ60km離れた離島・粟国島。1995年、目の前に美しい海が広がる島の北端に製塩所を構えた。1万5000本もの竹枝を使って高さ10mに組んだ立体式の塩田タワーは圧巻で、粟国の風が効率よく流れるよう、向きや大きさなどが考えぬかれた設計だ。そこに海水をかけ流し1週間ほどかけて濃縮、薪で焚いた平釜で煮詰めて結晶させている。
　体にやさしい塩をつくりたいという小渡さんの思いが込められた結晶は、海水のミネラルをバランスよく取り込むよう、独自の技法でじっくりにがりをなじませている。にがりをよく含むため、ナトリウム構成比も非常に低いうえ、まろやかで滋味深い塩に仕上がる。

大地と海のミネラルを含んだ石垣の塩

石垣の塩

沖縄

製塩所前の、石垣の塩ビーチ。

原産地
沖縄県

DATA
形　状	凝集晶
水分量	標準
食塩相当量	86.3g
工　程	逆浸透膜／平釜
ナトリウム	35.0g
原材料	海水

TASTE!
まろやかなしょっぱさで、酸味が少なく、強いコクと甘味を感じる

おすすめ食材&料理
塩おにぎり、生野菜のつけ塩に。食材にうまみと甘味を付加する

海水塩

石垣の塩がつくられているのは、沖縄県の最高峰・於茂登岳を望む名蔵湾。ラムサール条約の保護地区にも認定されている湾の沖1.5km、水深20mの地点で取水している。大きな川がない沖縄の塩にはめずらしく、川を通じて流れ込む大地のミネラルも含んだ海水を、逆浸透膜で濃縮、蒸気を使い3日かけて低温でじっくり結晶に仕上げている。コク深い味で、粒が小さく食材になじませやすい。

価格／200g入り 680円（税込）
株式会社石垣の塩
沖縄県石垣市新川1145-57
tel.0980-83-8711
http://www.ishigakinoshio.com/

独自の特許製法で実現したさらさらの塩

ぬちまーす

沖縄

敷地内の絶景スポット・果報バンタ。

原産地
沖縄県

DATA
形　状	パウダー
水分量	さらさら
食塩相当量	73.9g
工　程	逆浸透膜／噴霧乾燥／焼成
ナトリウム	29.1g
原材料	海水

TASTE!
一瞬しょっぱさを強く感じるものの、すぐにまろやかさが広がる。甘味、苦味、潮の香り

おすすめ食材&料理
食材の下ごしらえ、白身魚の塩煮、パン・お菓子づくりに

創始者が蘭栽培からヒントを得て生み出した、パウダー状の塩。製塩所はパワースポットとしても知られる、うるま市宮城島の崖上だ。空中で一瞬にして海水を結晶化させる特許製法は、すでに10か国で特許を取得している。にがりを含んだまま結晶させるため、多くの微量ミネラルを含む分、ナトリウム構成比が低く、まろやかな甘み。健康を気にする人に特に人気が高い。

価格／150g 1000円
株式会社ぬちまーす
沖縄県うるま市
与那城宮城2768
tel.098-983-1111
http://www.nutima-su.com/

海の力が強くなる満月の日の海水塩

満月の塩 福塩

沖縄

マングローブが生い茂る宮古島の内海で、満月の満潮時の海水のみを使用した海水塩。薪で焚いた平釜で炊き上げている。取水日を選んでいるのは、満月の日は生物の産卵が多くなるほど、海の力が強くなるから。全体的に力強い味わいで、オイル料理におすすめ。

TASTE! 力強いしょっぱさとしっかりした雑味
おすすめ食材&料理 豆類、小松菜など個性の強い葉野菜、鮎の塩焼き

原産地 沖縄県

DATA
食塩相当量 95.2g
ナトリウム 37.5g
形状 凝集晶
水分量 標準
工程 天日／平釜
原材料 海水

価格／150g入り 500円
大福製塩
沖縄県宮古島市
平良字島尻295
tel.0980-72-1132

「ショーカン（神の塩）」と呼ばれる塩

くがにまーしゅ 細塩

沖縄

手つかずの自然が多く残る多良間島（たらま）の海水を、あえて手を加えずそのまま結晶箱に入れ、太陽と風の力だけで濃縮・結晶させるという自然そのものの希少な海水塩。日照時間が短い沖縄で、数か月かけて結晶を育てる。太陽の香りともいえる酸味と、濃厚なうまみが特徴だ。

TASTE! しっかりしたしょっぱさと酸味、強いコク
おすすめ食材&料理 牛肉のグリル、トマトを使った料理

原産地 沖縄県

DATA
食塩相当量 (85.3g)
ナトリウム 33.6g
形状 立方体
水分量 しっとり
工程 天日
原材料 海水

価格／30g入り 300円
多良間海洋研究所
沖縄県宮古郡
多良間村字仲筋2351-7
tel.0980-79-2500

潮の香りただよう沖縄の海の結晶

浜比嘉塩（はまひが）

沖縄

琉球のはじまりとも伝わる浜比嘉島で、枝条架式塩田を使った塩づくりをしている（p.14）。にがりにこだわり、苦みとしょっぱさのバランスを考えながら、ほどよくにがりを残した塩に仕上げる。口に含むと潮の香りが鼻に抜け、ミネラル感をしっかり感じる。

TASTE! 潮の香りとミネラル感がある。ほどよい苦味とコクも
おすすめ食材&料理 マグロやカツオなどの赤身の魚、脂ののった白身魚、海藻類

原産地 沖縄県

DATA
食塩相当量 96.0g
ナトリウム 37.8g
形状 凝集晶
水分量 しっとり
工程 天日／平釜
原材料 海水

価格／100g入り 300円
株式会社高江洲製塩所
沖縄県うるま市勝連比嘉1597
tel.098-977-8667
http://hamahigasalt.com/

海水塩

まろやかでまっ白なパウダー塩

雪塩（ゆきしお）

沖縄

透明で美しい宮古島の海。

沖縄本島から南西に300km、宮古島の琉球石灰岩に浸透した地下海水を汲み上げてつくるパウダー状の海水塩。濃縮した海水を熱したドラムに噴霧して、瞬間的に水分を飛ばし、通常分離してしまうにがりを含んだまま結晶に仕上げる。片栗粉のような質感で食材になじみやすく、乳製品のような酸味があるため、塩スイーツづくりにぴったりだ。ナトリウム構成比が低いので、塩分が気になる人にも◯。

海水塩

原産地 沖縄県

DATA
形　状　パウダー
水分量　さらさら
食塩相当量　76.9g
ナトリウム　30.3g
工　程　逆浸透膜／加熱ドラム
原材料　海水

TASTE!
一瞬強く感じるが、まろやかなしょっぱさ。乳製品のような酸味

おすすめ食材＆料理
食材の下ごしらえ、乳製品を使った料理、ミルクアイス

価格／60g入り 350円
株式会社パラダイスプラン
沖縄県宮古島市平良字久貝870-1
tel.0120-408-385
http://www.yukisio.com/

そのまま酒のつまみにも。

白銀の塩 厳選特上

沖縄

国内では最も深い水深612m地点から取水された海洋深層水を原料に生産される塩。大人がすっぽり収まるほど大きな信楽焼きの土釜で、直火を使わずに間接的に熱を加え、徐々に結晶させていく。その中でも、粒が大きく育ったものだけを集めた希少品。まろやかなしょっぱさで濃厚なうまみ。酸味もあり、後味はクリア。

原産地 沖縄県

DATA
形　状　立方体
水分量　さらさら
食塩相当量　91.44g
ナトリウム　36.0g
工　程　逆浸透膜、平釜
原材料　海水

TASTE!
まろやかなしょっぱさで濃厚なうまみを感じる。酸味もあり後味はすっきり。

おすすめ食材＆料理
鶏肉料理。トマトや加熱したたまねぎなど味が濃い野菜。日本酒のつまみに。

価格／55g入り 800円
株式会社沖縄全薬
沖縄県宜野湾市新城2-9-2
tel.098-892-3986
http://www.okizen.co.jp/

オレンジ色に染まるふわふわの結晶塩

屋我地島の塩
やがじ

沖縄

沖縄北部、屋我地島の済井出ビーチの海水を天日で濃縮した後、鉄製の釜でじっくり煮詰めて仕上げた塩。ふわふわとした結晶は鉄の影響から、ほんのりオレンジ色に染まる。鉄由来の酸味と、力強いしょっぱさのある塩で、肉や魚の赤身のうまみを引き出す。

TASTE!	鉄由来の強い酸味、力強いしょっぱさ、苦味と雑味
おすすめ食材&料理	牛肉ステーキ、マグロやカツオなどの赤身の魚

原産地 沖縄県

DATA
食塩相当量（86.3g）
ナトリウム 34.0g
形　状 凝集晶
水分量 標準
工　程 天日／平釜
原材料 海水

価格／250g入り 600円
株式会社沖縄ベルク
沖縄県名護市
済井出473
tel.0980-52-6012

珊瑚礁の塩田でつくるうまみたっぷりの塩

屋我地マース
やがじ

沖縄

かつて沖縄の三大製塩地であった羽地内海に、入浜式塩田を復活させて塩をつくっている（p.17）。本州の塩田とは異なり、塩田の下地に風化した珊瑚礁を使用しており、その影響で、和風だしのようなうまみたっぷりの塩に仕上がる。製塩体験も受け付けている。

TASTE!	和風だしのような繊細でしっかりしたうまみ。潮の香り
おすすめ食材&料理	白身魚の塩煮、イカの刺身、野菜の煮物

原産地 沖縄県

DATA
食塩相当量（81.2g）
ナトリウム 32.0g
形　状 凝集晶
水分量 標準
工　程 天日／平釜
原材料 海水

価格／100g入り 953円
株式会社 塩田
沖縄県名護市字我部701
tel.0980-51-4030
http://www.enden.co.jp/
experience-study/index.html

海水塩

salt column
古くて新しい塩の形「水塩」

「水塩」とは海水の灰汁を取りながら、塩が結晶する直前まで煮詰めた濃縮海水のこと。江戸時代後期に庶民の間に醤油が普及するまでは、この「水塩」が広く使われていました。製品によって異なりますが、塩分濃度は15〜20％前後のものが多く、にがりと分離する「塩」に比べて、マグネシウムやカリウムなどのミネラルを多く含みます。ミネラルにはおいしい苦味やコク、酸味などが含まれているので、粒の塩に比べてまろやかで、コクや苦味をしっかり感じることができます。また、液体なので、素材にむらなく和えることができ、摂取する塩分量を減らすことができます。

伊江島で湧き出る汽水でつくる

湧出の塩(わじぃ)

沖縄

伊江島の湧出といわれる景勝地、琉球石灰岩を通った淡水が湧き出る、地元で大切にされてきた海中の水源地で取水する。ゲルマニウム鉱石を活用したオリジナルのネット式塩田で濃縮し、太陽と風の力で結晶させた塩。全体的に、力強く複雑で厚みのある味わい。

TASTE! 全体的に力強い。雑味があり味に厚みがある。濃いうまみ
おすすめ食材&料理 ゴーヤなど苦味のある食材のフリット、白身魚の塩焼き

原産地 沖縄県

DATA
食塩相当量(86.3g)
ナトリウム 34.0g
形状 粉砕
水分量 しっとり
工程 天日／粉砕
原材料 海水

価格／50g入り 258円(税込)
伊江島製塩
沖縄県国頭郡
伊江村字東江上3674
tel.0980-49-5224

バランスのよい味わいのふだん使いの塩

青い海

沖縄

糸満市沖合いの海水を、逆浸透膜で濃縮した後、25mプールほどの大きさの平釜で煮詰めて結晶化させる。塩のテイスティングをする際に「基準の塩」として使われるほど、味のバランスに優れているため、どんな食材にも合わせやすく、ふだん使いにおすすめ。

TASTE! 味、水分量、粒の大きさなどすべてにおいてバランスがよい
おすすめ食材&料理 料理全般、ハムづくりに使うと発色がよい

原産地 沖縄県

DATA
食塩相当量 90.6g
ナトリウム 35.6g
形状 凝集晶
水分量 標準
工程 逆浸透膜／平釜
原材料 海水

価格／500g入り 480円
株式会社 青い海
沖縄県糸満市
西崎町4-5-4
tel.098-992-1140
http://www.aoiumi.co.jp/

紅芋成分で染め上げたピンクの結晶

あっちゃんの紅塩

沖縄

沖縄本島北部にある製塩所。満潮時の海水を、平釜で濃縮・結晶させた「あっちゃんの塩」に、紅芋から抽出したポリフェノールを合わせてきれいな紅色の塩に仕上げる。レモンのような酸味とほのかな甘味があり、牛肉や海老など赤い色の食材と好相性。

TASTE! ほのかに甘い香り、レモンのような酸味
おすすめ食材&料理 赤い色の食材や、紅いもなどのいも類の揚げたもの

原産地 沖縄県

DATA
食塩相当量 82.6g
ナトリウム 32.5g
形状 フレーク
水分量 さらさら
工程 平釜／混合
原材料 海水、ポリフェノール、クエン酸

価格／100g入り 735円
有限会社 ティーダ・サイエンス
沖縄県国頭郡
本部町備瀬1779-1
tel.0980-51-7555
http://achan-sio.jp/

コストパフォーマンスに優れた甘味塩

北谷の塩
ちゃたん

沖縄

北谷町宮城海岸の海水淡水化センターから排出される濃縮海水を逆浸透膜でさらに濃縮し、立釜で結晶させた塩。徹底的なコスト削減によって低価格を実現しており、ふだん使いしやすい。酸味と甘味があるので、アイスなど乳製品を使ったスイーツづくりにもおすすめ。

TASTE! 乳製品のような酸味とまるみのある甘味
おすすめ食材&料理 乳製品を使った料理やスイーツ、トマトなど酸味と甘味がある野菜

原産地 沖縄県

DATA
食塩相当量 94.2g
ナトリウム 37.0g
形 状 凝集晶
水分量 標準
工 程 逆浸透膜/立釜
原材料 海水

価格/30g入り 120円
沖縄北谷自然海塩株式会社
沖縄県中頭郡
北谷町字宮城1-650
tel.098-921-7547
http://www.nv-salt.com

カルシウムたっぷりのさらさら塩

うるわしの花塩

沖縄

「北谷の塩」を焼成し、沖縄県原産の珊瑚カルシウムをブレンド。さらさらとした質感で、ナトリウム構成比が低い。まろやかなしょっぱさと強い甘味が特徴で、特に大豆を使った料理におすすめ。溶けにくいので調味料としてよりは、つけ塩やかけ塩によい。

TASTE! やわらかいしょっぱさで、甘味を強く感じる
おすすめ食材&料理 たまご料理、豆腐や納豆などの大豆製品

原産地 沖縄県

DATA
食塩相当量 88.0g
ナトリウム 34.6g
形 状 粉砕
水分量 さらさら
工 程 逆浸透膜/立釜/混合/焼成
原材料 海水、珊瑚カルシウム

価格/120g入り 600円
沖縄北谷自然海塩株式会社
沖縄県中頭郡
北谷町字宮城1-650
tel.098-921-7547
http://www.nv-salt.com

沖縄県の家庭で愛され続ける塩

シママース

沖縄

専売制度の下、300年つくり続けた「島の真塩」に近い塩を目指してつくられた再製加工塩。オーストラリアまたはメキシコの完全天日塩を沖縄の海水で溶かし、平釜で煮詰めて再結晶させている。コストパフォーマンスがよく、キレのよいしょっぱさのふだん使いしたい塩。

TASTE! しっかりしたしょっぱさの後に、ほのかな雑味。キレがよい
おすすめ食材&料理 塩豚、白身魚のフライ、パスタや野菜のゆで塩

原産地 沖縄県

DATA
食塩相当量 92.1g
ナトリウム 36.3g
形 状 凝集晶
水分量 標準
工 程 溶解/平釜
原材料 天日塩、海水

価格/1000g入り 320円
株式会社 青い海
沖縄県糸満市西崎町4-5-4
tel.098-992-1140
http://www.aoiumi.co.jp

海水塩

海水塩

久米島の清浄な海洋深層水でつくる塩
球美の塩

沖縄

沖縄本島から西に100km、久米島周辺の水深612mから汲み上げた海洋深層水でつくる塩。逆浸透膜で濃縮し、蒸気で熱した釜で結晶させている。最初に適度なしょっぱさと苦味があり、脂の多い部位や揚げ物を食べる際にさっぱりとさせてくれる。

TASTE! ほどよいしょっぱさと苦味。ほどよい酸味の後に甘味
おすすめ食材&料理 豚肉や鶏肉の脂の多い部位、揚げ物

原産地 沖縄県

DATA
食塩相当量 97.0g
ナトリウム 38.0g
形 状 凝集晶
水分量 標準
工 程 逆浸透膜／平釜
原材料 海水

価格／100g入り 300円
久米島海洋深層水開発株式会社
沖縄県島尻郡久米島町字宇江城2178-1
tel.098-985-5300

「神の島」で育てる完全天日塩
太陽ぬ真塩（てぃだぬまーす）

沖縄

琉球王朝時代に神事が行われたことから、神の島ともいわれる久高島（くだかじま）。久高島沖の海水を、太陽と風の力だけで結晶させている。苦味と珊瑚のカルシウム由来の甘味があり、山菜など苦味のある野菜のてんぷらに合わせると、深みのある味わいを楽しめる。

TASTE! 適度なしょっぱさの後に、強めの苦味。カルシウム由来の甘味
おすすめ食材&料理 山菜のてんぷら、オイルとともに焼き野菜やパンに添えて

原産地 沖縄県

DATA
食塩相当量 (81.2g)
ナトリウム 32.0g
形 状 立方体
水分量 標準
工 程 天日
原材料 海水

価格／120g入り 1500円
ナサー屋
沖縄県南城市知念字久高73
tel.080-1701-9797

海水ミネラルの研究を基に完成
ノエビア 南大東島の海塩N

沖縄

沖縄本島から東に400km、水深7000mの海溝に囲まれた南大東島でつくる塩で、多様なミネラルを含む。原料の海水には特にこだわりを持ち、取水船を使って、水深200mのポイントから汲み上げている。ほどよいしょっぱさと強めの苦味で、揚げ物をさっぱりと食べたいときに◎。

TASTE! ほどよいしょっぱさの後に、強めの苦味。すっきりした味
おすすめ食材&料理 豚肉の脂の多い部位、揚げ物

原産地 沖縄県

DATA
食塩相当量 92.9g
ナトリウム 36.6g
形 状 凝集晶
水分量 標準
工 程 平釜
原材料 海水

価格／200g入り 2000円
株式会社ノエビア
お客さまサービス室
東京都中央区銀座7-6-15
tel.0120-401-001

無添加、海水100％でナトリウム控えめ

まぐねしお

沖縄

「シママース」（p.103）で知られる製塩会社が、独自製法によって、塩化カリウムなどの添加物を一切使うことなく、沖縄の海水を100％使用し、塩分24％減を実現。マグネシウムもたっぷり含む。強い苦味があるので、揚げ物につけると油っこさを緩和してくれる。

※5訂日本食品標準成分表「食塩」比

TASTE! 弱めのしょっぱさ、しゅわっとした酸味と強めの苦味
おすすめ食材&料理 白身魚のフリット、とんかつなどの揚げ物。パンづくりに

原産地 沖縄県

DATA
食塩相当量 74.6g
ナトリウム 29.4g
形状 立方体
水分量 標準
工程 逆浸透膜／平釜／平釜／乾燥
原材料 海水

価格／100g入り 280円
株式会社 青い海
沖縄県糸満市西崎町4-5-4
tel.098-992-1140
http://www.aoiumi.co.jp/

海水塩

珊瑚礁の海水は甘味たっぷり

海のほほえみ

沖縄

2014年国立公園に指定された慶良間（けらま）諸島のひとつ、座間味島の塩。「ケラマブルー」といわれる透き通る珊瑚礁の海水を平釜で煮詰めて濃縮し、天日で結晶させている。珊瑚礁の海らしくカルシウム由来の甘味が強い、まったりとした味わい。加熱すると甘くなる野菜に。

TASTE! 甘味、適度な苦味
おすすめ食材&料理 加熱すると甘くなる野菜のグリル

原産地 沖縄県

DATA
食塩相当量
ナトリウム
形状 立方体
水分量 さらさら
工程 平釜／天日
原材料 海水

価格／70g入り 650円
民宿 ロビンソン
沖縄県島尻郡
座間味村字阿真144
tel.098-987-2676
http://www.ric.hi-ho.ne.jp/robinson/index.html

salt column

「ひとつまみ」と「少々」はどう違う？

料理の本でよく目にする「塩ひとつまみ」「塩少々」という表現。量が異なるって知っていますか。

ひとつまみ

ひとつまみとは、親指と人さし指、中指の3本の指でつまんだ量。さらさらした小さい粒径の塩で約1g（小さじ1/5）程度です。

少々

少々とは、親指と人さし指の2本の指でつまんだ量。さらさらした小さい粒径の塩で約0.5g（小さじ1/8）程度です。

ただし、種類によって粒の大きさや水分量が異なるので、同じ「ひとつまみ」「少々」でも、つまめる量も違います。塩を変えた際は、これまでの塩との差を確認しておくと、適切な量を手際よく用意できるでしょう。

藻塩

海藻に海水をかけ流す。

古代からつくられていた日本独自の海藻の塩

　海岸沿いに海藻の群生地があり、また、海藻を食べる食文化のある日本独自の製法です。

　諸説ありますが、海藻を乾燥させて塩を付着させ、そこに海水をかけ流して濃縮海水を得て、釜で煮詰めて結晶させることを藻塩焼きと呼びます。海藻のヨードが海水中に溶け出し、独特の色合いと風味が楽しめます。広島県や兵庫県、石川県や宮城県などでは土器が発掘されており、古代より海藻を活用した塩づくりが行われていたことがわかっています。現在では、藻塩は「海水に海藻を浸漬して製塩したもの、または海藻抽出物や海藻灰抽出物もしくは海藻浸漬にがりを添加したもの」と定義され、全国各地でとれる地元の海藻を使った藻塩づくりが行われ、白いものから濃い茶色のもの、緑色、黒色のものなど、バラエティー豊富にそろっています。

check! 藻塩ができるまで

❶ 原料を採る
海藻を収穫し、天日で干して乾燥させ、塩を付着させます。

❷ 海水と海藻を煮詰める
海藻に海水をかけ流して濃縮海水を得るか、海藻を海水といっしょに煮詰めるなどして、海藻のエキスを海水に移し、途中で海藻を取り出して、そのまま煮詰めて結晶させます。

隠岐の島で藻塩づくりをしている「ローソク島の藻塩」（p.110）は、沖に船を出し、海藻を収穫している。

塩の神が伝えた塩づくりを再現

塩竈の藻塩
しおがま

宮城

平釜で11時間炊く。

塩づくりに由来する名を持つ塩竈市で、塩土老翁が伝えたという製法を再現した藻塩づくりを行う。海水をホンダワラにかけ流して濃縮し、平釜で炊き上げて結晶させる。一晩寝かせるうちにできた大きな結晶を採取した後、さらに煮詰めて結晶化。しょっぱさはとてもまろやかで、最後に厚みのある甘味とうまみが長く続く。大きな結晶の「竈炊き結晶」、さらに一日炊いた「竈炊き藻塩」がある。

原産地 宮城県

DATA
形　状　凝集晶
水分量　標準
食塩相当量（93.4g）　工　程　浸漬／平釜／乾燥
ナトリウム　36.8g　原材料　海水、ホンダワラ

TASTE!
とてもまろやかなしょっぱさ。上品で厚みのある甘味とうまみ

おすすめ食材＆料理
にんじんやたまねぎなどの加熱すると甘味の出る野菜、塩おにぎり

価格／80g入り 500円
合同会社 顔晴れ塩竈
宮城県塩竈市尾島町27-30
tel.022-365-5572
http://mosio.co.jp/

藻塩

芳醇な磯の香りが鼻をくすぐる

玉藻塩

新潟

新潟県の景勝地、笹川流れ沿いで「塩の花」（p.69）を生産する製塩所の藻塩。目の前の海岸で朝収穫したばかりのホンダワラを天日干しした後、清浄な笹川流れの海水と合わせて煮詰め、エキスを抽出しながら濃縮・結晶させている。濃い茶色の結晶は口の中で溶けるごとに、ふわりと磯の香りが鼻をくすぐり、"これぞ藻塩"といった濃厚で力強いうまみが広がる。

原産地 新潟県

DATA
形　状　凝集晶
水分量　標準
食塩相当量（76.7g）　工　程　浸漬／平釜
ナトリウム　30.2g　原材料　海水、ホンダワラ

TASTE!
ふわっとした磯の香り、力強いうまみ

おすすめ食材＆料理
白身魚、塩おにぎり、生牡蠣とレモン

価格／150g入り 550円
有限会社日本海企画
新潟県村上市勝木63-2
tel.0254-77-3009
http://www.isosio.com/

瀬戸内の海で蘇る古代の塩
海人の藻塩

広島

原産地 広島県

DATA
形　状　粉砕
水分量　標準
食塩相当量（94.4g）
ナトリウム　37.2g
工　程　逆浸透膜／立釜
　　　　浸漬／平釜／焼成
原材料　海水、ホンダワラ

TASTE!
まろやかなしょっぱさ、濃厚な和風だしのようなうまみ

おすすめ食材&料理
白身魚の刺身、生牡蠣などの貝類、てんぷら、塩おにぎり

日本の渚百選にも選ばれた瀬戸内・上蒲刈島の浜でつくられる藻塩。もっとも潮流の速い岬の突端で取水したフレッシュな海水を濃縮し、乾燥させたホンダワラを浸して灰汁を取りながら炊き上げる。元々1984年に当地で古墳時代の製塩土器が出土したことを機に当時の塩を復活させようと、10年の歳月をかけて生まれた。その和風だしのような味はまろやかでじんわり味わい深い。

価格／100g入り 513円（税込）
蒲刈物産株式会社
広島県呉市蒲刈町
大浦7407-1
tel.0823-70-7021
http://www.moshio.co.jp/

海藻のエキスたっぷりの五島の藻塩
矢堅目の藻塩

長崎

製塩所には大きな平釜が並ぶ

原産地 長崎県

DATA
形　状　凝集晶
水分量　標準
食塩相当量　76.2g
ナトリウム　30.0g
工　程　浸漬／平釜／乾燥
原材料　海水、ホンダワラ

TASTE!
適度なしょっぱさ、はっきりした苦味、だしのうまみ、酢のような酸味

おすすめ食材&料理
白身魚のカルパッチョ、白身魚のてんぷら

五島列島・新上五島の海岸沿いに建つ製塩所でつくられる、昔ながらの藻塩。五島列島の美しい海ですくすくと育ったホンダワラを天日で乾燥させ、同じ五島沖の海水に漬け込んで、海藻のエキスをじっくりと抽出しながら、平釜で一昼夜炊いている。ほのかな磯の香りと苦味やうまみが混ざりあう塩は、オイルやレモンとともに白身魚に合わせると、魚のうまみをぐっと引き上げる。

価格／100g入り 400円
株式会社やがため
長崎県南松浦郡
新上五島町網上郷688-7
tel.0959-53-1007
http://www.yagatame.jp/

バランスのよい甘味のある塩

淡路島の藻塩(茶) PREMIUM

兵庫

淡路島の海水と国産の海藻を使用し、職人がじっくり炊き上げた後、焼成して仕上げている。深いコクがあり、ほのかな酸味の後にどっしりとした甘味を感じる。海藻の香りが強すぎないので、特に豆腐など淡泊な食材との相性がよい藻塩。

TASTE!	しっかりとしたコクと甘味
おすすめ食材&料理	お吸い物、豆腐、味が淡泊な白身魚

原産地 兵庫県

DATA
食塩相当量 92.7g
ナトリウム 36.5g
形　状 フレーク
水分量 さらさら
工　程 逆浸透膜/浸漬/平釜/焼成
原材料 海水、海藻

価格／80g入り 400円
株式会社多田フィロソフィ
兵庫県南あわじ市
榎列小榎列271-1
tel.0799-42-2231
http://www.e-moshio.com/

藻塩

上品な甘味のある有名シェフ愛用の逸品

かいふ藻塩

徳島

太平洋に面して200km続く、室戸阿南海岸国定公園内の自然豊かな海岸線沿いの製塩所。澄みきった新鮮な海水にホンダワラとアラメを加え、平釜で煮詰めて海藻のうまみを引き出す。海水の味と上品な甘味が続く、風味ある結晶は、有名イタリアンシェフも愛用の逸品。

TASTE!	適度なしょっぱさ、海水の味と磯の香り、あっさりした甘味
おすすめ食材&料理	鯛のカルパッチョ、きゅうりや白菜の浅漬け

原産地 徳島県

DATA
食塩相当量 87.7g
ナトリウム 34.5g
形　状 凝集晶
水分量 標準
工　程 平釜/浸漬/平釜/焼成
原材料 海水、ホンダワラ、アラメ

価格／80g入り 600円
かいふ・そると
徳島県海部郡
海陽町中山字ナウグ5
tel.0884-73-4140
http://www.kaifusalt.com/

特産品のもずくでできた人気の沖縄の塩

もずくしお

沖縄

日本で採れるもずくの9割以上のシェアを占める沖縄県。特産品のもずくを藻塩に仕立てた。塩蔵もずくを漬け込んだ際に出る、もずくエキスが抽出された塩水を、2〜3か月かけて熟成させ、釜で炊いて濃縮・結晶させている。磯の風味たっぷりで、沖縄土産としても人気。

TASTE!	まろやかなしょっぱさ、あっさりした甘さと酸味
おすすめ食材&料理	もずくのてんぷら、白身魚の塩煮

原産地 沖縄県

DATA
食塩相当量
ナトリウム
形　状 粉砕
水分量 さらさら
工　程 浸漬/平釜
原材料 海水、もずく

価格／100g入り 430円
天然もずくセンター
HAMAHIGA
沖縄県沖縄市池原1046
tel.098-938-0777

3種の海藻を合わせたミネラルたっぷりの塩

佐渡藻塩

新潟

塩工房。

原産地
新潟県

DATA

食塩相当量	61.5g	形 状	凝集晶
ナトリウム	24.2g	水分量	しっとり
		工 程	浸漬／平釜
		原材料	海水、ナガモ ホンダワラ、アラメ

佐渡ヶ島の西端に位置する七浦海岸で、真冬の1月～2月に採れるうまみが詰まったナガモ、ホンダワラ、アラメを、3日間海水で煮詰めて仕上げる。3種類の海藻を合わせた藻塩はめずらしく、濃い茶色の色はいかにも海藻のミネラルたっぷり。角のないしょっぱさで、濃厚なうまみと甘味、コーヒーのような苦味がある。ごはんや白身魚、イカなど淡泊な食材のおいしさを引き出す。

TASTE!
まろやかなしょっぱさ、非常に濃厚なうまみと甘味。コーヒーのような苦味。

おすすめ食材＆料理
塩おにぎり、お吸い物、白身魚の刺身、コーヒーを使った塩スイーツ

価格／200g入り 870円
佐渡屋萬平商店
新潟県佐渡市真野新町286
tel.0259-55-2174
http://meoto.net/

藻塩

日本でもっとも濃い色をした香ばしい藻塩

ローソク島の藻塩

島根

夕暮れのローソク島。

原産地
島根県

DATA

食塩相当量	(83.8g)	形 状	凝集晶
ナトリウム	33.0g	水分量	標準
		工 程	浸漬／平釜／乾燥
		原材料	海水、アラメ

隠岐の島には、夕刻、日本海に沈む太陽が島影に重なり、ほんの束の間ローソクのように見えることから「ローソク島」と呼ばれる美しい景勝地がある。この小さな無人島近くの製塩所ということで、塩の名の由来となった。日本でもっとも濃い色をした藻塩だが、磯の香りはあまり強くなく、カラメルのような香ばしさと、濃厚なうまみと熟したフルーツのようなねっとりとした甘味を感じる。

TASTE!
カラメルのような香ばしい苦味、ほのかな磯の香りとうまみ。熟したフルーツのような甘味

おすすめ食材＆料理
塩プリンや塩キャラメルなどの塩スイーツ、塩おにぎり、マンゴーなどの南国のフルーツ

価格／100g入り 380円
八幡一正
島根県隠岐郡
隠岐の島町久見321-1
tel.08512-5-3624

すっきりとしたうまみで食材になじむ藻塩

出雲 鵜鷺（うさぎ）の藻塩

島根

出雲沖の海水を煮詰めて濃縮し、一晩寝かせた後、上澄み液をさらに煮詰めて結晶させた塩に、地元で採れたアラメから抽出したエキスを配合している。最初は薄く感じるが、徐々に味が広がる。藻塩のなかでは比較的すっきりとした味わい。

TASTE! 適度なしょっぱさ、日本酒のような苦味、あっさりとしたうまみ
おすすめ食材&料理 野菜のグリル、白身魚の塩焼き

原産地 島根県

DATA
食塩相当量 88.0g
ナトリウム 34.6g
形　状 凝集晶
水分量 しっとり
工　程 平釜／混合
原材料 海水、アラメ

価格／120g入り 300円
鵜鷺げんきな会
島根県出雲市大社町鷺浦1045-1
tel.0853-53-5635

藻塩

天然ひじきのうまみがたっぷり

弓削塩（ゆげしお）

愛媛

瀬戸内に浮かぶ弓削島は、平安末期、京都東寺に塩を納める塩の荘園として栄えていた、歴史ある製塩の地だ。弓削島産の天然ひじきと海水を、平釜で煮詰めて濃縮・結晶させた藻塩。舌先でもひじきのうまみをしっかり感じる。鉄のような酸味は赤身の魚と好相性。

TASTE! 磯の香り、ひじきの味、鉄っぽい酸味。土の香り
おすすめ食材&料理 塩おにぎり、マグロの刺身

原産地 愛媛県

DATA
食塩相当量 （91.6g）
ナトリウム 36.1g
形　状 凝集晶
水分量 標準
工　程 浸漬／平釜
原材料 海水、ひじき

価格／80g入り 540円（税込）
株式会社しまの会社
愛媛県越智郡上島町弓削下弓削830-1
tel.0897-77-2232

高校生と共同開発したコクと甘味の藻塩

黒潮町の黒塩

高知

町役場からの提案をきっかけに、地元の高校生とともに取り組んだ末に生まれた、地元産のカジメを使った藻塩。海水を天日で濃縮した後、そこにカジメを入れて平釜で煮て結晶させている。しょっぱさは強めだが、強いコクがあり、その奥に甘味も感じる。

TASTE! 強いしょっぱさとコク、隠れた甘味
おすすめ食材&料理 魚の煮物、ゴボウの唐揚げ

原産地 高知県

DATA
食塩相当量 92.0g
ナトリウム 35.1g
形　状 凝集晶
水分量 しっとり
工　程 天日／浸漬／平釜
原材料 海水、カジメ

価格／100g入り 350円
有限会社 海工房
高知県幡多郡黒潮町浮鞭3369-13
tel.0880-43-1432

Chef's Interview 2

てんぷら小野
志村幸一郎氏

物語のある調味料、それが塩
じょうずに使えば食卓がいっそう華やかに

**冬の食材に合わせると
特に力を発揮する**

　東京・八丁堀に店を構える、「てんぷら小野」。店主の志村幸一郎氏は大手食品系商社から料理人の世界に転身したという、異色の経歴の持ち主。そんな志村氏にとって塩とは。「欠かせない存在です。新鮮な食材を油で揚げる、究極にシンプルな日本料理に、色とりどりのアクセントを与えてくれるのが塩ですね」

　現在、カウンターに常備する塩は2種類。「わじまの海塩」は、人間のミネラルバランスに近く、味も成分もバランスのよい塩。もう一方の「石垣の塩」は、シャープで脂切れのよい塩。店で焼いてから出しているので、粒子が細かく、さっくりと揚がった衣によくなじむ。

8月下旬の取材日、志村氏が手際よく揚げてくださったのは、厳選された季節の食材4品。①土栽培で育った大きな「秋みょうが」には、太陽をいっぱいに浴びた酸味のある天日塩「山塩小僧」。②「お頭つきの海老」には、レモンのような酸味のある「あっちゃんの紅塩」。③「泳ぎ鮎」には苦味を引き立てる「死海の塩」。④「おくら」にはうまみの強い「佐渡の深海塩」など、食材に合わせた塩が添えられている。

「粒子が大きい前者は溶けるのが遅いので、甘味を感じやすい。後者は溶けるのが早いので、鋭いしょっぱさを持っている。対照的な味わいです。さらに13品のコースでは、10種程度の異なる塩で旬の食材を楽しんでもらいます」

"素材のもっともおいしい瞬間をいただく"てんぷらのなかで、塩が一番力を発揮するのは冬だという。

「水温が下がり、身が締まって脂を蓄える魚や、白子、魚卵など、脂ののった食材が1年でもっとも多くなるからです」

油と衣で食べるてんぷらは、食材自身に脂が多い場合、どうしても脂過多になってしまう。

「こってりとした脂の切れをよくするなら、何より塩が効果的ですね。てんぷらの油がさっぱりと感じやすくなる、特に鉄由来の酸味があるものをセレクトしています」

塩の作用が引き出す
てんぷらの多彩な味

「てんぷらの調理は、いってみればすべて脱水作業」と語る志村氏。その理由を尋ねると、「食材から水分を抜いていくと残るのは、味と香りです。それが素材の持つ魅力そのもの。揚げる工程でどのくらい水分を飛ばし、味や香りを濃くするのか。これがてんぷらという料理なのです」

確かに海老ひとつとっても、てんぷらにした場合、身が引き締まり、刺身で食べるよりも甘味とうまみがいっそう凝縮されていると、感じる場合が多い。

「食材の味と香りが残ったところで、どの味を強調するか。それを決めるのが塩の役割」

例えばカルシウムが多い食材に、マグネシウムと鉄分の多い、苦味やコクを感じる塩を合わせると、味の対比でカルシウムの甘味が引き立つ。反対にカルシウムの多い塩を合わせれば、同種の味の相乗効果でうまみが増す、という寸法だ。

また、一風変わった使い方も教えていただいた。コースの途中で箸が止まった人へ、フランス料理でいうグラニテ（口休めのシャーベット）のように、テイストの異なる塩をひとつまみ料理に添えたり、甘いソフトドリンクにもほんの少し、塩を入れたりもするそうだ。

「添える塩を変えたり、塩で少し味を変えたりすることで、舌がリフレッシュするんですね」

⑤〜⑥全国各地の海と山から届いた季節の食材が、白木のカウンターの奥でツヤツヤと輝く。⑦志村氏自慢の塩パレット。さまざまな個性を持つ国内外の塩25種類がそろう。ケースの蓋には相性のよい食材や塩の特徴など、使いわけに必要な情報がびっしり。

食の感動を呼ぶ"塩のパレット"

「塩にそこまでの強いこだわりはなかった」と話す志村氏だが、今では20種類以上の塩を常備し、素材はもちろん、お客様の飲み物にも合わせた使いわけをするまでになった。

「きっかけは6年前、ソルトコーディネーターの青山志穂さんとの出会いでした。さまざまな塩の個性を理解したうえで、食材とのペアリングについて語ってくれたんです。てんぷらと塩がぴったり結びついた瞬間でしたね」

その後、やりとりを重ねるうち『塩のパレット』が完成。透明のケースに、個性豊かな25種類の塩がずらりと並び実に壮観だ。堪能な英語力を持つ志村氏を頼って店を訪れる、海外のお客様からも大人気で、感動を呼ぶ演出にもなっているという。

「味も然ることながら、料理の世界では魅せる技術、すなわち"華やかさ"も欠かせません。パレットを見て、各国の食のプロたちがみんな感激していますよ。フランスの国家最優秀職人のシェフや、ハリウッドの映画関係者などのセレブリティこそ、パレットの価値を理解してくれるようです」

どこの家庭にもある塩、何がそんなにスゴイのだろうか。

「物語のある調味料だからです。25種類あれば、その数だけ異なる風景や物語がある。お客様もその物語を楽しみつつ味わってくれるから、会話も自然と密になりますね」

最後に家庭での楽しみ方を尋ねてみた。

「確かに塩は一見地味な存在です。だからこそ、背景に目を向けて、相性のよい食材といっしょに使ってみる。そんな使いわけを家庭でも取り入れてみてほしいですね。食卓も会話も華やぎますし、何より塩をじょうずに使うだけで、驚くほど料理はおいしくなりますから」

志村幸一郎

埼玉県生まれ。大手食品系商社にて物流構築交渉や商品開発に携わりながら、並行して料理店での料理修行を行う。2006年結婚を機に「てんぷら小野」の2代目店主に。英語力を生かし、コミュニケーションを重視したサービスを実践。海外のVIPゲストからの信頼も厚い。日本各地に赴き、採れたての食材をてんぷらにしてふるまう「本格LIVEてんぷら」をはじめ、海外でのデモンストレーション、メディア活動など、てんぷらや日本食普及のため国内外で活躍中。2016年内閣府クールジャパン・地域プロデューサーに就任。http://tempura-ono.com/

Shop Data

てんぷら小野

住所：東京都中央区八丁堀2-15-5 第5三神ビル3F
TEL：080-4093-9761
休日：土曜日・日曜日・祝日
営業時間：17:30-L.O.21:00
アクセス：東京メトロ日比谷線「八丁堀駅」
　　　　　A5出口徒歩2分

Part 3
色どりが美しい
岩塩

岩塩は世界各地に点在する岩塩層から採取されます。
日本では採れないものの、全世界の塩生産量のうち約6割が岩塩という、
地球上でもっともポピュラーな塩。
赤やピンク、透明や黒まで宝石のような結晶が食卓を彩れば、
見ているだけでも楽しくなるでしょう。

岩塩

「クリスタル岩塩」（p.124）が採れるパキスタン・パンジャブの岩塩鉱山。

世界の塩の約6割を占める
海水の化石ともいえる塩

　岩塩の成り立ちはいくつかありますが、太古の昔に起こった地殻変動で大地に閉じ込められた海水が、長い年月を経て乾燥して塩湖となり、塩の結晶ができ、その上に土砂が堆積することで岩塩層となります。「岩塩」の多くはこの岩塩層を削り出したものです。約5億年前から200万年前に形成された「海の化石」・岩塩の埋蔵量は、数千億tにも及びます。おもな産出地は埋蔵量が多いアメリカ、ドイツ、イタリア、スペイン、パキスタンなどの国の内陸部で、すでに結晶したものを掘り出すので効率がよく、生産量は全世界の約6割を占めています。なお、岩塩層は日本には存在しません。

　塩を構成する各種ミネラルは固形になる濃度が異なるため、岩塩層は大まかにナトリウム層、カルシウム層など成分ごとにわかれています。マグネシウムを主体とするにがりを含まず、海水塩に比べて結晶がかたく、溶けにくいのも特徴です。

　岩塩の採取方法には2種類あります。そのまま結晶を掘り出す方法では、土壌に含まれる成分の影響を受けた岩塩が採れやすく、その土地ならではの岩塩の特徴を楽しむことができます。一方、ナトリウム層を水で溶かしてから取り出して再度結晶させる方法では、土壌の成分は沈殿するため含まれず、ほぼナトリウム純度100％の塩ができ上がるため、岩塩本来の特徴はなくなります。

Topics 色の違いで成分を見わけよう！

白 White
元来は透明ですが、結晶の中で光が屈折するため、白く見えます。土壌の影響をあまり受けておらず、岩塩のなかでもナトリウム純度の高い部分です。

紫 Purple
おもにチベットやインドなどで産出される、マグマの高温で焼かれた影響で硫黄が多く含まれている岩塩です。硫黄独特の甘味や香りが特徴的です。多く含まれると黒色になり、食用には適さなくなります。

ピンク Pink
おもにパキスタンやボリビアで産出される岩塩で、土壌に含まれる酸化鉄が塩の結晶中に入り込んでいるため、ピンク色に見えます。この鉄分は体内には吸収されませんが、鉄由来の酸味を呈します。多く含まれると黒色になり、食用には適さなくなります。

青 Blue
おもにイランで産出される、カリウムを多く含む岩塩。カリウムが多い分、ナトリウムの純度が低いため、しょっぱさはまろやかで、酸味が強く、ひやっとした冷たい感覚があります。

透明 Clear
土壌の影響をあまり受けず、さらに結晶が屈折せずに成長した場合、透明の結晶ができ上がります。透明度の高い岩塩は産出量が少なく希少。

check! 岩塩の採取法

乾式採鉱法
岩塩層まで坑道を掘り、ダイナマイトやカッターなどを使って適度な大きさに破砕した岩塩を、ベルトコンベアなどで地上に運び出す方法。土壌の影響を受けた岩塩がそのまま採取されるため、ピンク色や青色に色づいた岩塩などはこの方法で採取されています。役目を終えた岩塩鉱山は、核廃棄物の貯蔵庫に使われたり、空気が清浄なことからぜんそく患者の治療などに使われたりもしています。

溶解抽出法
地中に埋没した岩塩のナトリウム層に向かって地上から井戸を掘り、パイプを通して圧力の力で真水を注入し、溶かして塩水にし、地上に吸い上げる方法。その後何らかの方法で結晶させて塩として出荷されるほか、濃縮塩水のまま工業用に使用されたりします。乾式採鉱法より危険性が少なく、効率よく塩を採ることができます。また溶かしたときに土壌に含まれる鉄分などの特徴的な成分は沈殿するため、ほぼナトリウム純度100％の岩塩ができ上がります。

溶解抽出法は爆薬や人力を多く使わずに塩を採取できるため、危険性は少ない。

岩塩

日本人が惚れ込んだピンク色をした海水の化石

パハール岩塩

パキスタン

DATA
食塩相当量	94.5g
ナトリウム	39.0g
カリウム	340mg
マグネシウム	140mg
カルシウム	360mg

原産地 パキスタン

形　状　粉砕
水分量　さらさら
工　程　採掘／洗浄／乾燥／粉砕
原材料　岩塩

TASTE！
やや強めのしょっぱさ、鉄分からくるほのかな酸味。シンプルな味わい

おすすめ食材＆料理
牛肉ステーキ、ほうれん草など鉄分を多く含む野菜のオイルソテー、脂ののったマグロ

地下200mの岩塩鉱脈から採掘。きれいなピンク色の岩塩のみを選び、日本に運んでから仕上げる。

価格／120g入り571円
株式会社オフィスツーワン
東京都中央区
新川2-12-14松谷ビル201
tel.03-3523-1099
http://www.of21.co.jp/

　パキスタンの首都イスラマバードから車で6時間、インダス川流域の荒涼とした土漠地帯に、世界最大級ともいわれるパハール岩塩鉱山がある。地殻変動で急激に隆起した海底が、約6億年もの時をかけてこの地に岩塩層を形成したといわれている。
　創業者の櫻井史標さんが、パキスタン滞在中に熱中症で倒れかけたとき、地元の運転手に勧められたピンクの粒と水を飲みほしたところ、あっという間に回復した。これがパハールの岩塩との出会いだったという。
　その後、日本の高い品質基準をクリアするために工場を設立し、特に濃いピンク色の良質の岩塩のみを商品化した。雑味のないクリアな味で、ほうれん草やクレソンなど鉄分の多い野菜や脂の多い牛肉に合わせると、食材のコクが一段と深まる。粗挽きや粉末タイプもそろう。

悠久の時が育てた薄紅色の宝石

ピンクロックソルト

パキスタン

パキスタンのヒマラヤ山脈の麓で、6億年のときを経て結晶化した岩塩。濃い色の層を選んで採掘された結晶は美しく、まるで珊瑚のよう。やや強めのしょっぱさと鉄からくる酸味で、脂をきゅっと引き締め、牛肉のうまみや甘味をしっかりと引き出す。塊や細粒タイプもある。

TASTE! 強めのしょっぱさ、鉄由来の酸味
おすすめ食材&料理 牛肉ステーキ、脂ののったマグロやカツオの炙り

原産地 パキスタン

DATA
食塩相当量（95.7g）
ナトリウム 37.7g

形　状　粉砕
水分量　さらさら
工　程　採掘／洗浄／粉砕
原材料　岩塩

価格／400g入り 1300円
株式会社 FAR EAST
埼玉県飯能市大河原33-1
tel.042-973-2060
http://fareastinc.co.jp/

南米の大地から届いたまろやかなピンク塩

ローズソルト

ボリビア

ボリビアのアンデス山脈から産出される岩塩で、鉄分とカルシウムを多く含む。不純物の少ない上質な塊を選んで日本に運び、ていねいに仕上げている。ピンク岩塩のなかでは比較的まろやかな味わい。脂身の少ない肉類に合わせると、肉のうまみがじんわり深まる。

TASTE! まろやかなしょっぱさ、鉄分からくる酸味、ほのかな苦味
おすすめ食材&料理 脂身の少ない牛肉や豚肉のグリル

原産地 ボリビア

DATA
食塩相当量 97.8g
ナトリウム（38.5g）

形　状　粉砕
水分量　さらさら
工　程　採掘／洗浄／乾燥／粉砕
原材料　岩塩

価格／200g入り 400円
マルキョウアネット株式会社
東京都千代田区二番町11-10
麹町山王ビル101
tel.03-3264-1239
http://www.marukyo-a.net/

口の中で余韻が長く続く塩

ヒマラヤ産ピンク岩塩

パキスタン

「クリスタル岩塩」（p.124）と同じ岩塩層から採掘した、鉄分を多く含んだ岩塩。ヒマラヤ岩塩のなかではカリウムを多く含んでいる。鉄分が多いほうれん草や菜の花に合わせると、味にぐっと深みが出る。ミルで挽き、舌の上で少しずつ溶ける粒感を楽しみたい。

TASTE! ほどよいしょっぱさ、鉄とカリウム由来の酸味、ほのかな苦味
おすすめ食材&料理 牛肉、赤身魚、菜の花など鉄分の多い野菜のソテーやグリル

原産地 パキスタン

DATA
食塩相当量（98.5g）
ナトリウム 38.8g

形　状　粉砕
水分量　さらさら
工　程　採掘／洗浄／乾燥／粉砕
原材料　岩塩

価格／100g入り 444円
源気商会
神奈川県横浜市戸塚区
俣野町1403-10-108
tel.045-777-6920
http://www.genkishoukai.com/

岩塩

アメリカ随一の塩の州・ユタから届いた塩

リアルソルト

アメリカ

アメリカのユタ州で、塩分摂取のため大地を舐める動物たちの姿に、先住民が気づいたことから発見された。鉄分が多く、ところどころ黒い結晶も。強めのしょっぱさと酸味が牛肉の甘味とうまみを際立たせる。2001、2003年に全米の食のプロが集う品評会で金賞を受賞した塩。

TASTE! 強いしょっぱさ、鉄由来の酸味、強い雑味
おすすめ食材&料理 牛肉ステーキ、牛カツレツ

原産地 アメリカ

DATA
食塩相当量 (98.0g)
ナトリウム 38.6g
形 状 粉砕
水分量 さらさら
工 程 採掘／粉砕
原材料 岩塩

価格／135g入り 450円
ジャパンソルト株式会社
東京都中央区京橋1-7-1
八重洲ダイビル5F
tel.0120-16-4083
http://www.japan-salt.com/

アンデス山脈の茜色の宝石

アンデスの紅塩

ボリビア

ボリビアのアンデス山脈で採掘した淡いピンク色の岩塩。地殻変動で3000m以上隆起した地層の中で、3億年のときをかけて自然結晶した。岩には鉄分を含むが、風味としては酢に近い酸味なので、白身の魚など淡泊な食材にも合わせやすい。

TASTE! ほどよいしょっぱさと酸味。柑橘のような苦味
おすすめ食材&料理 グレープフルーツ、イカのマリネ、セビーチェ

原産地 ボリビア

DATA
食塩相当量 99.5g
ナトリウム 39.2g
形 状 粉砕
水分量 さらさら
工 程 採掘／洗浄／粉砕
原材料 岩塩

価格／250g入り 350円
株式会社ティーエスケー
京都府綴喜郡宇治田原町
郷之口末田39-2
tel.0774-99-7557
http://benijio.jp/

カリウムの多い酸味の塩

ポーランド岩塩

ポーランド

塩でできた宮殿で知られるヴィエリチカ岩塩鉱の岩塩が溶けた塩水に、カリウム含有量の多い岩塩をブレンドし、立釜で再結晶させたもの。岩塩のなかではカリウムがとても多く、口に含むとシュワッと溶けて、冷たさを感じる。ナトリウム純度は低く、しょっぱさは少ない。

TASTE! カリウムからくる冷たい酸味
おすすめ食材&料理 メロンやアボカドなどカリウムを多く含むフルーツ、揚げ物

原産地 ポーランド

DATA
食塩相当量 74.9g
ナトリウム 29.5g
形 状 立方体
水分量 さらさら
工 程 溶解／立釜／乾燥
原材料 岩塩

価格／250g入り 500円
女性起業ネットワーク
東京都足立区
梅島1-13-3-301
tel.03-3889-2951

PART 3 岩塩

ペルシャの大地で採れた青い結晶

ペルシャの岩塩 結晶

イラン

美しいブルーの岩塩層。

原産地 イラン

DATA		
	形　状	粉砕
	水分量	さらさら
食塩相当量　98.6g	工　程	採掘／粉砕
ナトリウム　　19.3g	原材料	岩塩

TASTE!
鉱物的な冷たさ、キレのよい酸味、雑味

おすすめ食材&料理
揚げ物、カリウムを多く含むフルーツ

イラン南部、ペルシャ岩塩の採掘地として知られるクーシャン鉱山のなかでも、ごく一部でしか産出されない希少な青く輝く岩塩。ナトリウムの構成比がとても低く、カリウムを多く含むため、しょっぱさはほとんど感じない一方、キレのよい酸味と鉱物的な冷たさ、雑味が残る。ナトリウム摂取量を制限されている人におすすめ。粒が粗めのためミルで挽くとよい。

価格／100g入り オープン価格
有限会社おちあいどっとこむ
静岡県富士市横割6-1-12
tel.0545-30-8835
http://www.77ochiai.com/

老化を防ぐ抗酸化力が高い健康塩

マグマ塩

インド

原産地 インド

DATA		
	形　状	粉砕
	水分量	さらさら
食塩相当量　98.3g	工　程	採掘／粉砕
ナトリウム　　38.7g	原材料	岩塩

TASTE!
強い硫黄の香りと甘味

おすすめ食材&料理
海老、蟹などの甲殻類、たまご、赤ワイン、油を使った料理

中国チベット自治区のヒマラヤ山脈の標高5000mから採掘される紫色の岩塩。硫黄を多く含み、抗酸化力が高いことから、当地では薬代わりにもされていたという。温泉たまごのような硫黄の香りと、甘味が印象的で、海老や蟹などに振ると甘味をいっそう引き立てる。アスパラガスとも好相性だ。また、200Lの湯にひとつかみ（50〜70g）入れるだけで、肌が潤うバスソルトとしてもおすすめ。

価格／100g入り 960円
シーラン株式会社
栃木県足利市問屋町1184-7
tel.0284-72-7526
http://www.searun.jp/

岩塩

「世界の屋根」ヒマラヤで採れる2億年前の塩

ヒマラヤ山麓の岩塩

ネパール

ネパールのヒマラヤ山脈から採取される紫色の岩塩。近年発見された岩塩で、約2億5000万年前に結晶化し、その後マグマの熱で焼かれたとされる。硫黄をたっぷり含み、人間の老化を促す活性酸素を減らす、抗酸化力が高い塩としても知られる。

TASTE! 強い硫黄の香りと甘味
おすすめ食材&料理 海老、蟹などの甲殻類、たまご

原産地 ネパール

DATA
食塩相当量 99.8g
ナトリウム 39.3g

形状 粉砕
水分量 さらさら
工程 採掘／粉砕
原材料 岩塩

価格／100g入り 590円
有限会社おちあいどっとこむ
静岡県富士市横割6-1-12
tel.0545-30-8835
http://www.77ochiai.com/

ほんのり甘い硫黄臭がクセになる

ベンガルの岩塩 カラナマック

インド

インド北西部に位置するカラコルム山脈の麓・カシミールの岩塩層から採掘された濃い紫色の岩塩。硫黄を多く含むため、口に入れると、独特の甘い香りが鼻に抜ける。個性的な硫黄の香りは、まろやかな食味のアクセントにぴったり。

TASTE! 強い硫黄の香りと甘味。強めの雑味
おすすめ食材&料理 海老、蟹などの甲殻類、たまご

原産地 インド

DATA
食塩相当量 96.9g
ナトリウム 38.1g

形状 粉砕
水分量 さらさら
工程 採掘／粉砕
原材料 岩塩

価格／100g入り 380円
有限会社おちあいどっとこむ
静岡県富士市横割6-1-12
tel.0545-30-8835
http://www.77ochiai.com/

めずらしいペルシャの黒塩

ペルシャの岩塩 ブラックソルト

イラン

イランの首都・テヘランの南東に位置するクーシャン鉱山から採掘した黒の岩塩。土壌の金属イオンの影響を受けて色づいているものの、風味的な個性はさほどない。適度なしょっぱさが続くなか、雑味、苦味を感じる。めずらしい色なので、添え塩にもおすすめ。

TASTE! 長く続く適度なしょっぱさ、雑味、苦味
おすすめ食材&料理 脂ののった青魚の塩焼き、ナッツや豆のサラダ

原産地 イラン

DATA
食塩相当量 98.6g
ナトリウム 19.3g

形状 粉砕
水分量 さらさら
工程 採掘／粉砕
原材料 岩塩

価格／100g入り 590円
有限会社おちあいどっとこむ
静岡県富士市横割6-1-12
tel.0545-30-8835
http://www.77ochiai.com/

シベリア岩塩 ミックス

シベリア地下700mで育った純白の結晶

ロシア

地下深くから運び出される塩

原産地 ロシア

DATA
形 状　粉砕
水分量　さらさら
食塩相当量　98.8g　工 程　採掘／粉砕
ナトリウム　38.8g　原材料　岩塩

TASTE!
角のないしょっぱさ、心地よい酸味、甘味

おすすめ食材&料理
豚肉や鶏肉のソテー、鶏ハム、塩豚、スープ

シベリアの地下約700mの岩塩層を巨大な掘削機を使って採掘したもの。太古の海が外界に触れることなく、2億年以上をかけて結晶したと推定される。やわらかいしょっぱさの後に、心地よい酸味と苦味があり、甘味の余韻が広がる。豚肉や鶏肉など特に白い肉類と好相性で、微粒と中粒が混ざって食材にもよくなじむ。ロシア国内では高級岩塩として知られる逸品。

価格／150g入り 300円
株式会社 門
熊本県八代市港町262-20
tel.0965-37-0031
http://russia-shop.jp/

大自然モンゴルの岩塩 ジャムツダウス

モンゴルの大自然が生んだ神様の塩

モンゴル

オブスノール盆地の岩塩鉱山。

原産地 モンゴル

DATA
形 状　粉砕
水分量　さらさら
食塩相当量　99.3g　工 程　採掘／粉砕
ナトリウム　39.1g　原材料　岩塩

TASTE!
ほどよいしょっぱさ、キレのよい酸味、後味はあっさり

おすすめ食材&料理
豚肉や羊肉の塩煮やソテー

モンゴルの北西部、オブスノール盆地の岩塩。砂漠や氷河、湿地や湖などさまざまな自然が同居する秘境で、世界遺産にも登録されている。この地で採れる岩塩は、古くから「ジャムツダウス（健康の神様の塩）」と呼ばれ、時には薬にも用いられる貴重なものだった。カルシウムのほどよい甘味が肉類の脂の甘味を引き立て、適度な酸味で後味もスッキリ。

価格／350g入り 600円
株式会社アリマジャパン
東京都千代田区
神田小川町2-8-20
tel.03-5217-0432
http://www.arima-japan.co.jp/

岩塩

まるで水晶。地下に眠る希少な塩の宝石

クリスタル岩塩

パキスタン

TASTE!
まろやかなしょっぱさの後に、ほのかな甘味と干した帆立のようなうまみ。雑味はなくクリア

おすすめ食材&料理
中華風スープ、魚介類を使った料理、帆立、トマトなどうまみの強い野菜

採掘されたばかりの巨大な塩の塊。食用ばかりでなく、大きなものは観賞用として求める人も多いという。

価格／250g入り 723円
源気商会
神奈川県横浜市戸塚区
俣野町1403-10-108
tel.045-777-6920
http://www.genkishoukai.com/

DATA

食塩相当量	(99.3g)
ナトリウム	39.1g
カリウム	110mg
マグネシウム	34mg
カルシウム	110mg

原産地 パキスタン

形　状　粉砕
水分量　さらさら
工　程　採掘／洗浄／粉砕
原材料　岩塩

しょっぱさ:5　酸味:6
苦味:5　うまみ:5
雑味:4　甘味:6

かつてガンダーラと呼ばれていた、ヒマラヤ山脈最西端に位置するパキスタン・パンジャブにある岩塩層から採掘された岩塩。全長300km続く岩塩層は、世界に数ある岩塩層のなかでも古いもののひとつで、約2億5000万年以上前の地層と推定されている。

一般的に、パキスタンの岩塩は鉄分を多く含むためピンク色のものが多いが、この岩塩は水晶のように無色透明。採掘量は岩塩層全体のたった5％以下というとても希少なものだ。体内を浄化しエネルギーを与える塩として、古来よりヨーロッパに伝承される「塩水療法」では"最高の塩"とされてきた。

ナトリウム値の高さに反して、まろやかなしょっぱさで、雑味がないクリアな味。水に溶けると干した帆立のような濃厚なうまみもいっしょに溶け出す。中華風スープや魚介類を使った料理で、深みのある味わいを楽しみたい。

透明度の高い貴重なヒマラヤ岩塩
ガンダーラの岩塩
クリスタルソルト

パキスタン

原産地 パキスタン

DATA
食塩相当量 98.6g
ナトリウム 38.8g

形 状 粉砕
水分量 さらさら
工 程 採掘／粉砕
原材料 岩塩

古代、アレクサンダー大王によって発見されたという、ヒマラヤ山脈最西端のケウラ岩塩鉱山から採掘された岩塩。これほど透明なものはめずらしい。適度なしょっぱさと粒のかたさを活かして、パンなどのトッピングにもおすすめ。

TASTE! 適度なしょっぱさ。雑味がなくクリア
おすすめ食材&料理 厚切りの豚肉のグリル、フォカッチャやプレッツェルのトッピング

価格／100g入り 330円
有限会社おちあいどっとこむ
静岡県富士市横割6-1-12
tel.0545-30-8835
http://www.77ochiai.com/

濃厚な食材や揚げ物に合わせたい四川の塩
四川省の岩塩

中国

原産地 中国

DATA
食塩相当量 96.5g
ナトリウム 38.0g

形 状 粉砕
水分量 さらさら
工 程 溶解／立釜
原材料 岩塩

中国内陸部に位置する塩の名産地、四川省。太古にできた岩塩層を水で溶かし、立釜で結晶させて仕上げた透明な岩塩。強いしょっぱさは揚げ物に最適。ほんのりとした甘味と苦味もあるので、オイルを使うたまご料理でもじょうずに味を引き立てる。

TASTE! 強めのしょっぱさ、ほんのりとした甘味、ほのかな苦味
おすすめ食材&料理 唐揚げ、野菜炒め、たまごとトマトの炒め物

価格／100g入り 330円
有限会社おちあいどっとこむ
静岡県富士市横割6-1-12
tel.0545-30-8835
http://www.77ochiai.com/

岩塩

salt column
大きくてかたい塩には「ミル」がおすすめ

そのまま使うには塩の結晶が大きすぎる時に、あると便利なのがミル。特にかたくて大きな結晶が多い岩塩は、粒胡椒のようにミルで挽いてから使います。

ミルは香りが飛びやすいスパイス類を、使う直前に挽けるように開発されたもの。かつては金属製の刃や回転軸が多く、塩で使うと特に錆びやすかったが、現在では、錆びないセラミック製のものが増えています。ミルに入れる塩は、湿気にくく、仕上げの振り塩など味の最終調整にも向いている、ナトリウムが多い塩がよいでしょう。特にナトリウム成分が多い傾向がある岩塩がおすすめです。

地下1000mに眠る岩塩と伏流水の塩
ラオスの天然岩塩
ラオス

塩の山が並ぶ塩田。

原産地 ラオス

DATA
形 状	粉砕
水分量	さらさら
食塩相当量	(89.4g)
ナトリウム	35.2g
工 程	天日／洗浄
原材料	岩塩

TASTE!
まろやかなしょっぱさ、ほどよい苦味、甘味とうまみ

おすすめ食材＆料理
トマトなどの濃厚なうまみの野菜、ひよこ豆のオリーブオイル焼き

東南アジア唯一の内陸国、ラオスでつくられる岩塩。地下1000m地点、約4億年前の岩塩層から汲み上げた太古の地下塩水を塩田で濃縮・結晶させている。さらに、濃度を調整した塩水で洗い、不純物を取り除いて完成する。まろやかなしょっぱさで、濃厚なうまみと甘味が、トマトなど味の濃厚な野菜や白い豆のコクをじょうずに引き出す。

価格／300g入り 1500円
株式会社TMI
東京都中央区
日本橋小伝馬町3-8 TIビル2F
tel.03-3666-6622
http://www.tmi1.co.jp/

アルプスの自然で育んだドイツの家庭塩
アルペンザルツ
ドイツ

壮大な自然のアルプス山脈。

原産地 ドイツ

DATA
形 状	粉砕
水分量	さらさら
食塩相当量	73.9g
ナトリウム	29.1g
工 程	溶解／立釜／乾燥／混合
原材料	岩塩、炭酸カルシウム、炭酸マグネシウム

TASTE!
やや強めのしょっぱさ、クリアな味、あっさりした甘さ

おすすめ食材＆料理
パスタや野菜のゆで塩、豚肉のソテーや塩釜焼き

ブルーの紙ボトルでお馴染みのドイツ産岩塩。バート・ライヒェンハルの2億5000万年前の岩塩層をアルプスの天然水で溶解し、異物を取り除いた後、立釜で結晶させ、炭酸カルシウムと炭酸マグネシウムをブレンド。その効果で、湿気に強く、さらさらが長持ち。苦味は弱く、すっきりとしたしょっぱさとカルシウム由来のほんのりした甘さを感じる。野菜のゆで塩にすると煮崩れ防止になる。

価格／250g入り 470円
SKWイーストアジア株式会社
東京都千代田区三番町2
三番町KSビル
tel.03-3288-7352
http://www.alpensalz.co.jp/

クリアなしょっぱさのシチリアの塩

サーレ・ディ・ロッチャ グロッソ

イタリア

イタリアのシチリアにある岩塩層から採掘された透明な岩塩。強めのしょっぱさで、雑味がなくクリアな味わいは、油っこいものをさっぱりとした後味にしてくれる。価格的にもふだん使いしやすく、梅干しなど漬け物づくりにおすすめ。細粒タイプもある。

TASTE! 強くてクリアなしょっぱさ、ほのかな甘味
おすすめ食材&料理 パスタや野菜のゆで塩、漬け物づくり、メカジキのオイル焼き

原産地 イタリア

DATA
食塩相当量 ―
ナトリウム ―

形 状 粉砕
水分量 さらさら
工 程 採掘/粉砕
原材料 岩塩

価格/500g入り 475円
ジャパンソルト株式会社
東京都中央区京橋1-1-1
八重洲ダイビル5F
tel.0120-16-4083
http://www.japan-salt.com/

さらさらでなじみがよいふだん使いの塩

バートイシュル・オーストリアアルプスの岩塩

オーストリア

映画『サウンド・オブ・ミュージック』の舞台として有名な、オーストリアのザルツカンマーグート地方。アルプスの自然に囲まれた岩塩層を溶解し、立釜で再結晶させている。強いしょっぱさと苦味は、白身肉の揚げ物にぴったり。

TASTE! やや強いしょっぱさと強い苦味、ほのかな酸味
おすすめ食材&料理 とんかつ、唐揚げなどの白身肉の揚げ物

原産地 オーストリア

DATA
食塩相当量 97.9g
ナトリウム 38.5g

形 状 立方体
水分量 さらさら
工 程 溶解/立釜/乾燥/混合
原材料 岩塩、炭酸カルシウム、塩化カリウム

価格/200g入り 350円
マスコットフーズ株式会社
東京都品川区西五反田5-23-2
tel.03-3490-8418
http://www.mascot.co.jp/

するどいしょっぱさが揚げ物にぴったり

ロレーヌ岩塩

フランス

フランス北東部、19世紀から採掘が続けられている歴史あるロレーヌ地方の岩塩。岩塩層に水を注入して濃縮された塩水を汲み出し、立釜で再結晶させている。強いしょっぱさと、雑味がないクリアな味わいで、揚げ物に合わせると、さっぱりとした食味を楽しめる。

TASTE! 非常に強いしょっぱさ、雑味がなくクリアな味
おすすめ食材&料理 揚げ物、パスタのゆで塩

原産地 フランス

DATA
食塩相当量 99.4g
ナトリウム 39.1g

形 状 立方体
水分量 さらさら
工 程 溶解/立釜/乾燥
原材料 岩塩

価格/250g入り 170円
株式会社白松
東京都港区赤坂7-7-13
tel.03-5570-4545
http://www.hakumatsu.co.jp/

岩塩

花びらのように薄く口どけのよいフレーク

フォッシルリバー 塩フレーク

スペイン

伏流水で溶けた2億4000万年前の岩塩層を汲み上げ、天日で結晶した後、洗浄をして仕上げた岩塩。スペイン内陸部の地中深くの岩塩層から生まれた薄いフレーク結晶は、舌の上でゆるやかに溶けて、骨太なしょっぱさとまろやかな苦味、じんわりとしたコクが広がる。

TASTE！ しっかりとしたしょっぱさ、まろやかな苦味、じんわり続くコク
おすすめ食材＆料理 冷奴、豆腐サラダをオイルとともに。レアに焼いた牛肉

原産地 スペイン

DATA
食塩相当量 97.5g
ナトリウム 38.4g

形　状　フレーク
水分量　さらさら
工　程　天日／洗浄
原材料　岩塩

価格／60g入り 1200円
株式会社メディファー
東京都千代田区九段北1-10-2 タイヤビル2F
tel.03-3261-3721
http://www.oliveoil-shop.jp/

マリでは贈答品にもなる貴重な岩塩

タウデニ村の岩塩

マリ

サハラ砂漠、マリ共和国のアルジェリア国境近くに位置するタウデニ村で採れる岩塩。ブロック状に切り出された岩塩は、ラクダの背に乗せられキャラバンによって、ソルトロード（塩の道）を通り各地に運ばれる。ほどよいしょっぱさと甘味は乳製品と相性がよい。

TASTE！ ほどよいしょっぱさと苦味、酸味。ミネラル感
おすすめ食材＆料理 乳製品を使った料理、豚肉の塩漬け

原産地 マリ

DATA
食塩相当量 96.5g
ナトリウム 38.0g

形　状　粉砕
水分量　さらさら
工　程　採掘／粉砕
原材料　岩塩

価格／100g入り オープン価格
有限会社おちあいどっとこむ
静岡県富士市横割6-1-12
tel.0545-30-8835
http://www.77ochiai.com/

salt column ― 塩のための道がある

岩塩や塩湖がない日本の内陸部では、ごく一部の地域を除き、塩は沿岸部から運ばれてくるものでした。その際、通ってくる道は「塩の道」と呼ばれ、日本各地に存在しました。

有名なものでは、三陸海岸と北上山地を牛（方言で「ベコ」）の背に塩を乗せて運んだ「野田ベコの道」や、新潟県糸魚川から長野県塩尻までの長距離を結ぶ「千国街道（ちくにかいどう）」があります。千国街道は川中島の合戦の際に、上杉謙信が武田信玄に塩を贈ったという逸話の舞台にもなった街道です。

一方、アフリカにもシルクロードならぬソルトロードが存在します。700km以上あるサハラ砂漠のルートを約3週間かけて横断する過酷な道。現在も、砂漠に点在する岩塩や塩湖で採れた塩をラクダの背中に乗せ、キャラバンたちは命がけで交易を続けています。

Part 4

変わり種いろいろ
そのほかの塩
〈湖塩・地下塩水塩・シーズニング〉

南米・ボリビアの絶景スポットとして知られるウユニ塩湖、
身体が浮いてしまうほどの塩分濃度を持つ死海など、
塩分を含んだ湖水が原料の湖塩。
温泉水や地下水を結晶化させた地下塩水塩。
そして、塩以外のさまざまな味や質感を持つ食材と、
塩を合わせて仕上げるシーズニング。
バラエティ豊かな塩たちを紹介します。

湖塩

鏡のような湖面が美しい、ボリビアのウユニ塩湖。

塩分濃度が高い湖で自然に結晶した塩

　塩分濃度の高い湖を「塩湖」といい、そこで自然に結晶した塩を「湖塩」と呼びますが、塩湖にはいくつかの成り立ちがあります。地殻変動によって陸に閉じ込められた海水が徐々に乾燥してできたもの、もともと盆地であった場所に塩分を含んだ水が流れ込み湖を形成した後、出口がないために徐々に塩分濃度が高まったもの。また、オーストラリアのデボラ湖のように、海水の飛沫が強い風によって運ばれ、塩分濃度が高まっためずらしい場所もあります。流入する川がないことが多く湖面が揺れないので、平坦な塩湖は鏡面のように周囲の景色を映します。ボリビアのウユニ塩湖は、そんな絶景スポットとして有名です。岩塩と海水塩の中間のような特徴を持つ塩が多い傾向があります。

check! 塩湖ができるまで

はるか昔に起きた地殻の隆起によって、陸地に取り残された海水が、長い年月をかけ水分が蒸発して、塩湖ができる。

PART ❹ そのほかの塩

世界有数の絶景スポットで生まれる純白の結晶

天空の鏡 ウユニの塩

ボリビア

粒の大きさ：大／小
しょっぱさ：強

しょっぱさ：6　酸味：5
苦味：7　うまみ：5
雑味：6　甘味：5

湖塩

DATA
食塩相当量	94.9g
ナトリウム	37.4g
カリウム	37.2mg
マグネシウム	42.5mg
カルシウム	555mg

原産地　ボリビア

形　状　粉砕
水分量　さらさら
工　程　採掘／粉砕
原材料　湖塩

TASTE!
適度なしょっぱさ、はっきりしたうまみと甘味、肝を思わせる苦味

おすすめ食材＆料理
きゅうりや白菜の浅漬け、豆腐や納豆、肝吸い、大腸など白系のホルモン料理、鮎の塩焼

収穫の最盛期を迎えるのは乾季まっただなかの6月。塩原に変わった湖面には、あちこちに塩山が並ぶ。

価格／360g入り 463円
薬糧開発株式会社
神奈川県横浜市西区
みなとみらい2-3-5
tel.0120-670-082
http://yakuryo.co.jp/

　ウユニ塩湖は、南米ボリビア中央西部、アンデス山脈に囲まれた標高約3700mにある塩湖で、その面積は四国の半分以上と、高地にある塩田としては世界最大規模を誇っている。太古の海が約180万年前に隆起してできた、世界でもっとも平らな場所。塩水が張った湖面が空を映し出す様は「天空の鏡」といわれ、世界有数の絶景スポットだ。
　乾季になると、塩をブロック状に切り出し、粉砕・洗浄して商品に加工し、世界中に輸出している。一部、乾季でも塩水が干上がらない場所からはフレーク状の結晶が採取されるが、日本国内での流通はほとんどない。細かく粉砕された塩のピラミッド型の結晶は、舌の上ですっと溶け、適度なしょっぱさと、はっきりとしたうまみ、甘味、そして肝のような苦味が感じられる。きゅうりや白菜などの淡泊な野菜や、白系のホルモンと相性がよい。

アッサルの塩

世界一の塩分濃度の湖で生まれた球形の宝石

ジブチ

波打ち際にできる塩のオブジェ。

原産地 ジブチ

粒の大きさ 大／小
しょっぱさ 弱／強

DATA
形状　球状
水分量　さらさら
食塩相当量（99.8g）　工程　採掘
ナトリウム　39.3g　原材料　湖塩

TASTE!
強めのしょっぱさと雑味、ほのかな酸味と甘味

おすすめ食材&料理
特に白身の生の魚介類

湖塩

宝石のような美しい塩の球体は、東アフリカのジブチ共和国にあるアッサル塩湖で生まれる。砂漠地帯に現れる蒼く澄んだ塩分濃度約35％の塩湖では、完全に自然の力のみによって球状に塩が結晶する。打ちよせる波間に塩の玉が転がり、角が取れる。冷凍庫で冷やした塩を皿に敷き、生魚など水分のある食材をのせると、見た目にも華やかで、かつ絶妙な塩加減が楽しめる。粒タイプもある。

価格／100g入り 400円
株式会社 FAR EAST
埼玉県飯能市大河原33-1
tel.042-973-2060
http://fareastinc.co.jp/

salt column　世界で一番大きい「塩湖」は？

世界でもっとも大きな塩湖は、中央アジアに広がるカスピ海。ロシア、アゼルバイジャン、イラン、トルクメニスタン、カザフスタンに囲まれています。面積は約374,000平方kmと、日本の国土とほぼ同じ広さがあります。「海」と名前がついているので海だと勘違いされがちですが、水が流れだす出口がなく、水分だけが蒸発して塩分濃度が濃くなっているため、「塩湖」の定義に当てはまります。チョウザメなど魚介類が豊富に獲れ、古くから東西交通路としても活用されてきました。

しかし、カスピ海の海底で石油の埋蔵が発見されて以来、「海として扱うべき」とする沿岸国と、「湖として扱うべき」とする沿岸国で論争が勃発し、いまだ決着がついていません。

カスピ海とバクー油田の油井やぐら。

静かなる塩湖の結晶
死海の湖塩　イスラエル

生物が生息できない、塩分濃度30％の死海の結晶。魚の内臓を思わせる苦味が特徴で、わかさぎの唐揚げなどと相性抜群。うまみと苦味を引き立てる。

原産地　イスラエル

DATA
- 食塩相当量　98.3g
- ナトリウム　38.7g
- 形状　粉砕
- 水分量　さらさら
- 工程　立釜／粉砕／洗浄／乾燥
- 原材料　湖塩

TASTE! 適度なしょっぱさ、魚の内臓のような苦味
おすすめ食材＆料理 鮎などの川魚や内臓ごと食べる魚料理

価格／100g入り 330円
有限会社おちあいどっとこむ
静岡県富士市横割6-1-12
tel.0545-30-8835　http://www.77ochiai.com/

うまみたっぷりのモロッコ岩塩
砂漠の国の塩　モロッコ

地中の伏流水により溶けて湧き出た岩塩などで人口塩湖をつくり、塩田に引き入れて天日で結晶化。しょっぱさと苦味が揚げ物に◎。うまみもある。

原産地　モロッコ

DATA
- 食塩相当量　99.0g
- ナトリウム　38.9g
- 形状　粉砕
- 水分量　さらさら
- 工程　天日／粉砕
- 原材料　湖塩（岩塩／海水）

TASTE! 強いが角がないしょっぱさと苦味、だしのようなうまみ
おすすめ食材＆料理 とんかつやコロッケなどの揚げ物、野菜スープ

価格／100g入り 530円
有限会社おちあいどっとこむ
静岡県富士市横割6-1-12
tel.0545-30-8835　http://www.77ochiai.com/

湖塩

南米の塩湖で生まれたうまみ塩
砂漠の湖 サリーナ湖塩　ペルー

ペルーとボリビアを跨ぐ広大な砂漠に忽然と現れる塩湖。湖畔のくぼみに塩水を入れて乾燥させ、土をかぶせて保存する。強い甘味とうまみが美味。

原産地　ペルー

DATA
- 食塩相当量　96.3g
- ナトリウム　37.9g
- 形状　粉砕
- 水分量　さらさら
- 工程　天日
- 原材料　湖塩

TASTE! 少し強めのしょっぱさ、強い甘味とうまみ
おすすめ食材＆料理 豚肉、脂ののった白身魚の塩釜焼き

価格／100g入り 380円
有限会社おちあいどっとこむ
静岡県富士市横割6-1-127
tel.0545-30-8835　http://www.77ochiai.com/

秘境で生まれる自然の白い結晶
デボラ湖塩　オーストラリア

デボラ湖は偏西風によって運ばれた海水の飛沫が蓄積し、約500万年前に形成された塩湖。野菜に合う甘味ある塩は、オーストラリアのオーガニック認定済。

原産地　オーストラリア

DATA
- 食塩相当量　99.5g
- ナトリウム　39.0g
- 形状　粉砕
- 水分量　標準
- 工程　天日／洗浄／粉砕
- 原材料　湖塩

TASTE! ほどよいしょっぱさの後に強めの甘味と苦味が続く
おすすめ食材＆料理 野菜の煮物、漬け物

価格／500g入り 300円
兼松塩商株式会社
大分県中津市植野24-1
tel.0979-32-5698　http://kanematsu-salt.com/

地下塩水塩

「スイーツソルト」（p.136）の原料となる源泉。

地中の塩水など土壌の影響を受けている塩

　地下塩水塩とは、地中に溜まった塩分濃度の高い塩水を原料にしてできる塩。地中に埋まった岩塩が地下を流れる伏流水によって、溶かされて溜まったものや、海にほど近い場所で湧く塩化物泉のように、海水の影響を受けて地下水に塩分が含まれたものがほとんど。

　地中に滞留しているので、土壌の影響を色濃く受け、海水塩や、ナトリウムを主体とする岩塩とは違った風味を醸し出します。

　なお、塩化物泉が湧く日本の内陸部などでは、約2300万年前から500万年前に形成された緑色凝灰岩と呼ばれる少量の海水を含む石が、火山の熱で温められて海水成分が溶け出しているという、めずらしい例もあります。

Topics 日本の地下塩水の多くは塩化物泉

　日本は多くの源泉に恵まれ、塩分を含んだ温泉も多く湧き出しています。新潟県や福島県の山間部、群馬県の北部や長崎県の小浜などでは、この源泉を利用した塩づくりが盛んに行われていました。しかし、長野県の大鹿村のような一部を除き、塩分濃度が海水よりも薄いことがほとんど。効率が悪いため、現在では塩化物泉から製塩を行う生産者は全国にも数えるほどしかいない、希少な塩になっています。

オーストラリアの大地の栄養をつめ込んだ結晶

オーストラリア・ピンクリバーソルト

オーストラリア

オーストラリアの首都・メルボルンから北西500kmほどにある、内陸の町・メルドゥラで採取される地下塩水を原料に生産されたフレーク状の塩。

マレー川が流れるこの一帯は、太古より降雨量が少ない上に気温が高く、地中に染み込む前に蒸発してしまうため、地下の塩分が濃縮され、塩分濃度の高い地下塩水が溜まっている。この地下の塩水を塩田に汲み上げて、太陽と風の力で結晶化。鉄分を多く含む土壌の影響を受け、結晶はきれいな薄いオレンジ色に。また、カルシウムを多く含むことから、塩味はまろやかな口当たり。鉄からくる酸味、そして肉や魚に多く含まれるイノシン酸のようなはっきりとしたうまみは、牛肉やマグロなどの赤身の肉、魚との相性が抜群。シンプルにソテーした食材に、軽く指でつぶしながらふりかけるだけで、口の中で広がる脂のうまみと、ゆるやかに溶ける塩味のハーモニーが楽しめる。

粒の大きさ：大/小
しょっぱさ：強

しょっぱさ：5　酸味：6
苦味：4　うまみ：7
雑味：5　甘味：7

地下塩水塩

TASTE！ ほどよいしょっぱさ、鉄由来の酸味、しっかりとしたうまみ
おすすめ食材＆料理　牛肉のステーキ、大トロなど脂ののった赤身の炙りやソテー

DATA

食塩相当量（96.5g）
ナトリウム　38.0g
カリウム　300mg
マグネシウム　800mg
カルシウム　150mg

形状　フレーク
水分量　さらさら
工程　天日
原材料　地下塩水

原産地　オーストラリア

価格／20g入り　756円（税込）
レピス・エピス
東京都目黒区自由が丘2-9-6
tel.03-5726-1144
http://www.lepiepr.com/

天空の塩田で600年続く天日塩
インカ天日塩

ペルー

マラス村の採塩風景

原産地 ペルー

DATA
- 形　状　粉砕
- 水分量　さらさら
- 食塩相当量　95.7g
- ナトリウム　37.6g
- 工　程　天日／粉砕
- 原材料　地下塩水（岩塩）

TASTE!
まろやかなしょっぱさ、粘度を感じる強い甘味

おすすめ食材&料理
じゃがいもやにんじんなどの熱すると甘くなる根野菜、蒸し野菜

地下塩水塩

アンデス山脈の中腹、標高3000mのマラス村では、インカ時代から変わらない塩づくりが続けられている。「天空の塩田」とも呼ばれる、山間に広がる5000枚もの棚田はまさに壮観のひと言。岩塩が溶けてできた地下塩水を塩田に引き入れ、天日で濃縮・結晶化する。まろやかな塩味と、ねっとりとした甘さを持ち、じゃがいもやにんじん、たまねぎなど野菜の甘味をぐんぐん引き出す。

価格／100g入り 300円
株式会社アルコイリスカンパニー
千葉県松戸市下矢切72
tel.047-711-5041
http://www.arcoiris.jp/

温泉の力で炊き上げた上質な塩
スイーツソルト

長崎

ていねいに結晶をすくう

原産地 長崎県

DATA
- 形　状　凝集晶
- 水分量　標準
- 食塩相当量　60.7g
- ナトリウム　23.9g
- 工　程　平釜
- 原材料　温泉水

TASTE!
適度なしょっぱさ、強めのミネラル感、余韻にほのかな苦味と甘味。しょうがのような香りが残る

おすすめ食材&料理
白身魚の塩焼き、ゆでたまご、葉野菜、ひやしあめ、甘酒

370年の歴史ある小浜温泉は、源泉温度が日本一高く、かつて温泉水を利用した塩づくりが行われていた。それを地元在住の木村さん親子の手で復活。CO_2排出量を考慮し、温泉水を源泉の熱で湯煎しながら濃縮・結晶させ、さらに天日にさらして仕上げている。強めのミネラルと上品な甘さのある塩は、食材の力をぐっと引き上げる。JR九州の豪華列車でも採用された逸品。

価格／80g入り 1000円
雲仙エコロ塩株式会社
長崎県雲仙市
小浜町マリーナ8-1
tel.095-856-9164
https://www.facebook.com/ecologeo

弘法大師の伝説が残る温泉の塩
会津山塩

福島

薪で焚く製塩釜。

原産地
福島県

粒の大きさ：大／小
しょっぱさ：強

DATA
食塩相当量	78.0g
ナトリウム	30.5g
形状	凝集晶
水分量	標準
工程	平釜
原材料	温泉水

TASTE!
ほどよいしょっぱさ、強い鉄のような酸味、強いミネラル感、適度な甘さと苦味

おすすめ食材&料理
ローストビーフや赤身の魚の塩焼き、牡蠣などの貝類

弘法大師が1200年前に開湯したといわれている、福島県の大塩裏磐梯温泉。塩がなくて難儀している様を憐れみ、大師が護摩を焚くと、塩水が湧き出したという伝説が残る。戦後に一度途絶えた温泉水での塩づくりだが、街づくりの一環として2007年に復活。塩分濃度の低い温泉水を平釜でじっくり炊き上げることにより生まれる豊かな味わいの塩は、濃厚な赤身肉や貝類のうまみを際立たせる。

価格／30g入り 400円
会津山塩企業組合
福島県耶麻郡北塩原村
大字大塩字太田2番地
tel.0241-33-2340
http://aizu-yamajio.com/

地下塩水塩

海底温泉水を結晶したやさしい塩
子宝の温泉塩

鹿児島

原産地
鹿児島県

粒の大きさ：大／小
しょっぱさ：強

DATA
食塩相当量	(75.6g)
ナトリウム	29.8g
形状	凝集晶
水分量	標準
工程	平釜
原材料	海水（温泉水）

TASTE!
まろやかなしょっぱさ、酸味と雑味、余韻にうまみと甘味

おすすめ食材&料理
ゆでたまご、落花生の塩煮、塩おにぎり

鹿児島県トカラ列島のひとつ小宝島では、海底から83℃の海水温泉が湧き出すという。その温泉水を汲み上げ、平釜で炊いて濃縮・結晶させた後、天日で干した塩は、やさしくまろやか。ほのかな酸味と雑味の後、うまみと甘味の余韻が広がる。味のバランスがよく、粒も小さめで食材へのなじみもよい万能塩。特にゆでたまごや落花生の塩煮、塩おにぎりなどこっくりとした食材に。

価格／250g入り 650円
有限会社小林工房
鹿児島県鹿児島郡十島村
小宝島1-19
tel.09912-4-2000

西伊豆の温泉水と海水のブレンド塩

さんぽの塩

静岡

駿河湾を望む、西伊豆の三浦地区に湧く、5つの塩分を含む源泉から汲み上げた温泉水と海水をブレンドし、平釜で煮詰めて仕上げている。ほどよいしょっぱさと強い苦味と雑味が、山菜や釜あげしらすなど、苦味のある食材を深みある味わいに昇華する。

TASTE！ ほどよいしょっぱさ、強い苦味と雑味
おすすめ食材&料理 山菜のてんぷら、釜あげしらす、白身魚の塩焼き

原産地 静岡県

DATA
食塩相当量 95.2g
ナトリウム 37.5g
形状 凝集晶
水分量 標準
工程 平釜
原材料 温泉水、海水

価格／100g入り 350円
松崎三浦温泉株式会社
静岡県賀茂郡松崎町石部592-4
tel.0558-45-0759
http://www.sanpo-onsen.com/

地下塩水塩

山の養分を蓄えてできただしのような塩

山塩

長野

南アルプスの山間に湧く大鹿温泉の旅館、山塩館の自家製塩。海水よりも濃い塩分を含んだ温泉水を平釜でじっくり煮詰めている。うまみの強い野菜や白米にシンプルに振るだけで、味に厚みが加わるだしのような塩。かつては大正天皇の献上品となった逸品。

TASTE！ まろやかなしょっぱさ、グルタミン酸のような濃厚なうまみ
おすすめ食材&料理 塩おにぎり、トマトなどのうまみの濃い野菜

原産地 長野県

DATA
食塩相当量 96.5g
ナトリウム 38.0g
形状 凝集晶
水分量 標準
工程 平釜
原材料 温泉水

価格／50g入り 550円
鹿塩温泉 湯元 山塩館
長野県下伊那郡大鹿村鹿塩631-2
tel.0265-39-1010
http://www.yamashio.com/

salt column

「盛り塩」の起源は中国の皇帝だった

店先や会社の玄関で見かける、小さく盛った塩。客を招く、福を招くといわれから、現代の風景にも定着しました。

起源は古く、中国の晋の始皇帝が中国を統一した頃という説があります。絶大な権力を誇る皇帝は3000名を超える美女を寵愛し、毎夜牛車に乗って美女のところへ訪れます。しかし、数が多すぎて、同じ美女のところに訪れるのは数年に一度。そこで考えられたのが、盛り塩。牛車を引く牛は、塩を大量に必要とするため、玄関先に塩を置くと、舐めるために牛が勝手に足を止めるので、皇帝はその美女のところに行かざるを得ないという寸法です。

日本でも、奈良時代や平安時代には、貴族の乗った牛車を引き止めるため、娘がいる家では玄関先に盛り塩をしていたそうです。

シーズニング

個性的な色と質感が楽しめる彩りの塩

塩にスパイスやハーブをブレンドしたものを総称して「シーズニング（ソルト）」といいます。「season」の「味をつける」という意から、料理に味をつけてくれる塩、味がついた塩となったようです。

最近では、でき上がった塩に材料を混ぜるだけでなく、海水をベースにしてつくったソースを煮詰めたもの、塩分を含んだエキスを煮詰めたもの、燻製にしたものなど、多彩なシーズニングがつくられるようになりました。香りがあり、それだけで料理の味が決まるものが多いので、ふだん使いにも、おもてなしの料理にも、便利に使えます。

ピンクや黒などの個性的な色合いや、さまざまな素材が混ざった質感、香りがいつもとは異なる彩りを食卓に加えてくれるでしょう。

加工を待つ「ブルーチーズソルト」。（p.142）

燻製 smoke

塩を燻製した、スモーキーなテイストのシーズニング・ソルト。料理の仕上げにひと振りするだけで、芳醇な燻製の香りがテーブルに広がります。シンプルな肉や野菜のソテーも、上質なおもてなし料理に変身！

マルドン スモーク

イギリス

DATA
食塩相当量	99.0g
ナトリウム	39.0g
原材料	海塩

イギリス産のピラミッド型海水塩「マルドン シーソルト」（p.34）をイングリッシュオーク（樽の木）で丹念にスモーク。シャクシャクした食感が楽しめる。スモーキーな香りは肉類に。

価格／125g入り 580円
株式会社 鈴商
東京都新宿区荒木町23
tel.03-3225-1161
http://www.suzusho.co.jp/

地中海クリスタルフレークソルト スモーク

キプロス

DATA
食塩相当量　98.1g
ナトリウム　38.6g
原材料　海塩　スモークフレーバー

地中海に浮かぶキプロス島で、手作業でつくられるピラミッド形の海水塩に燻製フレーバーをプラスしている。軽やかなフレーク状の結晶でシャクシャクとした歯ごたえが楽しめる。

価格／125g入り 1600円
有限会社アルテヴィータ
東京都世田谷区若林1-2-2-1001
tel.03-3487-3506
http://www.arte-vita.biz/

燻製塩

ボリビア

DATA
食塩相当量　（97.7g）
ナトリウム　38.5g
原材料　岩塩

イタリアンレストランが手がける、ボリビア産ピンク岩塩を燻製した塩。強すぎない燻香で使いやすい。容器についたミルで挽いて、同じく軽く燻製した食材に合わせるのが◯。

価格／50g入り 1000円
アル・ケッチァーノ
山形県鶴岡市下山添一里塚83
tel.0235-78-7230
http://www.alchecciano.com/

アドリア海の風

スロヴェニア

DATA
食塩相当量　——
ナトリウム　——
原材料　海塩

燻製のプロフェッショナルがスロヴェニア産海水塩に惚れ込み、苦労の末、完成させた燻製塩。芳醇なスモークの香りが鼻へ抜け、口の中にはうまみが広がる。肉やたまごにひと振りで美味。

価格／200g入り 2000円
エンジ株式会社
長野県北佐久郡軽井沢町
大字長倉字中山 628-9
tel.0267-44-6700
http://www.kazenoshiwaza.com/

シーズニング

salt column
おいしさの要は「いい塩梅（あんばい）」

塩はおいしいと感じられる濃度の範囲が砂糖などに比べると非常に狭く、その濃度は約0.5％～約3％ほど。「いい塩梅」という言葉があるように、微妙な塩加減がおいしさを大きく左右します。どのような塩を使うかも重要ですが、適切な塩加減で調理することが、食材のおいしさを引き出すためにはなにより重要といえるでしょう。

PART ❹ そのほかの塩

混ぜる
mix

塩にさまざまな材料を加えて、混ぜ合わせたシーズニング・ソルト。定番はハーブやスパイスを混ぜたもの。黒い塩はイカスミまたは炭をミックスして焦げの風味を演出したり、地域の特産品を使ったものも増えています。

シーズニング

トリュフ塩　イタリア

DATA
食塩相当量　95.8g
ナトリウム　37.7g
原材料　海塩、トリュフ、香料

イタリア・サルデニア産海水塩に、香り高いイタリア産の黒トリュフをブレンド。たまご料理やゆで野菜にひと振りするだけで、レストランのリッチな味わいに。天ぷらなどの日本食にも合う。

価格／50g入り 1944円
株式会社アーパ・アンド・イデア
東京都文京区水道 2-11-10 大都ビル 2F
tel.03-5319-4455
http://www.apidea.co.jp/

セル・デ・ヴァン メルロー　フランス

DATA
食塩相当量　93.0g
ナトリウム　35.5g
原材料　海塩、メルローワイン、黒胡椒、白胡椒、赤胡椒、タイム、月桂樹、セージ

フランスのイル・ド・レ産海水塩をビオのメルローワインに漬け込んで、数種類のスパイスとブレンド。チーズや牛肉に振りかけて。シラーやソーヴィニヨンもあるので使いわけたい。

価格／70g入り 1300円
有限会社フランソワーズ・ジャパン
埼玉県上尾市浅間台4-19-25
tel.048-771-4749
http://www.francoisejapan.com/

クレイジーソルト　アメリカ

DATA
食塩相当量　86.4g
ナトリウム　34.0g
原材料　岩塩、ペッパー、オニオン、ガーリック、タイム、セロリー、オレガノ

1960年代に誕生し、今や世界中で愛される定番の調味塩。アメリカ産岩塩に、ガーリックやタイムなど数種類のスパイス＆ハーブをブレンドしている。特に肉類との相性が抜群。

価格／113g入り 627円
日本緑茶センター株式会社
東京都渋谷区桜丘町24-4東武富士ビル
tel.0120-821-561
http://www.jp-greentea.co.jp/

ハーブ入りアルペンザルツ

ドイツ

DATA
食塩相当量	81.5g
ナトリウム	31.5g
原材料	岩塩、パセリ、セロリ オニオン、バジル ディル、マジョラム ベイリーフ、ローズマリー オレガノ、タイム

ドイツ産岩塩に10種類の天然ハーブをブレンド。香り高いハーブが、料理に彩りと香りをプラス。鶏肉や魚はもちろん、オイルと合わせてドレッシング代わりにするのもおすすめ。

価格／125g入り 490円
SKWイーストアジア株式会社
東京都千代田区三番町2 三番町KSビル6F
tel.03-3288-7352
http://www.skwea.co.jp/

GARDENSTYLE FANCY MUSHROOM MIX

日本・静岡

DATA
食塩相当量	88.9g
ナトリウム	35.0g
原材料	海塩、岩塩 ポルチーニ、トリュフ 黒にんにく、香料

ポルチーニやトリュフなど豊かな香りを放つ素材と、フランス、沖縄産の塩をブレンド。牛肉やクリームパスタの仕上げにぱらりとかけると、香りはもちろんのこと濃厚なうまみが楽しめる。

価格／90g入り 500円
有限会社 三角屋水産
静岡県賀茂郡西伊豆町仁科1190-2
tel.0558-52-0132
http://sankakuya.shop-pro.jp/

ブルーチーズソルト

カナダ

DATA
食塩相当量	99.8g
ナトリウム	39.3g
原材料	海水 ブルーチーズ

「カナディアンシーソルト」(p.48)にブルーチーズをブレンド。こっくりとした濃厚なチーズの風味を楽しめる。ポテトサラダやフライドポテトにおすすめ。ワインと合わせるのも◎。

価格／45g入り 600円
株式会社IRONCLAD
広島県福山市神辺町新潟野64-4
tel.084-962-5222
http://visalt.jp/

落花塩

日本・神奈川

DATA
食塩相当量	19.9g
ナトリウム	7.8g
原材料	落花生、天日塩 カシューナッツ ごま、クミン

ヨーロッパで人気のミックススパイスをヒントに、神奈川県西湘産の落花生と塩、スパイスをミックス。落花生の香ばしさとうまみは、たまごや焼き魚、アボカド、サラダにぴったり。

価格／60g入り 840円
落花チェー
神奈川県中郡大磯町大磯1668
tel.090-2645-6436
https://www.facebook.com/rakkache/

ハワイアンブラックソルト

アメリカ

DATA
食塩相当量　—
ナトリウム　—
原材料　海塩、炭

ハワイ産のピラミッド型の塩に、活性炭をブレンド。フレーク状の結晶はシャクシャクした食感が特徴。牛肉のステーキや豚肉のグリルに添えると香ばしさを演出してくれる。

価格／40g入り 756円（税込）
レピス・エピス
東京都目黒区自由が丘1-14-8
tel.03-5726-1144
http://www.lepiepi.com/

黒い塩

日本・秋田

DATA
食塩相当量　—
ナトリウム　—
原材料　海水、竹

秋田県の「男鹿半島の塩」（p.56）を、孟宗竹に詰め焼成した黒い塩。香ばしさと、ほんのり温泉たまごのような硫黄の香りが漂う。イカなどの白身の刺身との相性が抜群。

価格／40g入り 500円
株式会社 男鹿工房
秋田県男鹿市船川港船川字海岸通2-9-5
tel.0185-23-3222
http://ogakoubo.com/

シーズニング

珠洲の竹炭塩

日本・石川

DATA
食塩相当量　96.5g
ナトリウム　38.0g
原材料　海塩、竹

昔ながらの製法でつくった珠洲の海水塩を、能登の3年ものの竹に詰め、炭焼き職人が焼き上げた塩。やわらかくゆでた肉や、浅く焼いたステーキに香ばしさをプラスしてくれる。

価格／100g入り 602円
有限会社新海塩産業
石川県珠洲市長橋町15-18-11
tel.0768-87-8140
http://www.suzutennen-shio.jp/

フィオッキディサーレ ブラック

キプロス

DATA
食塩相当量　97.0g
ナトリウム　38.2g
原材料　海塩、食用炭

キプロス産のピラミッド形の海水塩に竹炭をブレンド。ローストビーフなど赤身の肉の仕上げとして。シャクシャクした結晶の食感と香ばしさが加わるので、アクセントにぴったりの塩。

価格／28g入り 676円
株式会社アーパ・アンド・イデア
東京都文京区水道2-11-10 大都ビル2F
tel.03-5319-4455
http://www.apidea.co.jp/

レモンソルト

日本・熊本

DATA
食塩相当量 ―
ナトリウム ―
原材料 海塩、レモン

熊本県産海水塩に有機栽培のレモンパウダーをブレンド。レモンの風味がしっかり残っているので、鶏の唐揚げはレモン不要なほど。揚げ物やサラダなどふだんの料理に気軽に使って。

価格／25g入り 450円
有限会社 ソルト・ファーム
熊本県熊本市中央区中唐人町292
tel.096-355-4140
http://saltfarm.jp/

みかん塩

日本・愛媛

DATA
食塩相当量 67.9g
ナトリウム 27.0g
原材料 海塩、みかんパウダー、香辛料

愛媛県産の温州みかんの皮をフリーズドライし粉末化したみかんパウダーと、「伯方の塩」（p.83）をブレンドしている。香辛料がアクセントになり、チョコレートとも好相性。

価格／18g入り 400円
伊方サービス株式会社
愛媛県西宇和郡伊方町九町字浦安1-1349-1
tel.0894-39-0902
http://www.mikanpowder.jp

すだちソルト

日本・徳島

DATA
食塩相当量 ―
ナトリウム ―
原材料 海塩、すだち

徳島県鳴門の海水塩に特産品のすだちパウダーをブレンド。香り高いすだちの風味が肉料理や揚げ物をさっぱりとした食味に。てんぷらのつけ塩としても◯。観光土産品認定品。

価格／55g入り 500円
有限会社ハス商会
徳島県勝浦郡勝浦町三渓豊毛本19-1
tel.0885-42-4559
http://www.has710.com/haslabo/

笹の雫

日本・新潟

DATA
食塩相当量 ―
ナトリウム ―
原材料 海塩、熊笹

新潟県産の海水塩に熊笹エキスをブレンド。さわやかな笹の香りが鼻に抜け、ほのかな甘味を感じる。料理はもちろん、あずきやバニラアイスと合わせてもおいしい。

価格／130g入り 649円
有限会社日本海企画
新潟県村上市勝木63-2
tel.0254-77-3009
http://www.isosio.com/

シーズニング

石垣の塩 モリンガ

日本・沖縄

DATA
食塩相当量　76.3g
ナトリウム　32.6g
原材料　海塩、モリンガ

スーパーフードとしても名高い、西洋わさびの木・モリンガの粉末を「石垣の塩」（p.98）にブレンド。口に含むと、甘味とほのかな苦味が広がる。てんぷらなど揚げ物のつけ塩に。

価格／20g入り 880円
石垣島モリンガ合同会社
沖縄県石垣市登野城217
tel.0120-499-334
http://www.ishigakijima.ne.jp/

わさびのおいしいお塩

日本・静岡

DATA
食塩相当量　42.5g
ナトリウム　16.7g
原材料　食塩、マルトース、昆布粉末、わさび香料

国産海水塩に国産わさびパウダーをブレンド。日高昆布の粉末も加え、わさびの辛さが引き立つ、うまみのある塩に仕上げた。刺身や天ぷらのつけ塩がおすすめ。

価格／20g入り 250円
株式会社 田丸屋本店
静岡県静岡市駿河区下川原5-34-18
tel.054-258-1115
http://www.tamaruya.co.jp/

月の塩 緑茶塩

日本・宮崎

DATA
食塩相当量　—
ナトリウム　—
原材料　海塩、緑茶（北浦産）

「月の塩 ダイヤモンド」（p.91）に、同町の特産品・緑茶をパウダーにしてブレンド。お茶の甘味と苦味、酸味がしっかり感じられる。てんぷらや塩スイーツと好相性。

価格／40g入り 370円
北浦総合産業株式会社
宮崎県延岡市北浦町古江3337-1
tel.0982-45-3811
http://www.michinoeki-kitaura.com/tsukinosio/

カラーソルト

日本・青森

DATA
食塩相当量　—
ナトリウム　—
原材料　海塩、レッドカラントほか

自社農場で育てたレッドカラントやボイズンベリー、パプリカなど、フルーツや野菜を主原料とした色素成分を用いてつくった塩。素材そのものの鮮やかな色合いが目を楽しませてくれる。

価格／43g入り 300円
有限会社下北半島ネットワーク機構
アグリ部門：ベリーオーチャード下北
青森県むつ市緑ヶ丘13-6
tel.0175-23-2168

シーズニング

桜の塩

日本・東京

DATA
食塩相当量　77.3g
ナトリウム　30.4g
原材料　海塩、桜の花の塩漬け

こだわりの伝統海塩「海の精」(p.59)を高温で壺焼きし、奈良・吉野の八重桜の花びらを独自製法でミックス。てんぷらに添えたり、豆腐やアイスクリームにも。季節限定品。

価格／10g入り 300円
海の精株式会社
東京都新宿区西新宿7-22-9
tel.03-3227-5601
http://www.uminosei.com/

シーズニング

煮詰める
boil down

塩に果汁などを加えて炊き上げ、再結晶したり、生牡蠣のエキスや梅酢などの液体を煮詰めて結晶化したりしてつくるシーズニング・ソルト。材料のうまみや風味がしっかり塩に入り、最後まで香りや味が続きます。

フラワーソルト

日本・新潟

DATA
食塩相当量　—
ナトリウム　—
原材料　海塩、ビオラ

自社で育てたこだわりのエディブルフラワーを乾燥させて、「日本海の塩 白いダイヤ」(p.67)とブレンド。仕上げにひと振りするだけで、シンプルな料理もぱっと華やかにしてくれる。

価格／12g入り 950円
株式会社脇坂園芸
新潟県阿賀野市境新209
tel.0250-62-6772
http://www.wakisaka-engei.jp/

ワイルドグレープソルト

日本・岩手

DATA
食塩相当量　—
ナトリウム　—
原材料　海塩、山ぶどう果汁

自社農園で栽培した無農薬ワイルドグレープジュースに、三陸宮古産の海水塩を混ぜ、温泉の地熱で乾燥させた塩。甘味と酸味があり、フルーツを使ったサラダやてんぷらに。

価格／30g入り 800円
WILD GRAPE FARM
岩手県八幡平市西根寺田8-86-3
tel.0195-77-1570
http://www.wildgrapefarm.com/

赤ワイン塩

日本・山形

DATA
食塩相当量　—
ナトリウム　—
原材料　海水、ぶどう

「酒田の塩」(p.58)に、山形県産山ぶどうのワインの風味をプラス。ワイン製造後に出るぶどうの果皮をいっしょに煮込む。ほのかな甘さが、牛肉の味つけやサラダにぴったり。

価格／30g入り 410円
酒田の塩
山形県酒田市宮梅字村東14-2
tel.0234-34-2015
http://www.sakatanoshio.com/

湧出の塩 だし塩

日本・沖縄

DATA
食塩相当量　89.9g
ナトリウム　35.4g
原材料　海水、たまねぎ、にんじん、かつおぶし、にんにく、昆布

沖縄本島沖、北西9kmに浮かぶ伊江島の海水をベースに、にんにくなど複数の素材を加えてタレをつくり、そのまま濃縮・結晶させた塩。バーベキューや焼肉に大活躍間違いなし。

価格／50g入り 258円
伊江島製塩
沖縄県国頭郡伊江村字東江上3674
tel.0980-49-5224

牡蠣の塩

日本・京都

DATA
食塩相当量　57.1g
ナトリウム　22.8g
原材料　(瀬戸内海)生牡蠣

瀬戸内海産の生牡蠣のエキスを抽出して濃縮・結晶させた変わり塩。牡蠣そのものの味が残っていて、うまみも強い。仕上げ塩に使えば料理や食材のうまみがいっそう引き立つ。

価格／15g入り 800円
日本クリニック株式会社
京都市右京区太秦開日町10-1
※2017年移転予定
tel.075-882-6711
http://www.japanclinic.co.jp/

イカスミ塩 ミエルシオ

日本・北海道

DATA
食塩相当量　60.9g
ナトリウム　24.0g
原材料　海水、イカスミ粉末

北海道・熊石町の海洋深層水とイカ墨粉末をいっしょに炊き上げている。イカの刺身など白い食材にのせてコントラストを楽しんで。振った量が見やすいので、減塩にも役立つ。

価格／25g入り 556円
山本産業有限会社
北海道札幌市北区あいの里4条5-15-7
tel.011-778-1230
http://www.nippon-1.com/

シーズニング

五代庵 梅塩

日本・和歌山

DATA
食塩相当量　(91.1g)
ナトリウム　35.9g
原材料　梅酢

梅を漬けた後の梅酢を濃縮・結晶させた変わり塩。名産の紀州南高梅のほのかな酸味とまろやかさで、ひと振りすれば絶品おにぎりに。クエン酸やポリフェノールの成分も含む。

価格／100g入り 324円
株式会社東農園
和歌山県日高郡みなべ町東本庄836-1
tel.0210-12-5310
http://www.godaiume.co.jp/

シーズニング

インディアンルビーソルト

インド

DATA
食塩相当量　86.3g
ナトリウム　34.0g
原材料　湖塩, ミロバラン, タマリンド, アラビアゴムモドキ, グーズベリー, セイタカミロバラン

インド産湖塩にハーブやフルーツを混ぜて、土釜で一昼夜炊き上げた、インド伝統製法の塩。強い硫黄の香りと甘味は、蟹や海老など甲殻類に合う。抗酸化力の高さもうれしい。

価格／250g入り 600円
アースコンシャス株式会社
東京都福生市熊川1639-1
tel.042-530-1001
http://www.saltlamp.jp/

奥能登揚げ浜塩田 香りしお 醤油しお

日本・石川

DATA
食塩相当量　90.8g
ナトリウム
原材料　海水, 醤油（大豆、小麦を含む）

伝統的な揚げ浜塩田から生まれた海水塩で能登産大豆を杉樽に入れて仕込み、3年熟成させた昔ながらの醤油を乾燥させたもの。濃厚なうまみと香ばしさを楽しめる。

価格／60g入り 650円
株式会社Ante
石川県加賀市篠原新町1-162
tel.0761 74-8002
http://ante-jp.com/

法律上の塩の分類

salt column

本書では原料別に分類しています。日本の法律上は、用途や製法別によって分類されます。

生活用塩
財団法人塩事業センターが販売する塩。またはイオン膜製塩法で製塩された塩や、天日塩を溶解再製した塩。

特殊製法塩
真空蒸発缶（立釜）を使わないで製塩された塩。または真空蒸発缶でつくられた塩を加工した塩。平釜で炊いた塩。本書で紹介している塩の多くは、ここに該当します。

特殊用塩
試薬塩のような特殊な用途の塩。

Senior Salt Coordinator

おすすめの塩と使い方

塩のおいしさ、楽しみ方を日々追求する、正真正銘の"塩マニア"シニアソルトコーディネーターの方々に、ふだんの使い方とイチ推しの塩をうかがいました。

Senior Salt Coordinator

1 青山志穂

味覚を鍛えるために合わない塩も選んでみる

ふだんの食事から実験を兼ねていることも多いので、1000種類くらいあるストックのなかから、料理に合わせて2～3種類を選んでいます。例えば肉を焼いたら、合うと思う塩を2種類、合わないと思う塩1種類を並べて、予想と舌の感想が合っているかどうか、さらに、合わない塩についても確かめます。そうすることで、味覚の幅はぐんと広がります。ちなみに、キッチンに常備しているのは、オールマイティな「青い海」(p.102)や野菜に合う「わじまの海塩」(p.64)。自分好みの塩を探すなら、まずはトマトか焼いた牛肉にかけて味比べをするのがおすすめです。

水キムチ
×わじまの水塩

きゅうりやにんじんなど、好みの野菜を適当な大きさに切り、濃度1％程度に薄めた「わじまの水塩」に漬け、冷蔵庫で半日冷やします。適度なしょっぱさが野菜に染み込み、野菜のうまみや甘味を引き出します。汁もいっしょにどうぞ。最後にレモンを搾るのも美味。

美味と健康
http://www.wajimanokaien.com/

そうめん
×大谷塩

淡泊なそうめんに、バターのような濃厚なコクを加えてくれる「大谷塩」。そうめんをゆでて水を切り、「大谷塩」とオリーブオイルをかけるだけで、あっさりしがちなそうめんを濃厚な味で楽しむことができます。刻みのりを少し散らすのもおすすめ。

→ p.65

砂肝の塩焼き
×屋我地島の塩

鉄分の多い砂肝と「屋我地島の塩」は相性抜群！　下ごしらえに塩を振りかけてから、グリルで数分焼くだけ。肉と塩の鉄分が同化して、肉のうまみがびっくりするほどアップします。手軽につくれて、ビールのおつまみに最高です。

→ p.101

とっておき活用法

飲酒後寝る前の1杯

お酒をたんまり飲んだ後は、寝る前に塩水を1杯。お酒を飲むと利尿作用で大量の水分が排出され、体内のミネラルバランスが崩れるので、濃度1％程度の塩水をコップ1杯飲んで寝ると、翌朝すっきり起きられます。

Senior Salt Coordinator

2
倉持恵美さん

フリーアナウンサー。酒屋の娘として、子どもの頃から食と酒の相性などを教え込まれる。現在は沖縄で、メディアでの情報発信とともに、野菜ソムリエなど食に関する資格を持ち、食の魅力を伝える活動を行っている。

台湾で出会った誕生日カラーの塩

自宅には100種類超の塩を食卓の脇に並べています。気分によって気軽に選んだり、来客時にも会話のネタにぴったり。日常的には、下味、野菜、肉、アクセントなど用途別に5〜6種類の塩を使いわけています。

海外に出かけたときも、塩に引かれてしまいますね。台湾の南、かつて製塩業が盛んだった台南市にある「夕遊出張所」はふしぎな塩屋さん。五行という中国の思想を元に選ばれた、1年366日分の誕生日カラーの塩が売られています。性格診断や魔よけ、浄化といった、食とは異なる顔や文化がかいま見れるのもまたおもしろい体験です。

ゆでたジャガイモ
×大自然モンゴルの岩塩 ジャムツダウス

大自然モンゴル岩塩は刺すようなしょっぱさではなく、口の中に細かく広がるしょっぱさがあります。シンプルにゆでたジャガイモに。羊肉との相性も抜群！岩塩の持つ酸味がよい働きをします。モンゴルの大地を思いながら味わってください。

→ p.123

うなぎの白焼き
×珠洲の竹炭塩＋わさびのおいしいお塩

白い食材に「珠洲の竹炭塩」の黒がのると、白と黒のコントラストが見た目にもおもしろい。焦げの風味の相乗効果で香ばしさがアップします。また、「わさびのおいしいお塩」は、わさび醤油よりもうなぎのふわふわ感とうまみをひき出してくれます。

→ p.143
→ p.145

チーズフォンデュ
×地中海クリスタルフレークソルトスモーク

蒸し野菜やソーセージにそのままかけたり、チーズを絡ませた後に振りかけたり……。豊かな燻香と香ばしさで味の幅がぐっと広がります。また、魅惑的なピラミッド形の結晶がお皿に並ぶだけでも目を引いて、食卓での会話が弾むこと間違いなしです。

→ p.140

とっておき活用法

煮詰まったコーヒーに
コーヒーメーカーなどで煮詰まってしまい、酸化してしまったコーヒーには、塩をひとつまみ入れましょう。酸味が抑えられ味がまろやかになっておいしくいただけますよ。

ひとつは持っていたい岩塩
インテリアとして飾るもよし、塊をすりおろして使うもよし。ひと口に岩塩といっても色も味も異なるのが魅力です。

Senior Salt Coordinator

©Nozi Uchida

3
田中園子さん

solco 代表。製薬会社の開発職を経て、さまざまな食のプロジェクトに関わる。2013 年に塩に開眼し、2014 年、東京都品川区戸越銀座商店街に、塩の専門店 salt&deli solco をオープン。
http://www.solco.co/

塩の食感をダイレクトに楽しめる後かけ

シャリシャリ、ガリッ。結晶の違いで生まれる塩の食感が好きなので、食材に味をつけずに調理し、最後に塩をつける「後かけ」が基本です。かたさやトロッとしたやわらかさなど食材の食感と、合わせたい食感を考えて塩をセレクト。さらに、食材と塩の産地が近いもの、同じ味わいのものと絞っていくのが楽しみです。高知県土佐の「あまみ」（p.79）の小島正明さんにうかがったお話ですが、「海水の味は四季によって異なる。例えば陸が新緑の季節なら、海中でも海藻が芽吹く」、だから春の塩は磯の香りが強くなるといいます。自然の姿そのものなのも塩の魅力ですね。

アボカド
×自凝零塩（おのころしずくしお）フレーク

塩をふるいにかけて、落ちない大きさに選別されたフレークタイプのこの塩は、味もやさしく、やわらかい口当たりの食材と合わせると、シャクシャクした塩の食感がより引き立ちます。トロッと熟したアボカドに、この塩とオリーブオイルをかけ、レモンを絞って、食感のコントラストを味わってみてください。

salt&deli solco
http://www.solco.co/

プリン
×ヒマラヤブラックソルト

たまご料理に合うこの塩は、たまごからできたスイーツとの相性も抜群。また、かぼちゃやさつまいもなど温めると甘くなる根菜にも合うので、かぼちゃプリン、さつまいもプリンはひと振りするだけで最高のスイーツに。

salt&deli solco
http://www.solco.co/

厚揚げ焼き
×百済浦の藻塩

塩作りは 2012 年からと、まだ作られて間もない島根県大田市のアラメエキス入り藻塩。見た目はミルクコーヒー、カルシウムが多く苦みがまろやかで味もミルキーな藻塩です。
焼いた厚揚げにさっと降ってかぶりつくと、豆腐のミルキーさと、焦げの香ばしさが相まっておいしい。

salt&deli solco
http://www.solco.co/

とっておき活用法

ごはんを炊くとき
ごはんを炊くときに塩を加えると、時間がたっても臭いが出ず、仕上がりがつやつやになります。

気だるい朝の1杯
朝だるいときに「粟國の塩 釜炊き」（p.97）や「満月の塩 福塩」（p.99）をお湯に溶かして飲むと、一瞬ですっきりしますよ。

photo: Kunikane Takaya

Senior Salt Coordinator

4 坂井洋子さん

ジュニア野菜ソムリエ。広告会社での約10年間の営業・企画職を経て、食に関する知識・資格を取得。現在はイラストレーター・マンガレポーター「べじこ」として活動中。
http://www.vegecotomato.com

好みの塩を持ってでかける
マイソルトが楽しい！

　お気に入りの塩を持ち歩く「マイソルト」を楽しんでいます。モーニングのゆでたまご、定食屋さんのお刺身のイカや揚げ物、外食でも塩がほしいなと思う場面は案外多いもの。飲食店では配慮も必要ですが、お店の方とも塩の話題で盛り上がるなんてこともしばしば。食以外でおすすめするなら、塩づくり体験。塩づくりが盛んな、石川県珠洲市、高知県黒潮町などにある製塩所の中には、一般向けの体験を受け付けています。海水を運んだり、熱い釜の前で結晶をひたすら見守ったり。塩づくりの大変さや職人さんのスゴ技を間近で感じ、ますます塩が愛おしくなります。

トマト
×土佐の塩丸

太陽と風の力で結晶させた天日塩と、太陽を浴びて育ったトマトの相性は抜群。トマトの味の濃さやうまみがより際立ちます。シンプルにトマトの丸かぶりはもちろん、トマト、バジル、オリーブオイルでつくるブルスケッタもおすすめ。

→ p.79

水
×ぬちまーす

ミネラルウォーターに塩をぱぱっと振って、家族で夏の水分補給に飲んでいます。海水のミネラルバランスをそのまま結晶させた塩は、パウダー状で水に溶けやすいうえ、まろやかで飲みやすい。かんたんスポーツドリンクです。

→ p.98

スープ・炒飯
×湧出の塩 だし塩

海水を煮詰めて結晶させただし塩。しっかりした味がついているので、味つけに重宝します。玉ねぎやにんじんなどの野菜や昆布でつくったシンプルなスープや、炒飯に使うと、塩とだし汁のうまみでおいしさがアップします。

→ p.147

焼き肉
×フィオッキ・ディ・サーレ・スモーク

ピラミッド形の結晶が美しく、燻製の香りがすばらしい塩。結晶も塩味もしっかりしているので、厚みのある肉にも負けず、しっかり噛みしめて食べると、燻製の香りと肉汁が混ざり合い、一気に幸せな気分に浸れます。

アーパ・アンド・イデア　http://www.apidea.co.jp/

Part 5
料理も暮らしも楽しくなる！
塩のおいしい使い方

牛肉に合う塩は？ 果物に合わせるならどんな塩？
食材や料理がぐんとおいしくなる「塩の使いわけ」のコツ。
塩の作用を利用した調理術、暮らしや美容での塩活用術に加え、
気になる健康と塩の関係も――。
塩がもっと楽しくなる"おいしい"使い方をまとめて紹介します。

使いわけで 塩をもっと楽しむ

個性豊かな塩をじょうずに活用するために、おぼえておきたいのが使いわけのコツ。
塩の作用と、塩選びが楽しくなるポイントを紹介します。

食材・料理をおいしくする塩の作用

結晶の形や味わいなど、塩の特徴を理解し、食材や調理法に合わせて使いわけることで、味にまとまりが出て、料理をよりおいしく仕上げることができます。

合わせる塩を決める際に意識すべきことは次の3つ。「同化」「対比」「抑制」です。食材同士の組み合わせにも使える料理の基本なので、おぼえておくとよいでしょう。

食材や調理法と相性のよい塩を選べば、少量の塩でもしっかりと効くので、塩自体の使用量を減らすことができます。塩分を気にしている人ほど、塩を使いわけることが大切なのです。

同化　同じ味を持つ食材と、塩を合わせるとうまみアップ

同種の味を持つ2種類以上の食材を混合したときに、それぞれの味の強さ以上に風味が強くなること。かつおだしと昆布だしを合わせるとうまみが増すのと同じような、いわゆる相乗効果。塩と食材の共通点を探すのがポイントです。

● 例えば　鉄分を含む赤身の肉には鉄分を含む岩塩を合わせる。

対比　味わいの対照的な塩を合わせて、食材の味を引き立てる

味わいの対照的な食材（塩）を少量加えることで、主たる味が強まります。いわゆる"塩"の味はなく、代わりに食材の特徴的な味が引き立ちます。ただし、臭みなど悪いところが目立つ場合があるので、鮮度のよい食材に使うとよいでしょう。

● 例えば　すいかにしょっぱさの強い塩を少量加えることで、すいかの甘味を引き立たせる。

抑制　しょっぱさは苦味と酸味を抑える

2種類以上の食材を合わせたとき、その一方または両方の味が弱められること。特にしょっぱさと苦味、しょっぱさと酸味で起こりやすい作用といわれます。塩を少量加えることで、酸味や苦味が抑えられます。

● 例えば　コーヒーに少量の塩を入れると、苦味と酸味が消えてまろやかな味になる。

家庭で楽しむなら
5タイプ＋おもてなしの塩

　苦い塩、甘い塩、うまみの強い塩……塩にはさまざまな個性があります。個性ごとにとにかく塩をそろえるのもひとつですが、ふだんの食事で塩を楽しむなら、まず「5つの塩＋おもてなしの塩」。これさえあれば、だいたいの味わいがカバーできます。

　下の図のように、塩はしょっぱさの強弱と粒の大きさによって、味わいの傾向を大まかにわけることができます。異なる傾向を持つ塩を4種類。そして、迷ったときに、何にでも合わせやすいオールマイティな塩を1種類。これだけでもじゅうぶんですが、さらに味や形がめずらしい、誰かに自慢したくなるような、おもてなしの塩を1種類用意しておけば完璧です。

基本の5塩とおもてなしの塩

- 赤身の肉や魚に合う塩
- 白身の肉や魚に合う塩
- 揚げ物に合う塩
- 野菜に合う塩
- オールマイティな塩
- おもてなしの塩

Topics　おもてなしの塩とは

「ピラミッドソルト」（p.39）など見た目にも美しい結晶の塩や、「セル・デ・ヴァン メルロー」（p.141）、トリュフ塩（p.141）などのトリュフやハーブを混ぜたシーズニングなど、めずらしいものを皿に添えて出すだけで食卓が盛り上がるでしょう。

しょっぱさ×粒で味わいが変わる

粒が大／しょっぱさ弱
- TASTE！ うまみがゆっくりと広がり、苦味が残る
- おすすめ食材&料理： 鶏肉、タイなどの白身魚、イカなど

粒が大／しょっぱさ強
- TASTE！ 口の中でしょっぱさやそのほかの味が長く残る
- おすすめ食材&料理： 牛肉、マグロ、カツオ、レバーなど

中央：オールマイティ

粒が小／しょっぱさ弱
- TASTE！ 苦味とうまみを感じた後、しょっぱさがすっと消える
- おすすめ食材&料理： きゅうりや白菜など味の淡泊な野菜、米など

粒が小／しょっぱさ強
- TASTE！ 最初にしょっぱさが来て、酸味が口の中を走ってすっと消える
- おすすめ食材&料理： 揚げ物、オイルを多く使う料理

次ページに本書で紹介した塩のマトリックスをまとめました。塩選びの参考にどうぞ！

しょっぱさ×粒の大きさマトリックスで とってもかんたん塩選び

粒の大きさ：大

- ピランソルト ソルトフラワー → p.37
- Flower Of Ocean シホ → p.60
- 塩の花 → p.69
- 矢堅目の藻塩 → p.108

- ペルシャの岩塩 結晶 → p.121
- 加計呂麻の塩 → p.95
- クリスタル岩塩 → p.124
- オーストラリア・ピンクリバーソルト → p.135

- 珠洲の結晶塩 → p.64
- あまみ → p.79
- 浜御塩 → p.86
- 玉藻塩 → p.107
- 会津山塩 → p.137

- プレミアム・シーソルト → p.36
- バリ島アメッドの塩 → p.40
- カンホアの塩 石窯焼き塩 → p.40
- 水晶塩 → p.42
- 小笠原の塩 → p.60
- 能登のはま塩 → p.63
- インカ天日塩 → p.136

- 佐渡の深海塩 → p.69

- カナディアンシーソルト → p.48
- 伊達の旨塩 → p.55
- 薪窯直煮製法 のだ塩 → p.56
- 越前塩 → p.68
- しお学舎のやさしいお塩 → p.74
- 海人の藻塩 → p.108
- マグマ塩 → p.121
- 佐渡藻塩 → p.110

- つるみの磯塩 → p.91
- 石垣の塩 → p.98
- ローソク島の藻塩 → p.110
- 大自然モンゴルの岩塩 ジャムツダウス → p.123
- ラオスの天然岩塩 → p.126

- ぬちまーす → p.98
- 雪塩 → p.100
- シベリア岩塩 ミックス → p.123

粒の大きさ：小 / 弱

本書で紹介したおもな塩を、
しょっぱさの強弱と粒の大小でマトリックスにまとめました。
塩の味わいや合う食材の傾向が一目でわかります。

※マトリックスの左上が白身の肉や魚に合う塩、右上が赤身の肉や魚に合う塩。
左下が野菜やごはんに合う塩、右下が揚げ物に合う塩、中央がオールマイティな塩を表している。

- マルドン シーソルト → p.34
- フレーキーシーソルト → p.45
- 蔵盛さんちの塩 粗塩 → p.100
- アッサルの塩 → p.132

- フィオッキ・ディ・サーレ → p.34
- ピラミッドソルト → p.39
- パハール岩塩 → p.118

- アラエア 火山赤土塩 → p.46
- 百姓の塩 → p.78
- んまか塩 → p.87
- 屋久島永田の塩 えん → p.94
- ヨロン島の塩 星の砂塩 → p.95

- マスコット クリスタルソルト → p.47
- 花塩 → p.67

- サルデニア島の海塩 粗塩 → p.36

- ハワイアン シーソルト → p.47

- 青い海 → p.102
- 子宝の温泉塩 → p.137

- カマルグ フルール・ド・セル → p.33
- わじまの海塩 → p.64
- 土佐の塩丸 → p.79

オールマイティ

- イスラエル 紅海の塩 → p.42
- 南の極み → p.45
- クリスマス島の海の塩 → p.48
- スイーツソルト → p.136

- 笹川流れの塩 → p.68
- 海の精 あらしお 赤ラベル → p.59
- 粟國の塩 釜炊き → p.97

- カムイ・ミンタルの塩 淡雪 → p.52
- 日本海の塩 白いダイヤ → p.67

- イル・ド・レ フルール・ド・セル → p.33
- 男鹿半島の塩 → p.56
- Salann Oki サラン オキ → p.78
- とっぺん塩 → p.87
- 月の塩 ダイヤモンド → p.91
- ヨロン島の塩 じねん → p.94
- 塩竈の藻塩 → p.107

- ノアムーティエ セルファン → p.32

- ゲランド エキストラファン → p.32
- アルペンザルツ → p.126

- 岩戸の塩 → p.74

- 天空の鏡 ウユニの塩 → p.131

- 宗谷の塩 → p.52

しょっぱさ 強

食材・料理別に使いわける

料理の味を引き立てるおすすめの塩を、食材・料理別に紹介。ここで紹介するのはベーシックな合わせ方です。まったく反対のテイストの塩を試してみるなど、どんどんチャレンジして楽しんでしまいましょう。

牛肉

鉄分を多く含む塩を使うと、酸味の同化作用によってうまみがアップします。しょっぱさが強い塩は肉の脂っこさを緩和させるのに適役です。

●例えば
アンデスの紅塩→ p.120、屋我地島の塩→ p.101、珠洲の竹炭塩→ p.143

豚肉

牛肉（赤身）と鶏肉（白身）の中間の味わいなので、しょっぱさが適度で粒も中粒～大粒程度の苦味のある塩がおすすめ。

●例えば
サルデニア島の海塩 粗塩→ p.36、シベリア岩塩ミックス→ p.123、オホーツクの塩 釜あげ塩→ p.54

鶏肉

振りかけてソテーするなら、まろやかで粒が大きめの塩が◎。鶏肉特有の脂の香りを消したい場合は、海洋深層水からできた塩やカリウムの多い塩がおすすめです。

●例えば
室戸の塩→ p.82、球美の塩→ p.104、あまみ→ p.79

内臓赤身

鉄分を多く含む塩が◎。砂肝のような歯ごたえのよい部位には、粒が大きめの塩を合わせると食感のよいアクセントになります。

●例えば
自凝雫塩→ p.75、バハール岩塩→ p.118、大自然モンゴルの岩塩 ジャムツダウス→ p.123

甘い野菜

かぼちゃやにんじん、たまねぎなど、加熱すると甘味の出る野菜には、しょっぱさが弱く、粒がやや大きい、甘味のある塩が好相性。相乗効果で甘味がより濃厚に。

●例えば
石垣の塩→ p.98、海の精 あらしお 赤ラベル→ p.59、戸田塩→ p.70

苦い野菜

苦味を同化させるのがポイント。しょっぱさが弱く、粒がやや大きいマグネシウムの苦味を感じるものがよい。山菜の場合は、雑味の強い地下塩水塩がおすすめです。

●例えば
海の愛→ p.83、壱岐の塩→ p.89、スイーツソルト→ p.136

水の野菜

レタスやきゅうりなどの水分の多い野菜は、水っぽさで塩の味が中和されるので、ややしょっぱさが強く、うまみを感じる塩がちょうどよい。

●例えば
越前塩→ p.68、天空の鏡 ウユニの塩→ p.131、イスラエル 紅海の塩→ p.42

土の野菜

土の香りのする根菜類に合うのは、舌の上で溶ける時に土の香りを感じる塩や、泥や土が混ざった塩がおすすめ。硫黄成分を含む塩も相性がよいでしょう。

●例えば
ゲランド エキストラファン→ p.32、あっちゃんの紅塩→ p.102、アラエア 火山赤土塩→ p.46

果物

苦味が強い果物にはしょっぱさと苦味の強い塩を、甘味の強い果物にはまろやかで甘味の強い塩を。瓜系の果物にはカリウムの多い塩を加えると、甘味やうまみが増します。

●例えば
わじまの海塩→ p.64、カマルグ フルール・ド・セル→ p.33、ひんぎゃの塩→ p.62

豆腐（大豆製品）

カルシウムが多く、しょっぱさがまろやかで、にがりを多めに含む塩。ただし、オイルと合わせる時はしょっぱさが強めのものが美味。

◉例えば
ぬちまーす→ p.98、蔵盛さんちの塩 粗塩→ p.100、フォッシルリバー 塩フレーク→ p.128

発酵食品

発酵食品には、発酵を阻害するカルシウムが少なく、ナトリウム、マグネシウム、カリウムがバランスよく含まれている海水塩がおすすめです。

◉例えば
わじまの海塩→ p.64、小笠原の塩→ p.60、青い海→ p.102

乳製品

乳製品には酸味があり、しょっぱさがまろやかな塩を。粒が細かくなじみやすいほうがよいでしょう。マグネシウムを含む塩は、カルシウムの吸収率をアップさせます。

◉例えば
雪塩→ p.100、北谷の塩→ p.103、クリスマス島の海の塩→ p.48

白身魚

しょっぱさがまろやかで粒が大きいフレークタイプの塩で、後味の消え方が綺麗なものや、潮の香りのする塩がおすすめ。日本海側でつくられた海水塩がぴったり。

◉例えば
プレミアム・シーソルト→ p.36、浜比嘉塩→ p.99、庄内浜の塩→ p.58

赤身魚

強めにしょっぱさを感じる、粒が小さめの塩。鉄のような酸味や、余韻が比較的長い塩、白身と同様に潮の香りのする塩がよいでしょう。

◉例えば
海みたま→ p.92、フレーキーシーソルト→ p.45、月の雫の塩→ p.57

貝類

溶ける時に潮の香りが鼻に抜ける塩や、海藻エキスを含んだ香りの強い藻塩など、個性の強いものがおすすめ。レモンのような酸味のある塩も◎。

◉例えば
海人の藻塩→ p.108、玉藻塩→ p.107、クリスタル岩塩→ p.124

甲殻類

硫黄成分を含んだ甘い香り、味がする塩に合わせると、甲殻類の香りと同化して、うまみがぐっとアップします。

◉例えば
キパワーソルト→ p.43、ヒマラヤ山麓の岩塩→ p.122、インディアンルビーソルト→ p.148

おにぎり

適度なしょっぱさを持ち、粒が細かく、甘味やうまみが強い塩は、米の甘味をじょうずに引き出します。マグネシウムや硫黄の多い塩は米が変色するので注意。

◉例えば
佐渡藻塩→ p.110、あげ浜塩田製法塩→ p.62、百姓の塩→ p.78

麺類

適度なしょっぱさで、粒が細かく料理になじみやすい塩で、甘味やうまみが強いものがおすすめです。オイルを使う場合は、しょっぱさが少し強いものがよいでしょう。

◉例えば
最進の塩→ p.88、大谷塩→ p.65、スイーツソルト→ p.136

たまご料理

しょっぱさはまろやかで、粒が細かい塩。カルシウムが多く甘味が強い塩を使うと、たまごの黄身の甘味が引き立ちます。

◉例えば
うるわしの花塩→ p.103、海んまんまーの塩 さらさらタイプ→ p.89、カンホアの塩 石窯焼き塩→ p.40

てんぷら（揚げ物）

しょっぱさが強めで粒が細かく、舌の上ですっと溶ける塩。または、フレークタイプの塩で、食感のある塩がよいでしょう。

◉例えば
知床の塩 極→ p.53、マルタ フレーク海塩→ p.41、四川省の岩塩→ p.125

パン・スイーツ

練り込むなら、粒が細かく、ナトリウム、マグネシウム、カリウムをバランスよく含んだ塩。トッピングには粒が大きく、溶けにくい岩塩がおすすめ。

◉例えば
宗谷の塩→ p.52、大谷塩→ p.65、輪島塩→ p.66

enjoy! salt

\ 店頭で困らない /
塩選びのいろは

スーパーの陳列棚にずらっと並ぶ塩。
「違いがわからない！」と棚の前で困ったことのある人も多いでしょう。
そんなときはまずパッケージの裏面を見てみましょう。

パッケージ情報でここまでわかる！

塩のパッケージの裏面には、法律で定められたさまざまな表示が記載されています。

大きくわけて次の2つです。

生産者や原材料などの情報が記載された「一括表示」と、塩を構成するナトリウムやそのほかのミネラル、食塩相当量が記載された「栄養成分表示」です。

実はこれらの表示には、塩の味をイメージするための、驚くほどたくさんの情報が隠れています。例えば、原材料からは、塩の種類や原産地。製造方法からは、釜で炊いた塩なのか、火力を使わずに仕上げた天日塩なのかがわかります。さらに、成分表からは、塩の味わいを左右する、ミネラルバランスが見えてきます。情報を読み解いていくことで、塩の個性がわかるのです。

情報を読み取る力を身に着ければ、スーパーマーケットにずらりと並ぶ塩のなかから、自分の好みの塩を選べるようになるでしょう。

成分表

塩100g中に含まれるエネルギー、たんぱく質、脂質、炭水化物、ミネラルが記載されています。掲載されているミネラルの種類は商品によって異なりますが、ナトリウムの値だけが記載されているものも多くあります。

現在、成分表がない商品もありますが、2020年にはすべての塩に「食塩相当量※」の記載を義務化。下の表にもある通り、ナトリウムの値でしょっぱさの強弱を知ることができるようになります。

※食品に含まれるナトリウム量を食塩の量に置き換えたもの。ナトリウム〈mg〉× 2.54 ÷ 1000 で推定値が産出できる。

Topics 成分で見る塩の味わい

塩に含まれるミネラルには、それぞれ異なる味わいがあります。マグネシウムが多ければ苦味が、カルシウムが多ければ甘味を感じる塩になります。どの成分がどのくらい入っているか、成分表をチェックして、その塩の味わいをイメージしてみましょう。

成分	味わい
ナトリウム	単純なしょっぱさ
マグネシウム	苦味、うまみ、コク
カリウム	酸味、鉱石的な冷たさ、キレのよさ
カルシウム	単体では無味だが、相対的に甘味
その他のミネラル	雑味

にがりの具合（水分量）

パッケージ越しに塩を観察します。塩に付着している水分は、マグネシウムとカリウムを主体としたにがりです。これが多く含まれてしっとりしている塩は、その分ナトリウムが少ないためしょっぱさがまろやかで、そのほかの味が強い傾向があります。反対に、にがりの少ない塩はしょっぱさを強く感じやすくなります。

名称

原則として塩の種類にかかわらず、「食塩」または「塩」と記載されています。ハーブやスパイスが入ったシーズニングは「調味塩」です。

原材料

海水、岩塩、湖塩など、塩の種類がわかります。再製加工塩の場合は、「海塩」「天日塩」＋α（粗製海水塩化マグネシウムや海水など）という記載になります。添加物が使用されている場合も、ここに記載されています。

栄養成分表示（100g中）	
エネルギー	0kcal
たんぱく質	0g
脂質	0g
炭水化物	0g
ナトリウム*	37.07g
カルシウム*	450mg
マグネシウム*	140mg
カリウム*	69mg
塩化ナトリウム*	94.23g

名　称	食塩	内容量	30g
原材料名	海水（沖縄県北谷町）		
製造者	沖縄北谷自然海塩株式会社 沖縄県中頭郡北谷町字宮城1番地650 TEL.098(921)7547		

製造方法	
原材料名	海水（沖縄県北谷町）
工　　程	逆浸透膜、立釜

ホームページ　塩の製造工程をご案内しています
http://www.nv-salt.com

■試験依頼先
財団法人
日本食品分析センター
■試験成績書発行年月日
2009年（平成21年）
8月3日
■試験成績書発行番号
第109073425-001号
*は「塩試験方法」によるもの

工程

食用塩公正取引協議会で推奨されている表示内容です（記載のないものもあります）。どのような製法でこの塩がつくられたか、「濃縮工程／結晶工程／仕上工程」の順番に記載されています。なお、濃縮工程と結晶工程が同じ場合はひとつに省略されます。例えば「平釜／平釜／焼成」→「平釜／焼成」という表記など。

公正マーク

食用塩公正取引協議会に加盟し認定された塩に記載されています（認可を受けても記載しなくてもよい）。表示内容と製造方法に相違がないこと、表示方法が正しいことを示すもので、表示がない塩もめずらしくありません。

memo 食用塩公正取引協議会とは、製塩企業などを中心にして平成20年に設立された団体。塩の商品表示ルールの策定など、塩の正しい知識の普及を目指している。

enjoy! salt

キッチンで 塩をトコトン使いこなそう

暮らしのなかでもっとも塩が登場する調理や食事の場面で、知っておくと便利な塩の作用や使い方をギュッとまとめました。

Operation 塩の作用

腐敗を防ぐ

腐敗菌の増殖には「温度・水・栄養」が必要ですが、塩には浸透脱水作用があるため、食材から水分を抜いて水分活性を下げると同時に食材内の水分と結合しながら塩分を蓄えることで、腐敗菌が入り込んで繁殖するのを防止します。

発酵を調整する

発酵は、微生物によって起こる現象です。塩の濃度を調整することによって、食品に含まれる水分量や塩分量を調整し、それぞれの微生物に最適な環境をつくることができます。味噌や醤油、漬け物の製造工程で役立っています。

酵素の働きを止める

塩には酸化酵素の働きを止め、食材の色を鮮やかに保つ作用があります。よく知られているのはりんご。濃度0.2％程度の塩水に漬ければ褐変を防ぐことができます。同様の作用から、野菜ジュースに0.5％程度の塩を加えると、ビタミンCが破壊されるのを防ぎます。また、ゆで野菜にも塩は欠かせません。ゆでる際に濃度1％程度の塩を加えると、野菜の鮮やかな緑色を保つことができます。ブロッコリーやほうれん草など、緑色の野菜に含まれる、緑色色素（クロロフィル）の安定を促し、酸化酵素の働きも抑えるからです。

塩はたんぱく質に作用する

塩には加熱されたたんぱく質が凝固するのを促進する作用、そして、たんぱく質を溶かす作用があります。
下ごしらえの際、魚や肉に塩を振るのは、うまみを含んだ肉汁が流れ出すのを防ぐため。つまり前者の作用です。ちなみに、ゆでたまごのゆで湯に塩を入れると、塩の味がつくだけでなく、中身のはみ出しを抑えてくれます。
魚のすり身をつくる際に、塩を入れると粘り気が出るのは後者の作用です。また、乾燥大豆を1％程度の塩水に漬けてから調理すると、大豆のたんぱく質が溶けるため、早くやわらかく煮ることができます。

生クリームが早くできる

生クリーム200mLに塩をひとつまみ入れると、入れない場合より早くしっかりとしたきめ細かな角が立ちます。また、塩の対比効果でコクが増し、生クリームの味が濃厚になります。

PART ❺ 塩のおいしい使い方

Taste 塩加減

おいしく感じる塩加減は決まっている

人が塩味をおいしく感じられる濃度は、ほかの調味料に比べて非常に狭く、約0.5％〜3.0％といわれています。かつて、徳川家康が側近に「世のなかでもっともおいしいもの・まずいものは何か」と尋ねたとき、「両方とも塩にございます」と答えたという逸話が残っているほど。塩加減というのは微妙で、ほんの少しの加減の違いが料理の味に大きく影響します。どの塩を使うかも重要ですが、塩加減をじょうずにコントロールすることこそがもっとも大切です。

ちょうどよい塩加減の目安

塩加減は後から調整することがむずかしいので、少ない量からはじめて、味見をしながら調整しましょう。迷ったときは体液と同じ約0.9％程度にしておくと、大きな失敗を防ぐことができます。

塩分濃度	料理例
0.6％	スープ、ごはん、酢飯
0.8％	味噌汁
1.0％	薄味の煮物、野菜のゆで湯、肉や野菜を焼く、炒める、サラダ感覚で食べる野菜の浅漬け　など
1.5％	通常の煮物
2.0％	浅漬け、酢の物の下味、常備菜などを保存するもの、濃い味の煮物
3.0％	魚の塩焼き、ピクルスなど保存用の漬物、パスタのゆで湯（海水程度）

〈注意点〉
その① 料理としてトータルでどのくらいの塩分量になるのかが重要なので、素材そのものやほかの調味料に含まれる塩分量をある程度理解しておきましょう。
その② 食べる人のコンディションを考慮しましょう。汗をたくさんかいた人や味を感じにくくなっている高齢者向けの料理や、お酒を飲む場合には濃いめにする。塩分に制限のある疾患の人の場合には最小限の量になるよう配慮しましょう。

Preliminary 下ごしらえ

たて塩は下ごしらえの万能塩水

「たて塩」とは、塩分濃度約3％の塩水を使って、野菜や果物の色止めや保存、魚介類の下ごしらえや調味に使用する技法。塩を直接振るよりも、食材にまんべんなく塩が行き渡りムラになりにくいという利点があります。

魚介類

洗うときにたて塩を用いると、表面のぬめりだけが取れ、うまみを逃がさずに、余分な水分を排出させることができます。身の薄い魚の場合、振り塩だと味がつきすぎたりムラになったりしやすいので、たて塩でムラなく薄く塩味をつけるのがおすすめです。

野菜類

切った後にたて塩に漬けると、酵素の働きによる褐変を防ぐことができます。また、きゅうりなどを薄切りにした後に漬ければ、水分を吸い出してしんなりさせ、全体にまんべんなく薄く塩味をつけることができます。

振り塩でうまみを凝縮

「振り塩」は食材に直接塩をかけること。塩の持つ浸透脱水作用で食材から水分を引き出し、うまみを凝縮したり、食材の表面を固めてうまみの流出を防いだりします。肉は重量の約2％、魚の塩焼きは約3％、野菜は約1％程度の塩がベスト。

魚

魚の表面にまんべんなく振ることで、魚から水分と臭みを吸い出し、うまみを凝縮。身が引き締まるので、形が崩れにくくなります。白身魚や切り身には薄めに、青魚や身が厚い魚にはやや強めに振りましょう。塩を振るタイミングは調理する20分前が目安。

肉

魚と違ってもともとの水分含有量が少ないので、調理する直前に塩を振ります。塩がムラになっていると火の通りもまばらになるので、全体にまんべんなくすり込むか、高い位置から振って、全体に付着するようにします。

野菜

味つけとうまみの凝縮に。塩が薄すぎると、うまく脱水作用が起こらないため、食材の重量の1％前後を目安に塩を振り、揉み込んだ後しばらく置いておきます。水気を絞ってから真水で洗うと、うまみが流れ出してしまうので、水洗いせずにそのまま食べましょう。

check! 知っておくと便利！まだまだある塩の活用法

呼び塩

数の子などの塩蔵食品の塩抜きをする場合には、真水に漬けると塩の抜けが遅いほか、余分な水分が食材に入り込んでうまみが薄まってしまいます。1〜2％程度の塩水に漬けると、浸透圧の作用で、早く塩が抜けるだけでなく、うまみが凝縮されたまま残ります。

水塩

濃度15〜25％程度のカルシウムを除去した塩水。調味に便利。液状なので食材の隅々まで付着し、少ない量でしっかりと塩味に仕上がります。パサつきがちな肉類がジューシーに仕上がる効果も。濃度25％の水塩をスプレー容器に入れて3〜4プッシュして使うと、およそ小さじ1/30程度、塩分量はだいたい0.1g程度と、減塩にも効果的です。

Keeping
保存

塩の大敵は水分
湿気の原因はすべてコレ

　塩が湿気てしまったとしたら、その原因はすべて水分です。ナトリウム純度の高い塩は、湿度75％を超えると、空気中の水分を吸収しはじめ、隣の結晶と水分を介してくっついた状態になります。その後、空気が乾燥することでそのままかたまって、塊になってしまうのです。

　塩に含まれる成分のなかでは、マグネシウムがもっとも水分を吸収しやすいため、マグネシウムを多く含む塩は、そうでない塩よりも湿気やすくなります。

湿気予防法はこれだ！

袋入りの塩は密封容器に入れ替える
シリカゲル（乾燥剤）を入れる
水分のついた指で触らない。できれば乾いたスプーンを使う
フライパンや鍋など湯気の出ている上で扱わない
湿気の多い場所に置かない
温度差の激しい場所に置かない
圧迫した状態で保存しない
焼塩を選ぶ
粒の大きい塩を選ぶ

Topics 塩が湿気てしまったら

湿気てしまっても腐敗しているわけではありません。どんな塩も、生産者が一生懸命つくったもの。捨てずに最後まで使い切りましょう。

・**衝撃を与えて砕く**
スプーンなどの柄やハンマーを使って叩き、塩の塊を崩す。

・**フライパンで乾煎りする**
極弱火で温めたフライパンで、湿った塩を乾煎りする。塩化マグネシウムが多い塩の場合は、苦味が強くなることがあるので避ける。

・**溶かして使う**
水に溶かしてペースト状にし、調理に使ったり、バスソルトやマッサージソルトとして美容に活用する。

塩の3stepクッキング

かんたん、おいしい！

塩の魅力が楽しめる、かんたんでおいしいレシピ。
困った時の1品におすすめ。

そのままでもよし、焼いてもよし
塩豚

1. 豚ロース塊400gに塩10gをまんべんなくすり込みしばらく置く。
2. 出てきた水分をふきとり、ペーパータオルとラップでぴったりと包み、冷蔵庫で3日寝かせる。
3. たっぷりの水を沸騰させて、弱火で約20分ゆで、そのまま鍋の中で冷ます。

さっぱり味で箸が進む
塩肉じゃが

1. 鍋に油を熱し、豚小間100g、切った玉ねぎ1/2個、じゃがいも2個を入れて炒める。
2. 水200mLに酒20mL、塩3g、みりん小さじ1を加え、落し蓋をして20分煮る。
3. 仕上げにブラックペッパーときざみネギを散らす。

なめらかな口当たり
塩豆腐

1. 絹ごし豆腐1丁は重石をしてしっかり水を切り、塩4gをまんべんなくまぶす。
2. キッチンペーパーで①を包み、冷蔵庫で1日寝かす（途中でキッチンペーパーを交換）。
3. 切りわけて、仕上げにオリーブオイルをかける。

好みの味で調味してもOK！
ソルトツナ

1. サクのままのマグロとお好みのハーブを濃度約3%の塩水でゆでる。
2. ザルの上に①を置き、半日から1日ほど寝かして水を切る。
3. 容器に②とオリーブオイル、唐辛子、ハーブを入れて漬ける。

何にかけてもおいしい
ねぎ塩だれ

❶ 酒大さじ1、水大さじ1、
　塩4gを入れてよく混ぜ、塩を溶かす。
❷ ❶にごま油小さじ1、
　ブラックペッパー適量を加えてさらに混ぜる。
❸ 粗みじん切りにしたネギ1/2本を❷とよく和える。

冷え性さんにおすすめ
塩ジンジャーハニーティー

❶ 紅茶200mLにはちみつ大さじ1、
　しょうがすりおろし小さじ1/3、
　塩1gを入れる。

果物の甘味が際立つ
塩ゼリー&フルーツ

❶ 濃度0.9%の塩水でゼリーをつくる。
❷ バナナ、パイン、キウイ、りんごなど
　お好みのフルーツを1cm角に切る。
❸ ❶の塩水ゼリーを1cm角に切り、❷の上に乗せる。

ノンアルコールソルティカクテル
モヒート風

❶ ミントの葉15枚とライム1/2、
　塩少々をグラスに入れて潰し、ソーダを注ぐ。

塩とお酒の ペアリングを楽しもう

食べ物や飲み物の相性を楽しむ"フードペアリング"。
うまみを引き出したり、甘味を引き締めたり……塩と酒でもペアリングを楽しんでみませんか。

酒の味や香りを引き立てる塩を選ぶ

　日本では昔から枡の縁に塩を盛り、それをつまみに日本酒を飲むという習慣がありました。酒の肴が不足していたり、貧しかったりと、必要に迫られて生まれた飲み方でしたが、現在は日本酒の味や香りが引き立つ、楽しみ方のひとつとして知られています。さらにマルガリータなどグラスの縁に塩をつけるカクテルは定番です。

　日本酒やビール、ワイン、カクテルなど酒にもさまざまな種類があります。塩も種類が多く、バリエーションは無限大。塩とのペアリングを考えることで、酒の楽しみがグンと広がります。

つまみになる塩

酒のつまみとして考える場合は、酒との相性はもちろんのこと、味や形に特徴がある塩を選ぶのがおすすめ。酒に添えて出す際に、見た目にも楽しく、会話のきっかけにもなるからです。ただ、あくまでも主役は酒。塩の味の余韻が長すぎない、最後に塩の味が残らない塩を選びましょう。食感のあるタイプの塩を選ぶと、カリカリした食感で、よりつまみ感が増します。

● 主な銘柄
蔵盛さんちの塩 粗塩（大きな立方体）→ p.100
ピラミッドソルト（ピラミッド形）→ p.39
マルドンシーソルト（トレミー）→ p.34

ビール

ビールには醸造方法によって数多くのスタイルがありますが、どのビールにも苦味があるので、マグネシウムを含んだ苦味のある塩を選ぶと、ビールと塩の苦味が合わさって口の中でうまみに変わります。バナナフレーバーのビールなら、甘味が強い塩を合わせるとよりバナナの香りが濃厚に。柑橘フレーバーのビールなら、柑橘類のような酸味のある塩を合わせるなどのように、共通した味わいを持つ塩をセレクトするのがおすすめです。

● 主な銘柄
粟園の塩 釜炊き（ビール全般）→ p.97
あっちゃんの紅塩（酸味のあるビール）→ p.102
インディアンルビーソルト（硫黄香のあるビール）→ p.148

日本酒

日本酒の原料は米なので、米と合う塩を選ぶのが基本。日本酒のうまみを引き立てる塩には、しょっぱさが強すぎず、ややまろやかで、うまみが濃厚な塩がよいでしょう。ただし、塩の余韻の長さが重要。キレがよく、すーっと後味が消えていく日本酒と合わせるなら余韻が短めの塩を。反対に、濃厚でもったりとした口当たりの日本酒なら、余韻が少し長めの塩がよいでしょう。

● 主な銘柄
　カムイ・ミンタルの塩 淡雪（甘口向き）→ p.52
　玉藻塩（甘口向き）→ p.107
　月の塩ダイヤモンド（辛口向き）→ p.91

ワイン

ワインに塩を少量入れて楽しむ飲み方があります。塩を選ぶ際は、ぶどうの品種、赤か白か、赤ならタンニンが強いもの、白ならミネラル感が強いものを目安にしましょう。例えば、ミネラル感の強い白ワインに、ナトリウム以外のミネラルが多い塩を入れるとフレッシュ感が増したり、タンニンが強すぎる赤ワインに、ほんの少ししょっぱさの強い塩を入れると渋みが抑えられたりします。気軽に楽しむなら、シーズニングもおすすめです。

● 主な銘柄
　ぬちまーす（ミネラル感の強い白ワイン）→ p.98
　トリュフ塩（赤ワイン）→ p.141
　セル・デ・ヴァン メルロー（赤ワイン）→ p.141

カクテル

マルガリータやソルティドッグなど、グラスの縁にレモンやライムの果汁を塗り、塩をつけるスノースタイルのカクテルもあります。ベースのアルコール、リキュールや果汁の種類に加え、溶かす場合には溶けやすいもの、グラスに付着させる場合には粒がそこそこ大きなものを選びましょう。使われている材料と同じ特徴を持つ塩を合わせるのが基本で、例えばグレープフルーツを使うカクテルには、柑橘類の皮のような苦味を持つ塩を合わせます。

● 主な銘柄
　マルガリータソルト（スノースタイル）→ p.49
　わじまの海塩（グレープフルーツを使ったカクテル）→ p.64
　ピランソルト ソルトフラワー（スノースタイル、甘いカクテル）→ p.37

こんなに便利！暮らしの塩活用術

家事

Idea 01 容器の匂いを取る

お弁当箱などに匂いが染みついてしまったけれど、漂白剤は使いたくないというときにおすすめ。匂いのついた容器にお湯を張り、塩小さじ1～2杯を入れ溶かして一晩置きます。その後、食器用洗剤で洗い流しましょう。すると匂いがとれてすっきり！

Idea 02 鍋の焦げつきをピカピカに

鍋の焦げた部分をしっかりお湯で濡らしてから、焦げが見えなくなるまで塩を振りかけます。10～15分ほど置いたら、スポンジで汚れをこすり落としましょう。一度で落ち切らない場合は、何度かこれをくり返します。焦げつきがとれて元の姿に。

Idea 03 机についたグラスの跡を取る

木製家具についてしまったコップや器の跡にも塩が有効。ついた跡を隠すように塩を振り、そこにほんの少量（ティースプーン1/4程度）の水を加えた後、やわらかい布かスポンジでこすります。しっかりと水拭きし、最後はワックスをかけて仕上げましょう。跡かたもなくキレイになります。

Idea 04 カーペットのシミを取る

ジュースなどをこぼしたらすぐに塩を振りかけて、しばらく吸い取らせた後、塩を取り除きます。これを何回かくり返して塩が水分を吸わなくなったら、掃除機で吸って、最後に水で濡らしたスポンジで軽く叩いて仕上げます。シミも気にならない程度に薄くなるでしょう。

Idea 05 コットンや麻の黄ばみに

大きな鍋に水4Lを入れて火にかけ、そこに塩120g、重曹120gを入れて溶かします。そこに黄ばんだコットンや麻の洋服を入れて1時間ほど煮た後、真水でしっかりとすすいで干しましょう。黄ばみが薄れてきれいな布に。

身体や環境にやさしい洗剤として、はたまた薬として、たいへん便利な塩。
家庭でのさまざまな活用術を一気にご紹介しましょう。

健康

Idea 01 鼻づまりすっきり！

塩水で鼻をすすぐと、粘膜に付着した汚れがきれいに取れるので、風邪予防や鼻づまりの解消に。ツンとしないコツは、濃度。体液と同じ濃度の約0.9％の塩水を使うこと。水500mLに塩4gを入れてよく溶かして塩水をつくり、片方の鼻の穴を押さえて、もう片方の鼻の穴から塩水を吸い込み、口から出します。これを片側数回ずつ、両側で行います。

※吸い込むのが怖い方は、スポイトを使って鼻の中に塩水を入れてもOKです。

Idea 02 のどの痛みを緩和する

うがい薬は刺激が強くて苦手……という方におすすめ。水200mLに塩ひとつまみを入れよく溶かします。最初は口を閉じてブクブクうがいをします。次に上を向いて口を開け、「あー」と声を出しながら、ガラガラうがいしてのどを洗いましょう。緑茶で行うとカテキンの殺菌効果もプラスされるので、より効果的です。

Idea 03 効率よく水分補給

下痢や嘔吐などが続くと、体内の水分とミネラルが失われて脱水症状を起こす危険があります。その場合は水500mLに塩4g、砂糖20gをよく溶かしたものを飲むと、吸収率がよくなり、経口補水液の役割を果たします。

Idea 04 まぶたの腫れに

泣いた後や睡眠不足でまぶたが腫れてしまったときにおすすめ。熱湯500mLに塩5gを加えてよく混ぜ、コットンに浸します。コットンがほどよく冷めたらまぶたの上にのせ、10分ほど置きます。

Idea 05 蚊にさされたかゆみがすっきり

蚊にさされてかゆみがある部分に塩をのせ、ほんの少し水分を加えてすり込むと、かゆみが消えます。塩の浸透脱水作用によって蚊から注入されたかゆみ成分が吸い出されるからです。かきむしった後では効果がなく、塩がしみて痛いので、かきむしる前に試してみて。

enjoy! salt

もっとキレイになる！
塩の美容術

美容

〈注意点〉
塩の結晶は石膏と同じかたさであるだけでなく、とがった結晶が多いため、大粒だと肌を傷つけてしまうことも。肌に直接使うなら、できるだけ細かい粒の塩を選ぶのがポイント。

Idea 01 湯船に入れて代謝アップ！

200Lの一般的なバスタブに、ひとつかみ（50〜70g程度）の塩を入れます。ナトリウムの効果で末梢血管の血流がアップし身体の芯から温まって、代謝が高まり、発汗を促します。デトックスや疲労回復、風邪予防にも効果的。特に、マグネシウムが多い塩を入れれば、湯あたりがやわらかくなったり、潤い効果のあるセラミドの生成を促進します。硫黄が多い塩なら、硫黄によるデトックス効果が期待できるでしょう。

Idea 03 塩で頭を洗うと頭皮がすっきり

塩は頭皮の脂を溶かし、健康な状態を保つ手助けをしてくれます。抜け毛が気になっている方にもおすすめ。

- シャンプーをしてよくすすいだ後、大さじ1杯程度の塩を頭皮に振りかけて指の腹を使ってマッサージをします。
- 頭皮から脂が出て、指が水をはじくようになったら洗い流します。
- トリートメントは使いません。ただし、髪のパサつきが気になる場合は、酢酸（湯で酢を薄めたもの）を髪につけましょう。

Idea 04 塩歯みがきで歯茎がキュッ

塩の殺菌、収斂作用（組織の収縮を引き起こす）で歯茎を引き締めます。歯みがき粉で歯を磨いた後、指の腹に塩をのせて、歯茎を中心にやさしくマッサージをします。表側だけでなく、裏側もしっかりとマッサージしましょう。

Idea 02 角質がミルミルとれる

塩のかたさは、古くなった角質を取り除くのにぴったり。肌のくすみや黒ずみが気になる人は、2週間に1回のペースで行うと効果的です。まず、身体を洗った後にしっかり湯船で温まってから行います。塩でマッサージを行う際には、右記の注意点を守りましょう。

〈注意点〉
- 中粒以上の塩では肌に傷がつき、色素沈着の原因となるため、微粒もしくはパウダー状の塩を使う。
- 必ずぬるま湯で溶かしてクリーム状にしてから、円を描くように軽く肌をなでる。ごしごしこすらない。
- ひじ、ひざ、かかとなどの角質の厚い部分には多めに塗布する。
- 目の周りや粘膜は避ける。
- 溶かした塩（マッサージソルト）は使い切る。
- つけたままで長時間放置すると乾燥肌の原因になるので、必ず真水できれいに洗い流し、化粧水などで保湿する。

多様なミネラルを含む塩はじょうずに使えば、美容アイテムにもなるんです。
お得で有効な塩美容法、ぜひお試しください。

Topics 美容に効果的なミネラルの作用

塩には非常に多くのミネラル成分が含まれています。なかでも特に美容に効果的な成分を紹介しましょう。

・身体を芯から温める「ナトリウム」

古くから食塩を含んだ温泉（塩泉）が、日本各地で湯治に使われてきたように、ナトリウムが含まれたお湯には、末梢血管の血流が促進し、身体を芯から温め、発汗を促す作用があります。また、ペースト状にした粒の細かい塩はマッサージソルトにも◯。

・保湿に効果的「マグネシウム」

体内に存在する約300種類もの酵素の作用に関与しており、たんぱく質や皮膚の代謝にも必須の成分で、皮膚や粘膜を保護してくれる役割も持ちます。風呂の湯に溶かすと、皮膚のたんぱく質がマグネシウムと結びついて皮膜をつくるので、乾燥を防止。さらには湯あたりをやわらかくしてくれます。

〈注意点〉
塩を使うと鉄がさびやすくなるので、風呂や洗面台などで使用した場合は、真水でよく洗い流すこと。

・デトックスには欠かせない「硫黄」

たんぱく質やアミノ酸の構成要素となるため、毛髪や皮膚・爪には欠かせない成分。ビタミンB_1やパントテン酸と結合して補酵素となり、糖質の代謝を促します。そのほかにも、胆汁の分泌を補助し、有害な成分が体内に蓄積されるのを防ぐ解毒、角質を軟化させて除去しやすくする作用もあります。

〈注意点〉
敏感肌の人は使用前にパッチテストを行うこと。

・エイジングケアにお役立ち「亜鉛」

老化の原因である活性酸素の過剰発生を抑制する働きに関わります。また、細胞の生まれ変わりに必要な成分でもあり、アミノ酸と結合してたんぱく質を安定させたり、コラーゲンの生成にも役立ちます。

おすすめ！バスグッズ

沖縄の製塩所がつくるバススクラブ。ハイビスカス、モズクエキスの天然保湿成分配合。
青い海 スクラブソープ
（株式会社青い海）
http://www.aoiumi.co.jp/

てのひらサイズのヒマラヤ産岩塩を丸ごと閉じ込めたバスボム。4種類の塩と酒粕を配合
お守りコスメ・お浄め塩玉
（ドクター・プラーナビー）
http://e-omamori.jp/

日本海で採れた海藻とにがり、カモミールなどのハーブを配合した入浴用化粧品。2～3回くり返し使える。
海藻の潤い Bath HERB
（ミネラル工房）
http://www.shiroi-diya.com/

塩の歴史

塩は人間の生命維持に不可欠。そのため世界各国のあらゆる地域で生産されてきました。
塩を巡って争いが起きるなど、歴史的な出来事に塩が関わっていることも多くあります。
国土が狭く塩資源に恵まれていない日本では、
海水塩製造の効率化と質の向上を求め、さまざまな工夫が行われてきました。

世界の塩づくり

　古来より世界各国で、その国の塩資源を活用した塩づくりが行われ、それぞれ発展を遂げてきました。

　多種多様な塩資源に恵まれた中国では、紀元前2000年頃からすでに製塩の記録が残っており、それぞれの地域にある塩資源を活用。海水や塩湖、地下塩水に恵まれていたため岩塩の採掘は大々的には行われていませんでした。

　ヨーロッパでは、アルプスのハルシュタットで紀元前1000年頃からすでに岩塩の採掘が行われていました。しかし、岩塩層が辺鄙な場所にあること、海水や塩湖、地下塩水などの資源に恵まれていたことから、岩塩以外の塩の産出がメインでした。ヨーロッパ最古の製塩方法は、海水を穴の中に流し込んで天日で乾燥させる方法だったといいます。ポーランドにあるヴィエリチカ岩塩鉱山では、紀元前5000年から岩塩の採取が行われ、「塩でできた宮殿」として世界遺産にも登録されています。

日本の塩づくり

　海水とごく一部の地下塩水しか塩資源がない日本では、塩をつくるためにさまざまな工夫が凝らされてきました。

　最古の製塩方法は土器と海藻を使ってつくる「藻塩」。千葉県で出土した縄文時代後期（約3500年前）の製塩土器が製塩の記録としては日本最古のものです。古墳時代になると全国各地に製塩土器が広まり、多くの沿岸地域で製塩が行われるようになりました。

　8世紀頃になると、能登半島に自然浜を利用した揚浜式塩田が登場。その後、濃縮工程では入浜式塩田や流下式塩田が発明され、結晶工程で使われる釜の材質が土から石や鉄へと変化していきました。

　大きな変化が訪れたのは1971年。専売制

日本の製塩方法の移り変わり

時代	縄文	弥生	古墳	飛鳥	奈良	平安	鎌倉	南北朝	室町
濃縮工程	藻塩焼き	藻塩焼き	藻塩焼き	藻塩焼き	藻塩焼き				
濃縮工程			揚浜式塩田	揚浜式塩田	揚浜式塩田	揚浜式塩田	揚浜式塩田	揚浜式塩田	揚浜式塩田
結晶工程	土器	土器	土器	土器	土器		石釜	石釜	石釜
結晶工程				土釜・あじろ釜	土釜・あじろ釜	土釜・あじろ釜	鉄釜	鉄釜	鉄釜

度下の塩業整備事業により、ごく一部を除いて、すべての塩田が廃止となり、イオン膜法を使った塩のみ製造が可能となりました。1997年、塩の製造が自由化され、日本の製塩技術は急速な発展を遂げています。

塩の専売制度

専売制度とは、ある物の生産・流通・販売を管理下に置き、国家が利益を得るための制度のことです。塩はその重要性から、多くの国で専売制度が施行されてきました。

中国では紀元前 2000 年頃から塩を年貢にする制度があり、紀元前 600 年頃に世界初の専売制度が導入されました。フランスでは16世紀頃から高額な塩税がかけられ、フランス革命の一因になったといわれています。

日本で専売制度が本格導入されたのは日露戦争の頃。戦費獲得と国産塩の品質・生産力向上が目的でした。その後、何度かの整備事業を経て、1971 年「第 4 次塩業整備事業」で転換期を迎えます。国内で 7 社のみがイオン膜濃縮法での塩の製造を許可され、それ以外の製塩所はごく一部を除き、廃業していきました。その後、自然塩復興運動を経て、日本の専売制度は 1997 年に終焉を迎えます。

世界各国で導入され、廃止と復活をくり返してきた専売制度は、現在、多くの国で廃止されています。

日本における自然塩復興運動

1971 年、塩業整備事業により廃業となった製塩所の経営者や有識者など、有志が集まり、各地でかつての塩を取り戻すための「自然塩復興運動」がおこりました。有志によって結成された「食用塩調査会」「塩の品質を守る会」「青い海とマース（塩）を守る会」などが主体となり、政府との交渉や一般消費者への啓蒙活動を行った結果、1973 年には「再製加工塩」の製造販売が認められることとなりました。

運動から派生する形で、再製加工塩ではなく国産海水 100％の塩づくりを目指す製塩者が登場。沖縄県や東京都の伊豆大島に建てた製塩施設で研究を続け、1979 年には実験目的での国産海水 100％を使った製塩の許可、1980 年には会員に対する年 12kg 以内の塩の配布許可、1985 年にはとうとう会員以外への販売許可を獲得するに至りました。

現在、国内 500 か所以上の製塩所で個性豊かな塩がつくられ、2003 年には塩の輸入も自由化。4000 種類を超える塩が楽しめるようになったのは、こうした歴史的な運動があったからなのです。

安土桃山	江戸	明治	大正	昭和	平成元年～平成18年	平成19年～現在
入浜式塩田					イオン膜	
				流下盤枝条架		ネット式・枝条架 平釜・立釜 逆浸透膜など多数
					立釜（真空式）	
						立釜・平釜・加熱ドラム 噴霧乾燥など

\enjoy! salt

\生命に不可欠って本当？/

塩と健康

塩＝高血圧というイメージから、何かと悪者扱いされがちな塩ですが、海から生まれた生命を源に持つ人間には、必要不可欠なものなのです。

人体に及ぼす塩の働き

ナトリウム、マグネシウム、カリウム、カルシウムを主成分とする塩は、身体の機能調整に重要な役割を果たすほか、骨や血液、細胞などの構成成分です。

身体の基礎的な機能調整には、おもにナトリウムとカリウムが大きな役割を果たします。また、カルシウムは骨や歯の構成成分、マグネシウムは骨・歯・筋肉・脳・神経に含まれることで、骨粗しょう症の予防に役立つなど、それぞれに役割があります。

浸透圧を一定にする

細胞内液にはカリウムが、細胞外液にはナトリウムが多く存在し、細胞の浸透圧を一定に保つ役割を果たします。浸透圧が保たれることで、細胞は正常に活動することができているのです。

酸性、アルカリ性のバランスを保つ

人間の体液は通常pH7.4前後のアルカリ性ですが、呼吸や運動などの代謝によって酸性物質が生成され、酸性に傾くことに。それをナトリウムが中和して、アルカリ性に保つ助けをします。

消化液をつくり栄養素の吸収を助ける

消化液の生成を助け、たんぱく質の分解を促進。さらに、栄養素はイオン化してはじめて体内に吸収されるため、栄養素のイオン化を助ける塩のミネラルは、栄養素の吸収に欠かせません。

神経伝達や筋肉の動きをサポート

神経伝達や筋肉の収縮・弛緩は脳からの電気刺激で行われています。塩の溶け込んだ水が電気を通しやすいように、適切な濃度の塩分があることで、脳からの電気信号がスムーズに伝わります。

体内に海を持つ人間に塩は不可欠

　海で生まれ進化してきた人間の体内には、海の代わりに塩分が含まれています。身体に溶け込んだ塩は、体内のさまざまな器官で、ほかの栄養素と共に重要な役割を果たしてくれますが、人間の体内では塩をつくることができないため、食品として摂取する必要があります。

　私たち人間は、塩を体内に取り入れながら塩分濃度を適切に保つことで、健康的な生命活動を行うことができるようになっているのです。

人間の身体の60％は水分。そこに約0.9％の塩分が含まれている。適切な量の塩を摂取し、体内の塩分濃度を適切に保つことで、身体は健やかな状態で活動できる。

pick up! 間違いだらけ!?塩と高血圧のかかわり

高血圧の本当のところ①

　厚生労働省の推奨する成人の1日の塩分摂取量は健康値の見直しが行われるたびに少なくなり、2015年度では男性で8g／日、女性で7g／日となりました。平均摂取量も右肩下がりで、下の図から見ても年々減少中。その一方で、「塩が原因」とされている高血圧性疾患の患者数は右肩上がりになっています。

高血圧の本当のところ②

　高血圧は、一次と二次の2種類にわけられます。一次性高血圧は、血管の老化、ストレス、過労、肥満、食塩の慢性的な過剰摂取などが原因に挙げられますが、明確な原因は特定することができません。二次性高血圧は、腎臓病やホルモン異常などの原因となる病気があるものを指し、病気が改善されれば高血圧も治ります。

高血圧の本当のところ③

　高血圧はさらに食塩感受性と食塩非感受性にもわけられます。食塩感受性の患者は減塩による血圧低下が望めますが、食塩非感受性の患者では、血圧の低下に塩分摂取はほとんど影響がありません。そして、日本人の高血圧患者のうち約半分は「食塩非感受性」であるという研究結果もあります。

塩分摂取量と高血圧性疾患の患者数の移り変わり

（厚生労働省「国民健康・栄養調査」2005～2014年）
（厚生労働省「患者調査 主な疾病の総患者数」2005、2008、2011、2014年）

enjoy! salt

\ 減塩はもう古い!? /
「適塩」を目指そう

最近の塩と高血圧の研究で、高血圧には種類があること、塩はただ減らせばいいわけではない、ということがわかってきました。健康が気になる人に、本当に必要なのは「適塩」なのです。

極度の減塩がもたらすおもな症状

すでに述べたように、塩は身体の中で重要な役割を果たしています。極度に体内の塩分が減ると、正常な機能を果たせなくなり、さまざまな弊害が引き起こされます。

高血圧を誘発する
血液中のナトリウム濃度が減少しすぎると、生命の危機を感じた腎臓から血圧を上げるホルモンが分泌され、血圧が上昇する。

交感神経が活発化し、免疫力が低下する
常時ストレス状態となって、末梢神経で循環不良が起こるため、代謝不良や免疫力の低下などを招く。

脱水症状を引き起こす
体内から塩分が失われると、体内の塩分濃度を元に戻そうとして、水分が排出され、脱水症状を引き起こす原因になる。

酵素の活性が失われる
酵素の半数以上はミネラルを必要とするため、ミネラルがないと活性を維持することができず、役割を果たすことができない。

食欲の減退、胃腸障害を引き起こす
塩は消化液の原料となるため、塩が不足すると消化液が生成できなくなり胃に負担がかかる。

体力の低下、無気力、倦怠感（けんたいかん）
体内のミネラルバランスが崩れるため、細胞が正常な活動を行えなくなる。

筋肉疲労、痙攣（けいれん）が起きる
体内の塩分濃度が薄まるため、電気信号がスムーズに伝わらなくなり、体に負荷を与える。

適塩とは

人それぞれの身体、環境に合った適度な量の塩を摂取すること

その人それぞれに合った適度な塩の量を摂取すること、それを「適塩」といいます。

居住地域、生活環境、運動頻度、年齢、性別、身長や体重など、人の状態によって、1日のうちに失われる塩の量、つまり必要とされる塩の量はさまざまです。さらに、汗をたくさんかく日もあれば、ほとんどかかない日もあるので、状態は刻々と変化します。

必要な塩分量というのは、人や日によってバラバラで当たり前。自分の状況を把握し、その日その時に応じた塩の摂り方をすることこそが「健康的に塩を摂取する」ということなのです。

塩に限らず、何でも摂りすぎは身体に悪影響を及ぼしますが、反対に極度に減らすのも同様です。「適塩」を心がけて、健康的な生活を送りましょう！

環境・食生活の違いで必要な塩分量は異なる

かつて「健康のために」と、高血圧対策として叫ばれてきた減塩。しかし、近年の研究で、高血圧は塩分摂取量だけが原因ではないことがわかってきました。つまり、必ずしも減塩＝健康とはいえないというわけです。

また、日本人の塩分摂取量は、欧米に比べて多いといわれていますが、高温多湿で体内の塩分を失いやすい気候、塩分排出を促しやすい植物性食品中心の食生活を考えると、当然のことといえます。環境や食生活に合った量の塩をきちんと摂取する（適塩）、それこそが健康への近道です。

適塩のバロメーターは自分の舌

水を飲んだときのことを思い出してください。のどが渇いているときは甘くおいしく、そうでないときは飲みにくさを感じませんか。これは身体の本能的な反応です。塩も同様で、身体にミネラルが足りていないときはおいしく、足りているときはしょっぱく感じます。誰にでも備わっている舌こそが、適塩のバロメーターとなるのです。

適塩生活のための心がけ

食材や調理法に適した塩を選ぶ
量より質にこだわる。食材や調理法に適した塩を選ぶことで、塩の量を減らすことができる。

できるだけシンプルな味つけで食べる
塩と良質なオイルなど最小限の調味料で、食材そのものの味を楽しむ。塩分コントロールもかんたん。

料理は適温を保つ
温度が高すぎたり低すぎたりすると、塩味や甘味を感じにくくなり濃い味つけになりやすい。

濃い味、薄い味の品を両方出す
薄味ばかりだと満足感が低下する。濃い味を1品並べることで、食事の満足感が向上する。

加工食品を摂りすぎない
加工食品は味つけが濃いめなうえ、添加物によって、知らぬ間にナトリウムを多めに摂ってしまいがちに。

だしや酸味、香辛料をじょうずに利用する
だしを濃くしたり、酢やスパイスなどの香りを活かしたりすると、塩を減らしても物足りなさを感じにくくなる。

仕上げにかけたりつけたりする
舌に直接味を感じるほうが少量で済むため、薄味で調理し、食卓で必要な量の塩をかけて食べるのが◎。

塩名索引 salt Index

	商品名	国または都道府県	塩の種類	Page
あ	会津山塩	福島	地下塩水塩	137
	青い海	沖縄	海水塩	102
	青島の塩	宮崎	海水塩	93
	赤ワイン塩	山形	シーズニング	147
	粟國の塩 釜炊き	沖縄	海水塩	97
	あげ浜塩田製法塩	千葉	海水塩	62
	赤穂の天塩	兵庫	海水塩	76
	赤穂の焼き塩 窯焚き塩	兵庫	海水塩	76
	アッサルの塩	ジブチ	湖塩	132
	あっちゃんの紅塩	沖縄	海水塩	102
	アドリア海の風	スロヴェニア	シーズニング	140
	天草の塩 小さな海	熊本	海水塩	90
	海人の藻塩	広島	藻塩	108
	あまみ	高知	海水塩	79
	アラエア 火山赤土塩	アメリカ	海水塩	46
	あらしお	静岡	海水塩	70
	アルペンザルツ	ドイツ	岩塩	126
	淡路島の藻塩(茶) PREMIUM	兵庫	藻塩	109
	アンデスの紅塩	ボリビア	岩塩	120
い	家島の天然塩	兵庫	海水塩	76
	イカスミ塩 ミエルシオ	北海道	シーズニング	147
	壱岐の塩	長崎	海水塩	89
	いごてつの天日塩	高知	海水塩	81
	石垣の塩	沖縄	海水塩	98
	石垣の塩 モリンガ	沖縄	シーズニング	145
	出雲 鵜鷺の藻塩	島根	藻塩	111
	伊豆盛田屋の 完全天日塩	静岡	海水塩	71
	イスラエル 紅海の塩	イスラエル	海水塩	42
	イル・ド・レ フルール・ド・セル	フランス	海水塩	33
	岩戸の塩	三重	海水塩	74
	インカ天日塩	ペルー	地下塩水塩	136
	インディアン ルビーソルト	インド	シーズニング	148
	インド洋の海水塩	スリランカ	海水塩	44
う	うすゆき自然塩	北海道	海水塩	54
	宇多津 入浜式の塩	香川	海水塩	80
	海の泉の塩	山形	海水塩	57
	海の精 あらしお 赤ラベル	東京	海水塩	59
	海のほほえみ	沖縄	海水塩	105
	海んまんま 一の塩 さらさらタイプ	佐賀	海水塩	89
	海の愛	愛媛	海水塩	83
	海一粒	高知	海水塩	82
	海みたま	宮崎	海水塩	92
	うるわしの花塩	沖縄	海水塩	103

	商品名	国または都道府県	塩の種類	Page
え	越後やすづか 雪むろの塩	フィリピン	海水塩	44
	越前塩	福井	海水塩	68
	遠州沖ちゃん塩	静岡	海水塩	70
お	オーストラリア・ピンクリバーソルト	オーストラリア	地下塩水塩	135
	大谷塩	石川	海水塩	65
	小笠原 島塩	東京	海水塩	61
	小笠原の塩	東京	海水塩	60
	男鹿半島の塩	秋田	海水塩	56
	奥能登揚げ浜塩田 香りしお 醤油しお	石川	海水塩	148
	奥能登揚げ浜塩	石川	海水塩	65
	自凝零塩	兵庫	海水塩	75
	オホーツクの塩 釜あげ塩	北海道	海水塩	54
か	GARDENSTYLE FANCY MUSHROOM MIX	静岡	シーズニング	142
	GARDENSTYLE PRECIOUS MIX	静岡	海水塩	71
	海部乃塩	徳島	海水塩	83
	かいふ藻塩	徳島	藻塩	109
	牡蠣の塩	京都	シーズニング	147
	加計呂麻の塩	鹿児島	海水塩	95
	カナディアンシーソルト	カナダ	海水塩	48
	釜炊き一番塩	北海道	海水塩	53
	カマルグ フルール・ド・セル	フランス	海水塩	33
	カムイ・ミンタルの塩 淡雪	北海道	海水塩	52
	カラーソルト	青森	シーズニング	145
	カリブ海 バハマ産 天日塩	バハマ	海水塩	49
	感謝の塩	広島	海水塩	77
	ガンダーラの岩塩 クリスタルソルト	パキスタン	岩塩	125
	カンホアの塩 石窯焼き塩	ベトナム	海水塩	40
き	キパワーソルト	韓国	海水塩	43
	宮廷塩	中国	海水塩	43
	錦塩	長崎	海水塩	89
く	くがにまーしゅ 細塩	沖縄	海水塩	99
	球美の塩	沖縄	海水塩	104
	クリスタル岩塩	パキスタン	岩塩	124
	クリスマス島の海の塩	キリバス	海水塩	45
	クレイジーソルト	アメリカ	シーズニング	141
	黒い塩	秋田	シーズニング	143

商品名	国または都道府県	塩の種類	Page
黒潮町の黒塩	高知	藻塩	111
黒山海	東京	海水塩	62
燻製塩	ボリビア	シーズニング	140
け ゲラン ドエキストラファン	フランス	海水塩	32
こ 御塩	香川	海水塩	80
五代庵 梅塩	和歌山	シーズニング	148
子宝の温泉塩	鹿児島	地下塩水塩	137
五島灘の塩 本にがり仕立て	長崎	海水塩	88
古都ニンの天日塩 フラワーソルト	クロアチア	海水塩	38
琴引の塩	京都	海水塩	75
さ サーレ・ディ・ロッチャ グロッソ	イタリア	岩塩	127
最進の塩	福岡	海水塩	88
酒田の塩 白塩	山形	海水塩	58
桜の塩	東京	シーズニング	146
笹川流れの塩	新潟	海水塩	68
笹の雫	新潟	シーズニング	144
佐渡の深海塩	新潟	海水塩	69
佐渡藻塩	新潟	藻塩	110
砂漠の国の塩	モロッコ	湖塩	133
砂漠の潮 サリーナ湖塩	ペルー	湖塩	133
Salann Oki サランオキ	島根	海水塩	78
サリーナ ディ チェルビア サーレ ディ チェルビア	イタリア	海水塩	35
猿蟹川の塩	鹿児島	海水塩	96
サルデニア島の海塩 粗塩	イタリア	海水塩	36
さんぽの塩	静岡	地下塩水塩	138
し しお学舎の やさしいお塩	三重	海水塩	74
塩竈の藻塩	宮城	藻塩	107
塩の花	新潟	海水塩	69
死海の塩	イスラエル	湖塩	133
四川省の岩塩	中国	岩塩	125
シベリア岩塩 ミックス	ロシア	岩塩	123
シママース	沖縄	海水塩	103
庄内浜の塩	山形	海水塩	58
知床の塩 極	北海道	海水塩	53
深層海塩ハマネ	東京	海水塩	61
す スイーツソルト	長崎	地下塩水塩	136
水晶塩	中国	岩塩	42
珠洲の海 あげ浜	石川	海水塩	65
珠洲の結晶塩	石川	海水塩	64

商品名	国または都道府県	塩の種類	Page
珠洲の竹炭塩	石川	シーズニング	143
すだちソルト	徳島	シーズニング	144
せ セル・デ・ヴァン メルロー	フランス	シーズニング	141
セルリアンシーソルト	アメリカ	海水塩	49
全羅南道の海水塩	韓国	海水塩	43
そ 宗谷の塩	北海道	海水塩	52
SOLASHIO	香川	海水塩	80
た 大自然モンゴルの岩塩 ジャムツダウス	モンゴル	岩塩	123
タウデニ村の岩塩	マリ	岩塩	128
伊達の旨塩	宮城	海水塩	55
玉藻塩	新潟	藻塩	107
ち 地中海クリスタル フレークソルト スモーク	キプロス	シーズニング	140
北谷の塩	沖縄	海水塩	103
つ 通詞島の天日塩	熊本	海水塩	90
津軽海峡の塩	青森	海水塩	57
月の塩 ダイヤモンド	宮崎	海水塩	91
月の塩 緑茶塩	宮崎	シーズニング	145
月の雫の塩	山形	海水塩	57
つるみの磯塩	大分	海水塩	91
て 太陽ぬ真塩	沖縄	海水塩	104
デボラ湖塩	オーストラリア	湖塩	133
デルタサル	スペイン	海水塩	38
天空の鏡 ウユニの塩	ボリビア	湖塩	131
と 土佐の塩丸	高知	海水塩	79
とっぺん塩	長崎	海水塩	87
トリュフ塩	イタリア	シーズニング	141
に 日本海の塩 白いダイヤ	新潟	海水塩	67
ぬ ぬちまーす	沖縄	海水塩	98
の ノアムーティエ セルファン	フランス	海水塩	32
能登のはま塩	石川	海水塩	63
は バートイシュル・ オーストリア アルプスの岩塩	オーストリア	岩塩	127
ハーブ入り アルペンザルツ	ドイツ	シーズニング	142
梅花石の恵 関門の塩	福岡	海水塩	88
伯方の塩(粗塩)	愛媛	海水塩	83
白銀の塩 厳選特上	沖縄	海水塩	100
鉢ヶ崎の塩	石川	海水塩	66
花塩	新潟	海水塩	67
花の塩	石川	海水塩	66
パハール岩塩	パキスタン	岩塩	118

商品名	国または都道府県	塩の種類	Page	商品名	国または都道府県	塩の種類	Page
浜比嘉塩	沖縄	海水塩	99	マルドン スモーク	イギリス	シーズニング	139
浜御塩	長崎	海水塩	86	マングローブの森の海水塩	フィリピン	海水塩	44
浜守の荒塩	島根	海水塩	77	満月の塩 福塩	沖縄	海水塩	99
はやさき 極小	熊本	海水塩	90	満潮の塩	宮崎	海水塩	93
バリ島アメッドの塩	インドネシア	海水塩	40	み みかん塩	愛媛	シーズニング	144
ハワイアン シーソルト	アメリカ	海水塩	47	南大西洋の海水塩	ブラジル	海水塩	49
ハワイアン ブラックソルト	アメリカ	シーズニング	143	南大東島の海塩	沖縄	海水塩	104
ひ ヒマラヤ産 ピンク岩塩	パキスタン	岩塩	119	南の極み	オーストラリア	海水塩	45
ヒマラヤ山麓の岩塩	ネパール	岩塩	122	美浜の塩	愛知	海水塩	71
百姓の塩	山口	海水塩	78	む ムーンソルト 粒小	東京	海水塩	61
百年の海	熊本	海水塩	92	室戸の海洋深層水 マリンゴールドの塩	高知	海水塩	82
ピラミッドソルト	インドネシア	海水塩	39	室戸の塩	高知	海水塩	82
ピランソルト ソルトフラワー	スロヴェニア	海水塩	37	も もずくしお	沖縄	藻塩	109
ひんぎゃの塩	東京	海水塩	62	モティア サーレ・インテグラーレ・フィーノ	イタリア	海水塩	35
ピンクロックソルト	パキスタン	岩塩	119	や 矢堅目の藻塩	長崎	藻塩	108
ビンハオ村の海水塩	ベトナム	海水塩	41	屋我地島の塩	沖縄	海水塩	101
ふ フィオッキ・ディ・サーレ	キプロス	海水塩	34	屋我地マース	沖縄	海水塩	101
フィオッキディサーレ ブラック	キプロス	シーズニング	143	屋久島永田の塩 えん	鹿児島	海水塩	94
フォッシルリバー 塩フレーク	スペイン	岩塩	128	山塩	長野	地下海水塩	138
Flower Of Ocean シホ	東京	海水塩	60	山塩小僧	高知	海水塩	81
フラワーソルト	新潟	シーズニング	146	ゆ 雪塩	沖縄	海水塩	100
ブルーチーズソルト	カナダ	シーズニング	142	弓削塩	愛媛	藻塩	111
フレーキーシーソルト	ニュージーランド	海水塩	45	夢の塩	宮崎	海水塩	93
プレミアム・シーソルト	ポルトガル	海水塩	36	よ ヨロン島の塩 じねん	鹿児島	海水塩	94
へ 戸田塩	静岡	海水塩	70	ヨロン島の塩 星の砂塩	鹿児島	海水塩	95
ペルシャの岩塩 結晶	イラン	岩塩	121	ら ラウシップ	北海道	海水塩	54
ペルシャの岩塩 ブラックソルト	イラン	岩塩	122	ラオスの天然岩塩	ラオス	岩塩	126
ベロ 海の塩	フランス	海水塩	35	楽塩	鹿児島	海水塩	96
ベンガルの岩塩 カラナマック	インド	岩塩	122	落花塩	神奈川	シーズニング	142
ほ ポーランド岩塩	ポーランド	岩塩	120	り リアルソルト	アメリカ	岩塩	120
ポルトガル天日塩	ポルトガル	海水塩	38	りぐる	高知	海水塩	81
ま まぁさましゅ	鹿児島	海水塩	96	れ レモンソルト	熊本	シーズニング	144
薪窯直煮製法 のだ塩	岩手	海水塩	56	ろ ローズソルト	ボリビア	岩塩	119
まぐねしお	沖縄	海水塩	105	ローソク島の藻塩	島根	藻塩	110
マグマ塩	中国	岩塩	121	ロザリオ塩	熊本	海水塩	92
マスコット クリスタルソルト	メキシコ	海水塩	47	ロレーヌ岩塩	フランス	岩塩	127
マドゥラ島の海水塩	インドネシア	海水塩	41	わ ワイルドグレープソルト	岩手	シーズニング	146
マルガリータソルト	アメリカ	海水塩	49	わさびの おいしいお塩	静岡	シーズニング	145
マルタ フレーク海塩	マルタ	海水塩	41	湧出の塩	沖縄	海水塩	102
マルドン シーソルト	イギリス	海水塩	34	湧出の塩 だし塩	沖縄	シーズニング	147
				輪島の海塩	石川	海水塩	66
				わじまの海塩	石川	海水塩	64
				ん んまか塩	長崎	海水塩	87

Information さらに塩の知識を深めたい人におすすめの講座と資格を紹介します。

日本ソルトコーディネーター協会

この本の著者、青山志穂が代表理事を務める日本ソルトコーディネーター協会。「たくさんの塩が手に入るようになった今だからこそ、正しい知識をもとに、塩を活かし、楽しんでほしい」と2012年に設立。塩に関する研究、イベントや講座の開催、協会認定資格の発行など生産者と消費者の架け橋として、塩とその正しい知識の普及に努めています。

日本ソルトコーディネーター協会の活動内容

- 塩に関する研究
- イベントや講座、書籍の出版などを通じた塩の知識を広く伝える活動
- 協会認定資格「ソルトコーディネーター」の育成
- 塩の加工・販売
- 塩を通じた地域産業の活性化

協会認定資格「ソルトコーディネーター」とは

塩と食に対する正しい知識を身につけた塩のスペシャリストです。塩のおいしさや楽しさを追求し、人に伝えることができるようになることを目的にしています。趣味として楽しむことはもちろん、飲食店のメニュー開発や料理教室など、自身の職業に活かすために目指す方も多い資格です。習熟度によって「ジュニアソルトコーディネーター」「ソルトコーディネーター」「シニアソルトコーディネーター」にわかれています。

日本ソルトコーディネーター協会では、ソルトコーディネーター養成のための講座を開催しています。

カリキュラムに沿って、体系的に塩と食にまつわる知識を深めることができる講座です。

※詳しい内容はホームページをご覧ください。

Data

一般社団法人日本ソルトコーディネーター協会
〒901-0403 沖縄県島尻郡八重瀬町字世名城177
TEL：098-800-2019（10時〜17時）土日祝休　FAX：098-993-7566（24時間受付）
http://saltcoordinator.jp/

著者紹介

青山志穂（あおやま・しほ）

シニアソルトコーディネーター
一般社団法人日本ソルトコーディネーター協会代表理事

東京都出身。2007年より沖縄県在住。慶應義塾大学卒業後、大手食品メーカーを経て、塩の専門店に入社。そこで塩の奥深さに目覚め、社内向け資格「ソルトソムリエ」制度設立のほか、人材育成、商品開発を担う。
2012年、独立し、一般社団法人日本ソルトコーディネーター協会を設立。日本初となる塩のプロフェッショナルを育てるべく、「ソルトコーディネーター」資格制度を立ち上げる。
現在は、テレビ、ラジオ、雑誌などで塩の魅力を語るほか、全国の食品系メーカーと共同で商品開発や、有名シェフとのコラボレーション、お店にあった塩のセレクト＆コーディネート、東京、沖縄、香港など、日本・世界各地で塩の講座を開催するなど、あちこち飛び回りながら、塩の名産地沖縄の塩をはじめとした世界各地の塩と、料理をさらにおいしくする塩の使いわけを研究し、日々、塩（適塩）を普及すべく活動中。
主な著書（共著）に『塩図鑑』（東京書籍）、『琉球塩手帖』（ボーダーインク）がある。

協力　アル・ケッチァーノ　奥田政行
　　　てんぷら小野　志村幸一郎
　　　高江洲製塩所　高江洲優
　　　株式会社塩田　上地功
　　　日本ソルトコーディネーター協会　http://saltcoordinator.jp/
　　　シニアソルトコーディネーター／倉持恵美、坂井洋子、田中園子、
　　　ソルトコーディネーター／石山奈都枝、菊入なかよ、菊地清香、久保靖則、近藤伸大、塩田廣重、
　　　塩田昌弘、土井聡、平家さやか、松原亜実、三里あれん、三船円果、弥生一葉、吉村真理子、
　　　ジュニアソルトコーディネーター／飯山美恵子、浦上順子、金子奈津子、當眞利江

編集協力　株式会社スリーシーズン

日本と世界の塩の図鑑
～日本と世界の塩245種類の効果的な使いわけ方、食材との組み合わせ方～〈検印省略〉

2016年　11月　19日　第　1　刷発行
2019年　2月　9日　第　3　刷発行

著　者——青山　志穂（あおやま・しほ）
発行者——佐藤　和夫
発行所——株式会社あさ出版
　　　　〒171-0022　東京都豊島区南池袋 2-9-9 第一池袋ホワイトビル 6F
　　　　電　話　03（3983）3225（販売）
　　　　　　　　03（3983）3227（編集）
　　　　F A X　03（3983）3226
　　　　U R L　http://www.asa21.com/
　　　　E-mail　info@asa21.com
　　　　振　替　00160-1-720619

印刷・製本（株）光邦
乱丁本・落丁本はお取替え致します。

facebook　http://www.facebook.com/asapublishing
twitter　　http://twitter.com/asapublishing

©Shiho Aoyama 2016 Printed in Japan
ISBN978-4-86063-928-0 C0070